Adobe Lightroom 2

The Missing FAQ

Real Answers to Real Questions asked by Lightroom Users

Victoria Bampton

Lightroom Queen Publishing

Adobe Lightroom - The Missing FAQ - Version 2.0

ISBN - 978-0-9560030-1-0 (PDF Format)
ISBN - 978-0-9560030-2-7 (Paperback)

Many thanks to the members of Lightroom Forums (http://www.lightroomforums.net) and Digital Wedding Forum (http://www.digitalweddingforum.com) who asked most of the questions, and for the encouragement to get on and write this book!

Special thanks to Brad Snyder, Dave Huss, Sean McCormack, Jeffrey Friedl & Paul McFarlane for their help in getting this project finished.

And to the many other people who have helped out along the way... you know who you are!

Update reference: 108080208

Table of Contents

Output to Other Programs, Screen, Print & Web

Other Tips, Tricks and Troubleshooting

Table of Contents... in detail

Is there a limit to the number of photos that
can be imported in a single import?

Can I import CMYK files into Lightroom?

Lightroom appears to be corrupting my photos – how do I stop it?

Lightroom is changing the colors of my
photos... what could be happening?

Import Error Messages 109

It says "Some import operations were not performed. The
files appear to be unsupported or damaged."

It says "The following photos will not be imported
because they are already present in the catalog."

It says "Some import operations were not performed. The
files already exist in the catalog." What does this mean?

It says "Some import operations were not
performed. The files are too big."

It says "Some import operations were not performed. The
files could not be read. Please reopen the file and save
with 'Maximize Compatibility' preference enabled."

It says "Some import operations were not performed.
The files use an unsupported color mode."

How do I move the Library Filter bar to the Secondary Display?

Why does the Secondary Display switch from Grid to Loupe when I change the Main Screen to Grid?

Can I detach the panels and rearrange them?

Folders 124

How do the folders in Lightroom's Folder panels relate to the folders on my hard drive?

What's this new Volume Browser?

I have a long list of folders – can I change it to show the folder hierarchy?

When I look at a parent folder in Grid view, I see the photos in the subfolders as well. Can I turn it off so I can only see the contents of the selected folder?

Lightroom thinks my photos are missing – how do I fix it?

Where has the Missing Files collection gone? How do I find all of the missing files in my catalog now?

I need to move some or all of my photos to a new hard drive – how can I do so without confusing Lightroom?

How does the Synchronize Folder command work?

Is there a way of seeing the photos and their duplicates so that I can sort through them?

How can I find the original file on my hard drive?

I'm deleting photos in Lightroom, set to send to Recycle
Bin/Trash, so why isn't it deleting them?

It's taking forever to delete photos – should it really take this long?

I turned off auto rotate in the camera by accident
– how can I rotate photos easily?

My photos have imported incorrectly rotated
and distorted – how do I fix it?

Are there any shortcuts to make rating and labeling quicker?

I've flagged my photos, but the flags disappear when I view
these photos in another folder or collection – why?

Why would I want flags to be local instead of global?

I gave my photos color labels in Lightroom
– why can't I see them in Bridge?

I gave my photos different color labels in Lightroom – why
are they all white in Bridge? I labelled my photos in Bridge
– why isn't Lightroom showing my color labels?

Is it possible to view flag/rating/color labels
status when in other modules?

Is it possible to sort by camera?

How do I sort my entire catalog from earliest to latest or vice versa, regardless of which folders the photos are in?

How do I filter my photos to show photos fitting certain criteria?

How do I filter my photos to show... just one flag/color label/rating?

How do I filter my photos to show... photos with no color label?

How can I use the Text filters to do AND or OR filters?

How do I change the Metadata filter columns?

How do I select multiple options within the Metadata filter columns?

Can I combine Text filters, Attribute filters, and Metadata filters?

How do I search for a specific filename?

How can I view all of the photos tagged with a specific keyword or keyword combination?

Is it possible to display all of the photos in a catalog that are not already keyworded?

Can I save the filters I use regularly as presets?

Can I delete the filter preset I created accidentally?

Collections

How are Collections different from Folders?

What are the different icons for Collections?

What's the difference between Vibrance and Saturation?

Why are Contrast & Brightness set to 25 & 50 by default, instead of 0?

What does the Clarity slider do?

Why doesn't the Vignette adjust to the Crop boundaries?

How do the Post-Crop Vignette sliders interact?

I want to use a Point Curve, but only Parametric Curves
are available in Lightroom. Is it possible?

What do the three triangular sliders docked at
the base of the Tone Curve display do?

There are some hot pixels on my sensor in other programs,
but I can't see them in Lightroom. Where have they gone?

Sharpening & Noise Reduction 238

I've turned sharpening right up to the maximum, but it
doesn't seem to be doing anything – why not?

Why isn't Lightroom's Develop module sharpening very strong?

Why can't I view sharpening in Fit to Screen mode?

How do the sharpening sliders interact?

Why can't I see the effects of the noise reduction?

Is it possible to use plug-ins such as Noise
Ninja or Neat Image to reduce noise?

What does the Amount slider do?

How are the buttons different from the sliders?

How do I create a new brush mask?

What do Size and Feather do?

What's the difference between Flow & Density?

Is the Adjustment Brush pressure sensitive when
used with a graphics pen tablet?

What does Auto Mask do?

How do I reselect an existing mask?

Where have my mask pins gone?

How do I add to an existing brushed mask?

How do I erase from an existing brushed mask?

How can I tell whether I'm creating a new
mask or editing an existing mask?

How do I create a new gradient mask?

How do I adjust an existing gradient?

How do I show the mask I've created?

Can I change the color of the mask overlay?

Can I fade the effect of an existing mask?

Can I layer the effect of multiple masks?

Can I invert the mask?

Can I synchronize my settings with other photos?

I've somehow removed the toolbar with the Crop/Red Eye
Reduction/Spot Removal tools from the Develop module and can't
find a way to get them back where they should be. Help?

Why do my photos change color? When the first preview appears,
it looks just like it did on the camera, and then that disappears
and it applies other settings. How do I turn that off?

I set my camera to black and white. Why is
Lightroom changing them back to color?

How do other programs like iView, PhotoMechanic, Apple's
Preview, Windows Explorer, Breezebrowser etc. get it right?

My Canon raw files exhibit an odd shift particularly
in the red tones – can I fix this?

When I crop to 8x10 in Lightroom and then open
in Photoshop, why is it not 8"x10"?

Is it better to upsize in Lightroom or in Photoshop?

Can I export to multiple sizes in one go?

Can I set Lightroom to automatically export back to the same
folder as the original, or a subfolder of the original folder?

Can I set Lightroom to overwrite the original when exporting?

How do I change the filename while exporting?

Can I stop Lightroom asking me what to do when it
finds an existing file with the same name?

Can you 'Apply sharpening to preview photos only' like you can in ACR?

Why does the Export Sharpening only have a
few options? How can I control it?

Which Export Sharpening setting applies more
sharpening – screen, matte or glossy?

Why are Lightroom's prints too dark?

How do I get Lightroom to see my custom print profile?

Why does my custom ICC printer profile not
show in Lightroom's list of profiles?

How do I install new web galleries?

The default flash gallery appears to be capped at 500 photos,
but I need to include more – how can I change the default?

Is it possible to add music to the galleries?

How can I change a web gallery I've already created?

How can I save certain settings to a default gallery
template, such as identity plates and color settings?

How do I upload my gallery?

Why doesn't the FTP upload work – it says "Remote Disc Error"?

Can I have multiple galleries on my website?

I've renamed the files outside of Lightroom and now
Lightroom thinks they're missing. I've lost all of my
changes! Is it possible to recover them?

I renamed my photos inside of Lightroom, but I've accidentally
deleted those renamed files from the hard drive. I do have copies
of the files on DVD, but they have the original filenames, so
Lightroom won't recognize them. Is it possible re-link them?

Preview Problems 388

Everything in Lightroom is a funny color, but the original photos
look perfect in other programs, and the exported photos don't
look like they do in Lightroom either. What could be wrong?

How do I change my monitor profile to check whether it's corrupted?

Lightroom doesn't show me a preview of my
PSD file in Grid view – why not?

Other Problems 391

I have a huge problem! I accidentally deleted my photos from my hard
drive and I don't have backups! There are 1:1 previews in Lightroom's
catalog – is there any way of creating JPEGs from the previews?

Lightroom has slowed to a crawl – how can I speed it up?

How do I change Lightroom's memory management?

Does Lightroom use multiple cores?

I've heard of incompatibilities with nVidia graphics cards and software
– is there anything I can do, other than using a different graphics card?

Leopard Finder crashes when I try to view previews of photos
which have Develop settings embedded. How do I fix it?

Your custom Camera Raw Profiles can also
be installed to the User folders...

How do I show hidden files?

I've heard Lightroom 2.0 is now 64-bit. How is that beneficial?

How do I install the 64-bit version?

My Mac version doesn't have an 'Open as 32-bit' checkbox. Why not?

I'm switching from PC to Mac - how do I switch my Lightroom license?

How many machines can I install Lightroom on?

How do I deactivate Lightroom to move it to another machine?

Is the download on Adobe's website the full program or just an update?

Introduction

A Quick Intro to this Book

Adobe® Photoshop® Lightroom™ 1.0 was released on February 19th 2007 after a long public beta period, and rapidly become a hit. Thousands of users flooded the forums, looking for answers to their questions. With the release of version 2, that popularity can only continue to build.

This book is not intended to be a step by step introduction to Lightroom – there are already books which fill that need and some things are far too obvious to need a book anyway – but there is one big gap – troubleshooting and reference material.

When you have a question, where do you look? Do you trawl through thousands of web pages looking for the information you need? Perhaps post on a forum and wait for hours for anyone to reply? Maybe try to figure out the Help files? From now on, you look right here!

Adobe Lightroom 2 – The Missing FAQ is a compilation of the most frequently asked questions, which you'll find listed in the Table of Contents... In Detail on the preceding pages. It's also available in PDF format so you can easily search for the information you need.

No cheesy jokes to make you cringe... just good solid information about your favorite program.

As many readers will have upgraded from version 1.4.1, we will refer to some of the changes made in version 2.0.

The Book Format

As you glance through the pages of this book, you'll notice it's split into chapters for each of the Lightroom modules and other important topics.

Within each chapter are a series of questions and their answers, divided further into groups of similar questions.

As you read on, you'll also notice links to other related topics, particularly useful if you're searching for the answer to a specific issue.

 Links to other related topics are marked with a pin.

In the front you'll find a list of all of the questions covered in this book. In the PDF format you can also use the search facility or bookmarks to find exactly the information you need.

The final chapters list various other useful information, particularly default file locations for preferences, presets and catalogs for each operating system, and also a list of all of the known keyboard shortcuts too. Shortcut sheet updates can be downloaded from http://www.lightroomqueen.com/

Windows or Mac?

The simple answer is... it doesn't matter. The screenshots are of the Mac version, but the Windows version is almost identical. Lightroom is entirely cross-platform, and therefore this book will follow the same pattern. Where keyboard shortcuts differ by platform, both are noted.

The Database Concept

Database vs Browser

A Quick Intro to Lightroom

Adobe Photoshop Lightroom combines digital asset management with powerful image processing tools, and provides an easy way to display your photos, whether as a slideshow, a print or on the web.

It's based on an SQLite database, which holds all of the data about each of your photos. As a result, searching for photos is much quicker than a browser-based alternative, and the photos can still be found even if they're offline.

As it's a database rather than a browser, you have to import photos into that database before you can start working on them. Changes you make to those photos are then stored in Lightroom's catalog until you choose to export for use in other programs.

The image correction tools are designed primarily for raw processing, however they also work on JPEG, TIFF and PSD files.

What's the difference between the Database, the Catalog and the Library?

These terms are often used interchangeably.

'The Catalog' and 'The Library' are both usually used to describe the underlying database that holds all of the data about your photos, including any changes you've made to those photos using Lightroom.

The database was originally called a Library, however that caused some confusion, so it's now called a Catalog, to differentiate between that and the Library module where you organize your photos.

Why a database rather than a browser?

Adobe already offer a browser for those who prefer that setup – Bridge.

Many of Lightroom's features are dependent on its database backbone, and wouldn't be possible as a simple file browser.

Searching image metadata (EXIF, keywords etc.) is much faster as a result of the database, and Lightroom can search for photos which are offline as well as those currently accessible.

Amongst other things, Lightroom can create virtual copies, collections of photos, store extensive edit history for each image, and track information on settings for slideshows, prints and web galleries and their associated photos, all of which depend on the database.

Do I have to import my photos? Can't I just browse to view them?

You do have to import your photos so that Lightroom can add them to its database, however you can set it to 'Add photos to catalog without moving' so that they are simply referenced in their existing locations without moving or copying.

 See the 'Import' chapter starting on page 89

Of course, the photos don't have to stay in your catalog once you've finished processing them. You can always remove them, or transfer them to an archive catalog if you'd prefer.

Do I have to export my photos? Why can't I just save them?

Exporting is the same as saving as a JPEG/PSD/TIFF in pixel based programs such as Photoshop, except this is non-destructive editing, so your original isn't overwritten.

Information about the changes you've made to your photos is stored in the catalog until you're ready to export.

 See the 'Export & Editing in Other Programs' chapter starting on page 291

Catalog Facts

Is there a maximum number of photos that Lightroom can hold?

There is no known maximum number of photos you can store in a Lightroom catalog. Theoretically your computer might run out of address space for your photos between 100,000 and 1,000,000 photos, although there are many users running catalogs of more than 100,000 photos, myself included.

Is there a maximum number of photos before Lightroom's performance starts to degrade?

There is no magic number – it depends on the computer specification.

Is there a maximum file size that Lightroom can import?

The maximum image size that Lightroom 2.0 can import is 65,000 pixels along the longest edge, which has increased from 10,000 pixels in version 1.

 See 'It says "Some import operations were not performed. The files are too big.' on page 112

Working with Catalogs

Why do I have 2 different files for my catalog?

*.lrcat is the catalog/database which holds all of your settings.

*.lrdata is the previews. It's made up of lots of little preview files.

 See 'Previews & Speed' section starting on page 373

Catalogs from previous versions had other file extensions to identify them.

*.aglib identified the early beta catalogs.

*.lrdb was the catalog for version 1.0.

*.lrcat is the catalog for version 1.1 onwards.

Can I rename my catalog?

You can rename the catalog in Explorer (Windows) / Finder (Mac) as if you were renaming any other file.

You should also rename the previews file so that it reflects the new name of the catalog, however if you don't rename the previews correctly, Lightroom will simply recreate all of the previews. No harm done except for the time involved, although if you have offline files, previews won't be recreated until they are next online.

So, for example:

Lightroom Catalog.lrcat --> New Name.lrcat

Lightroom Catalog Previews.lrdata --> New Name Previews.lrdata

When you next come to reopen Lightroom, it will likely ask you which catalog to open, in which case you simply direct it to the newly renamed catalog.

How do I create a new catalog and then switch between catalogs?

Hold down the Ctrl key (Windows) / Opt key (Mac) while opening Lightroom. A dialog will appear asking you to select an existing catalog, or you can create a new catalog with the name and location of your choice.

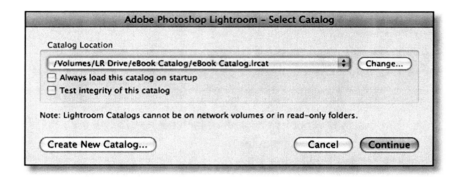

If Lightroom is already running, you can also start a new catalog using the File menu > New Catalog... command, or open an existing catalog using the File menu > Open Catalog... command.

How do I set or change my default catalog?

By default, Lightroom opens your last-used catalog, however you can change that in Lightroom's Preferences > General panel. You can choose to open a specific catalog, the most recent catalog, or to be prompted each time Lightroom starts.

If you have it set to open a specific catalog or the most recent catalog, you can override it and view the Select Catalog dialog by holding down Ctrl (Windows) / Opt (Mac) while starting Lightroom.

I have Lightroom set to prompt me when I start Lightroom, but how do I change the catalog that's automatically selected in the list?

The list of catalogs defaults to the last default catalog you selected in Preferences. If you use one particular catalog more than the others, you may wish to set that catalog to automatically be selected in the list.

To change the default catalog in that list, go to Preferences > General panel, and set the 'When starting up use this catalog' popup menu to your most-used catalog. Closing the Preferences dialog stores that selected catalog as your new default, and then you can reopen the Preferences dialog to change it back to 'Prompt me when starting Lightroom'.

The next time you open Lightroom, the usual prompt dialog will appear, but your most-used catalog will already be selected.

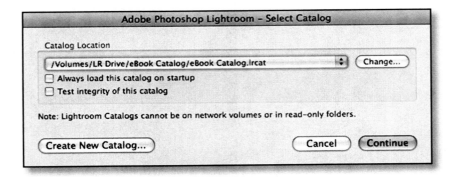

Single or Multiple Catalogs

How does Import from Catalog work?

Import from Catalog allows you to take a whole catalog, or a part of it, and merge that into another existing catalog, so that you can transfer photos between catalogs without losing any of your metadata.

First, open the main catalog that you wish to merge into. Select File menu > Import from Catalog..., and navigate to the second catalog.

Lightroom reads the second catalog and checks it against the main catalog, resulting in this Import from Catalog dialog:

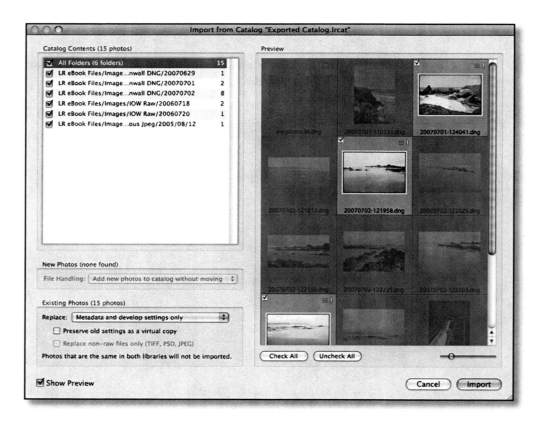

Depending on the choices you make, new photos are imported into the main catalog, either referenced in their existing locations, or being copied to another folder of your choice in their existing folder hierarchy.

Existing photos are checked for changes, and only those that have updated metadata will be updated in the main catalog. Photos that haven't changed are dimmed.

Lightroom can either replace just the metadata and settings, or replace the original files too. You also have the option to replace originals on non-raw format only, as you may have done additional retouching on other formats.

Settings existing in the main catalog can be preserved as a virtual copy if you're concerned about accidentally overwriting settings.

How does Export from Catalog work?

Export from Catalog allows you to take a subset of your catalog – perhaps a folder or collection – and create another catalog from those photos, complete with all of your metadata, and the previews and original files too if you wish. You can then take that catalog to another computer, and merge it back in later if you so choose.

 See 'How does Import from Catalog work?' on page 60

To split your catalog using Export from Catalog, you first need to decide on the photos you wish to include. You can export any selected photos using File menu > Export as Catalog, or a folder or collection from the right-click context sensitive menu > 'Export the Folder/Collection as Catalog...' commands.

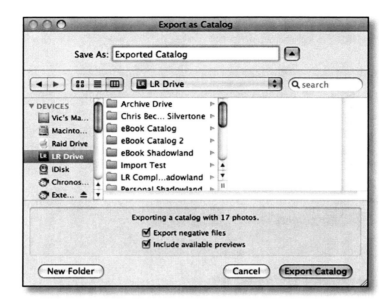

In the following dialog, choose a location for your exported catalog. In that same dialog, you also choose whether to 'Export negative files', which will create duplicates of your original files in the same location as the exported catalog. This is particularly useful when taking a subset of your catalog to another computer.

You have the option to 'Include available previews', which will export the previews if they have already been rendered. This is important if you're exporting a catalog subset to take to another computer but you won't be taking the original files with you. You'll still be able to work on metadata updates such as rating and keywording even without the original files or negatives.

The resulting catalog is a standard catalog, just like any other. If you've chosen to 'Export negative files', there will also be a subfolder called 'Images', with copies of your original files in folders reflecting their original folder structure.

You can transfer that catalog to any computer, and either double-click on it to open, hold down Ctrl (Windows) / Opt (Mac) on starting Lightroom, or use the File menu > Open Catalog... command to open it.

Having finished working on that catalog, you can use Import from Catalog to merge it back into your main catalog.

 See 'How does Import from Catalog work?' on page 60 and 'Multiple Machines' section starting on page 68

Should I use one big catalog, or multiple smaller catalogs?

The main reason to keep all of your photos in a single catalog is to be able to easily search. If your photos are split over multiple catalogs, you'd have to open each catalog and search within that catalog, before moving onto the next. That defeats the object of having a searchable catalog!

On the other hand, a small catalog is often faster than a huge catalog, particularly on slower hardware.

A few questions to ask yourself:

- How many photos are you working on at any one time? And how many do you have altogether?

- How fast is your computer – can it cope with a huge catalog at a reasonable speed? Or does it run much better with a small catalog?

- Do you want to be able to search through all of your photos to find a specific image? Or do you have another DAM (digital asset management) setup that you prefer to use for cataloguing your photos?

- If you decide to work across multiple catalogs, how are you going to make sure your keyword lists are the same in both catalogs?

- If you use multiple catalogs, is there going to be any crossover, with the same photos appearing in more than one catalog?

- Do you want to keep the photos in your catalog indefinitely or just while you're working on them, treating Lightroom more like a basic raw processor?

Your answers will likely depend on WHY you're using Lightroom. For some people, using multiple catalogs isn't a problem – they already have another system they use for DAM, and they want to use Lightroom for the other tools it offers. For example, some wedding photographers may decide to have a catalog for each wedding, and if they know that a photo from Mark & Kate's wedding is going to be in Mark & Kate's catalog, finding it really isn't a problem.

You may also decide to keep 'Personal' files entirely separate from 'Work' files – these kind of distinctions work well as long as long as there's never any crossover between the two. Keeping the same image in multiple catalogs gets confusing!

Many high–volume photographers need the best of both worlds – a small fast catalog for working on their current photos, and then transferring them into a large searchable archive catalog for storing completed photos. That is certainly another viable option, and a good compromise for many.

 See 'I've decided to use a smaller working catalog, but then import into a large searchable archive catalog when I've finished working with them. How do I transfer them from one catalog to another?' on page 69 and 'I use multiple catalogs, but I'd like to keep my keyword list identical and current across all of the catalogs – is there an easy way?' on page 161

I don't want to use Lightroom as an asset management program, just as a raw converter. Can I use a separate catalog per job?

If you never want to search for photos across multiple jobs, then one catalog per job is fine.

I've decided I'm going to have my photos in one large working catalog, but then I'd like to archive the job off into an individual catalog for archival storage. How do I export to a small catalog?

When you're ready to archive, you simply need to follow the instructions for exporting as a catalog.

 See 'How does Export from Catalog work?' on page 61

That will create its own individual catalog, which you can then archive. You can store the exported catalog anywhere – perhaps with the original files, with the finished files, or elsewhere on your hard drive.

If you need to refer back to it later, simply open it as any other catalog, by holding down Ctrl (Windows) / Opt (Mac) while starting Lightroom, or using the File menu > Open Catalog... command.

Depending on your folder structure, it may report the photos as missing, however it's very simple to update the links, and carry on working as normal.

 See 'Lightroom thinks my photos are missing – how do I fix it?' on page 129

I've decided to use a smaller working catalog, but then import into a large searchable archive catalog when I've finished working with them. How do I transfer them from one catalog to another?

1. Open your 'Archive' catalog, or create one if you haven't done so already.

 See 'How do I create a new catalog and then switch between catalogs?' on page 58

2. Select File menu > Import from Catalog...

3. Navigate to your 'Working' catalog and select the folders that you want to transfer into your 'Archive' catalog, deselecting the others.

 See 'How does Import from Catalog work?' on page 60

4. Import those completed folders into your 'Archive' catalog and check they've imported as expected.

5. Close your 'Archive' catalog and open your 'Working' catalog.

6. Select the files you've just transferred. I would recommend writing to XMP – it's a good backup plan.

 See 'How do I write settings to XMP?' on page 283

7. Press Delete to remove those files from the 'Working' catalog – just be careful to choose 'remove from the catalog' rather than 'delete from the hard drive'.

Simply repeat the process whenever you wish to transfer more photos into the 'Archive' catalog.

I seem to have 2 catalogs. I only use 1, so can I delete the other?

It's probably safest to open the spare catalog first to check that you definitely don't want it. To do so, either use File > Open Catalog... or double-click on the catalog in Explorer (Windows) / Finder (Mac).

You can safely delete the spare catalog and its previews files as long as you're sure there's nothing in it you need.

When I used ACR I only kept the XMP files archived – can't I just do that?

Yes! Not all of the information is stored in XMP, so just double check that you won't be deleting something you need.

Lightroom doesn't write to XMP by default, so you'll need to either enable 'Automatically write changes into XMP' in Catalog Settings > Metadata panel, or select all of the photos in Grid view once you've finished processing, and press Ctrl-S (Windows) / Cmd-S (Mac) to manually write the settings to XMP.

 See 'XMP' section starting on page 281

Multiple Machines

I need to work on my photos on my desktop and my laptop – what are my options?

You have 3 main options:

1. A single portable catalog – you place your catalog and photos on an external hard drive, and plug it in to the machine you're using at the time.

2. Split and merge catalogs using Import from Catalog and Export to Catalog, ideally using one computer as a 'base' (usually the desktop) and taking smaller catalogs out for use on the secondary computer (usually the laptop).

 See 'How does Import from Catalog work?' on page 60 and 'How does Export from Catalog work?' on page 61

3. Use XMP to transfer settings between computers – however some data is not stored in XMP.

 See 'Which data is not stored in XMP?' on page 283

Let's consider a few different scenarios...

I work on a single laptop and my photos are on an external hard drive – when I take my laptop out, but leave the external hard drive at home, can I continue working on the files?

If your catalog and previews are on your laptop, rather than on the external drive, then you will still be able to do some work within Lightroom.

You'll want to make sure that you've rendered at least Standard-Sized Previews while the external drive is still connected, and if you plan on zooming in, you'll want 1:1 Previews.

 See 'What is the difference between Minimal previews, Standard previews and 1:1 previews?' on page 373

When the external drive is disconnected, the photos will be reported as missing, however they will be found again once the drive is reconnected.

With the drive offline, you'll still be able to do Library tasks – labeling, rating, keywording, creating collections, etc., and you can print, but only in draft mode. You won't be able to do anything that requires the original files – working in Develop module, exporting files, moving files between folders, and so forth.

I primarily work on my desktop, but I'd like to be able to temporarily transfer part of my catalog to my laptop and then merge the changes back later. Is that possible?

1. Upload into your main catalog as normal.

2. Decide what you want to take with you, and use the File menu > Export as Catalog... command to create a smaller catalog with just those photos. Exporting directly to a small external hard drive is usually the simplest solution.

3. Make sure you allow it to 'Include available previews', and if you want to be able to work on the original files, for example making changes in Develop module, 'Export negative files' too.

 See 'How does Export from Catalog work?' on page 61

4. Moving to your laptop, plug in that external hard drive, open Lightroom, and open that new catalog that you've just created.

 See 'How do I create a new catalog and then switch between catalogs?' on page 58

5. Work as normal on that catalog.

6. When you get back to your desktop computer, connect the external hard drive and select File menu > Import from Catalog...

7. Navigate to the catalog you've been working on and an Import dialog will appear.

8. As the photos will already be in your main working catalog, it'll ask you what you want to do with the new settings – you can choose what you wish to update. Once you've confirmed that it's updated correctly, you can delete the temporary catalog.

 See 'How does Import from Catalog work?' on page 60

I like to upload into a catalog on my laptop when I'm out shooting and start editing – how can I move those files into my main desktop catalog when I return home, without losing the settings?

It is simplest to create a new catalog on your laptop, and import the photos into that catalog as usual.

Creating the catalog and files on an external hard drive makes it even easier to transfer the files.

Once you return to your desktop machine, copy that catalog over, or plug in the same external hard drive, in order to access the catalog and photos.

Then simply use Import from Catalog to transfer the photos and their settings over to the main desktop catalog.

 See 'How does Import from Catalog work?' on page 60

Why haven't my presets copied over with the catalog?

Your presets, by default, are not stored with the catalog. You can transfer them manually so that they appear on each machine. It's easiest to allow File Synchronization software to keep the entire presets folder synchronized between both computers.

 See the 'Useful Information' chapter starting on page 394

If you work on a single catalog on multiple machines, there's also the 'Store presets with catalog' option in Preferences.

This options allows you to store the presets with the catalog itself, for use on whichever computer you're working, however it does mean that the presets will not be available to other catalogs.

Network

Can one catalog be opened simultaneously by several workstations across a network?

No. The catalog has to be on a local hard drive (not a network drive) and can only be opened by one user.

The SQLite database Lightroom currently uses isn't well suited to network usage – the file would be too easily corrupted beyond repair by something as simple as the network connection dropping at the wrong moment.

You can split photos off into a separate catalog (Export as Catalog), work on them elsewhere, and then merge it back into the main catalog (Import from Catalog) once you've finished.

 See 'Multiple Machines' section starting on page 68

Is it possible to have the catalog stored on a Network Accessible Storage unit (NAS) but open it on a single machine?

No, even single user network access is disabled as it's too easy to corrupt your catalog beyond repair in its current form.

The photos can be on your NAS, but the catalog itself must be stored on a local drive, whether internal or external.

Is it possible to have the catalog on a local drive, but the files on a network drive?

Yes, it's a bit slower to access files over a network, but it is possible. It's just the catalog which can't be on a network drive.

Is it possible to use XMP files to allow some degree of sharing across the network?

Many people have asked whether it's possible to use XMP data to allow basic sharing of settings across a network, so here's an overview of how it could work...

The photos are placed on a shared folder on the network, whether:

• The files are on Computer 1, and Computer 2 can access them.

• The files are on Computer 2, and Computer 1 can access them.

• The files are on network storage such as NAS that both computers can access.

• The files are on a server that both computers can access.

Each computer needs its own catalog, stored on a local drive.

Import the files into both catalogs, with the Import dialog set to 'Add photos to catalog without moving'. This will mean that both computers are referencing exactly the same files.

In Catalog Settings > Metadata panel, there is an option to 'Automatically write changes into XMP'. Turn that on in both catalogs.

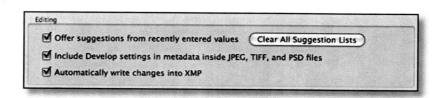

If 'Automatically write changes into XMP' is turned on, every time you make a change to the metadata of a photo, whether that is ratings, labels, Develop settings etc., it gets written back to the XMP as well as to the catalog. The write to XMP is usually delayed by about 10–15 seconds after the change, to prevent unnecessary disc writes.

 See 'XMP' section starting on page 281

Now for the clever bit, when it comes to sharing files...

Added in version 1.1 was a metadata icon. This little icon changes direction depending on whether the metadata is most up to date in your Lightroom catalog or in the XMP.

Lightroom's catalog has updated metadata which hasn't been written to XMP. Click on the icon to write to XMP. You shouldn't be seeing this icon, as you are automatically writing to XMP every time it changes.

Metadata in the XMP file has been updated externally and is newer than Lightroom's catalog. Click on the icon to read from XMP. This is also known as the 'metadata dirty' icon.

Metadata conflict – both the XMP file and Lightroom's catalog have been changed. Click on the icon to choose whether to accept Lightroom's version or the XMP version.

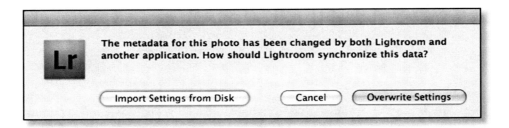

The metadata is checked for updates whenever a file is made the active (most-selected) file, or when you synchronize the folder, amongst other times.

 See 'How does the Synchronize Folder command work?' on page 134

So, 2 different scenarios...

Scenario 1...

Computer 1 & Computer 2 are both looking at the same folder of photos at the same time, working on rating and culling those photos. As Computer 1 adds a 5 star rating to a photo, that is written to XMP. There is a slight delay before writing to the XMP, otherwise there would be a higher performance hit. 2 minutes later, Computer 2 selects that file, and after a few seconds, the 'Metadata Dirty' badge is displayed, showing that a 'read' is required. Click on that badge and choose 'Import Settings from Disc' to update Computer 2's view of that image. It's not perfect – it's certainly not an instant solution – but it works for some people. Using Lightroom on the Computer 1, and viewing those photos in Bridge on Computer 2 (to view, not change, otherwise you hit the same delays), is another alternative.

Scenario 2...

Computer 1 & Computer 2 both have the same photos in their catalogs, but are working on different jobs. When the person operating each computer sits down to start a job, they first right-click on that job's folder and choose Synchronize Folder to retrieve the latest settings from XMP. As they work, the settings are written back to XMP, so that the XMP always has the most up-to-date information. It makes no difference which computer last used those files, as they read from XMP each time they start. The delay between working on the shared files largely prevents conflicts.

And finally, in either scenario, when someone later comes along on Computer 3 and adds those files to their catalog (also referenced at their existing location), the metadata will be automatically carried across from the XMP.

A few warnings....

- This is not particularly supported by Adobe, and if you decide to try it, you do so at your own risk. There isn't any known risk to your files, but you can never be too careful!

- Fighting for the same files on the network will be slower than working from a local drive. Having 'Automatically write changes into XMP' can also decrease performance slightly.

- If you both write to XMP at the same time, one computer will overwrite the others settings.

- If Computer 1 writes to XMP, then Computer 2 makes changes to the same file and writes to XMP without first reading Computer 1's changes, then Computer 1's changes will be overwritten in the XMP. They don't merge.

Backup

Does Lightroom back up the photos as well as the catalog?

No, Lightroom's own backup is just a copy of your catalog, placed in a folder named with the date and time of the backup. You definitely want to ensure that you're backing up your photos separately.

I run my own backup system – do I have to let Lightroom run backups too?

You certainly don't have to let Lightroom run backups, but be careful if your own backup system overwrites previous backups.

Lightroom's own backup system creates duplicates of the catalog at set intervals – this is so that if your catalog becomes corrupted, you can revert to an earlier backup.

If your own backup system overwrites the previous backups, you could be overwriting an uncorrupted catalog with a corrupted one.

Is it safe to have Time Machine back up the catalog?

Due to way Time Machine works, trying to back up the Catalog file while it's open could cause corruption, so it's best to exclude your catalog from Time Machine's backup, and use an alternative backup strategy instead.

Can I delete the oldest backups?

You can safely delete all but most current backups if you wish, however it is sensible to open the last couple of backups to ensure that they're not corrupted, before you delete the earlier versions.

 See 'How do I create a new catalog and then switch between catalogs?' on page 58

Alternatively, zip them into compressed folders – they compress very well, massively reducing the file sizes.

I haven't got time to back up now – can I postpone the backup?

In the dialog which pops up when a backup is due to run, you have the options to either 'Skip Now', which postpones the backup until the next time you open the catalog, or you can select 'Backup in one week', or whatever other time period you have chosen for your backups.

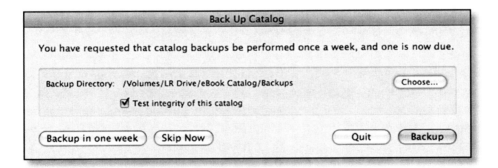

How can I make it back up on exit instead of when starting?

There isn't currently an option to back up when exiting, however you could set it to backup at a suitable interval, and then just close and reopen the file to trigger the backup. If you're on a Mac, the quickest way to close and reopen your currently catalog is to use File > Open Recent list and select the checked catalog file. If you're on Windows, you have to do it properly!

How do I change the backup location?

The backup directory is changed in the Back Up Catalog dialog, which appears when a backup is due to run.

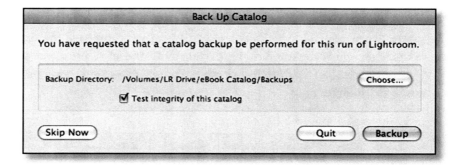

If you need to show the Back Up Catalog dialog to change the location when a backup is not normally due, you can run a backup on demand. To do so, go to Catalog Settings > General panel and change the backup frequency temporarily to 'when Lightroom starts'. Restart Lightroom so that the backup dialog comes up, and then you'll be able to change the backup location.

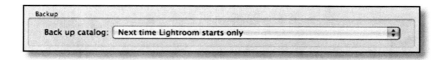

Don't forget to then change it back to your normal backup schedule.

Moving to a new computer

I need to wipe my computer – how do I back up and retain all of my Lightroom adjustments, preferences, presets etc.?

All of your adjustments are stored in Lightroom's catalog, so that will be the main file to back up.

You can find your catalog location by going to Catalog Settings > General panel.

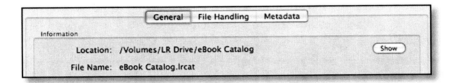

For extra security, you may choose to write most of your settings to XMP as well. To do so, select all of the files in Grid view and press Ctrl-S (Windows) / Cmd-S (Mac). That stores your most crucial settings with the files themselves, and can be particularly useful if the transfer goes wrong!

 See 'XMP' section starting on page 281

It is also a good idea to make sure that Lightroom's folder panel is showing a clean hierarchy before you back up the catalog. This makes it very easy to re-link the files if the folder location changes.

 See 'I have a long list of folders – can I change it to show the folder hierarchy?' on page 127

Don't forget to back up all of your photos! Remember, they are only referenced by the catalog, not contained within the catalog file.

Finally, you'll also want to back up your preferences and presets.

 See 'Default File Locations' section starting on page 395

How do I move my catalog & photos to another hard drive manually or using Export as Catalog?

Before you do anything else, you'll want to follow the back up procedures outlined in the previous question, including backing up your catalog, presets, preferences and photos, and setting up your catalog folder hierarchy.

 See 'I need to wipe my computer – how do I back up and retain all of my Lightroom adjustments, preferences, presets etc.?' on page 81

Having done so, it's time to transfer.

If you're simply moving between hard drives in the same computer, your preferences and presets can stay in their current location, as they won't be affected.

The simplest option is to pick up and move the catalog and photos to their new location using Explorer (Windows) / Finder (Mac) or any file synchronization software.

Alternatively you can use Export as Catalog to create a new catalog and duplicate photos on the other hard drive, and then delete the existing one, however there is a risk that in the process you would miss any files that aren't currently in Lightroom's catalog, so be careful if you choose that option.

 See 'How does Export from Catalog work?' on page 61

Once the files are transferred, you need to open Lightroom to the correct catalog. Hold down Ctrl (Windows) / Opt (Mac) while opening Lightroom and it'll ask which catalog to open, so go ahead and open the *.lrcat file you've just copied over.

 See 'How do I create a new catalog and then switch between catalogs?' on page 58

The folders may go grey because they're no longer in the location Lightroom's expecting. Simply right-click on the top level folder once it's gone grey, and choose 'Find Missing Folder...'

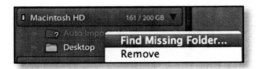

If the folder name hasn't gone grey yet, you can use 'Update Folder Location...' in that same right-click menu.

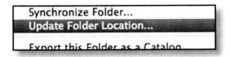

Point to the new location of the folder and leave it to update.

 See 'Lightroom thinks my photos are missing – how do I fix it?' on page 129

How do I move only my catalog to another hard drive?

If only your catalog is moving, and the photos are remaining in their existing locations, you can close Lightroom and move your catalog using Explorer (Windows) / Finder (Mac). When Lightroom next launches, it will ask which catalog to open.

How do I move only my photos to another hard drive?

 See 'I need to move some or all of my photographs to a new hard drive – how can I do it without confusing Lightroom?' on page 132

How do I move my catalog & photos from Windows to Mac or vice versa?

The process of moving your catalog cross-platform is exactly the same as moving to a new machine of the same platform.

 See 'How do I move my catalog & photos to another hard drive manually or using Export as Catalog?' on page 82

Upgrading from version 1

Which versions will upgrade to 2.0?

Catalogs from version 1.0 to 1.4.1 and from the public beta of 2.0 will upgrade.

Catalogs from the public beta releases prior to version 1 must be upgraded to version 1 before upgrading to version 2.

If I upgrade, can I go back to version 1?

Once you've upgraded your catalog, you won't be able to open the upgraded catalog in version 1. You'll still have your version 1 catalog untouched, however if you work on the upgraded copy in version 2, for example using a trial version, and then decide to go back to version 1, the changes you've made to your photos in version 2 will not show up in your version 1 catalog. That said, you won't want to go back anyway! This is the dialog you'll see if you try to open a version 2 catalog in version 1:

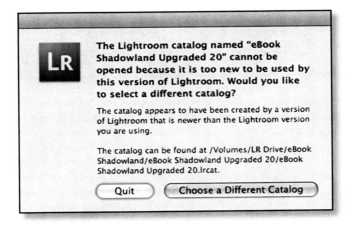

How do I upgrade my catalog from version 1 to version 2?

Firstly, a standard warning... make sure you have a current catalog backup, just in case something goes wrong. Proper measures have been put in place to avoid disasters, but you can never be too careful.

When you open Lightroom 2 for the first time, it will follow your version 1 preferences, and either prompt you for a catalog to open, or try to open your default catalog.

Whenever you try to open a version 1 catalog, Lightroom 2 will show the following dialog, asking to upgrade your catalog. You can select a different name or location for the upgraded catalog if you wish. The new version 2 catalog will be an upgraded copy – your original version 1 or version 2.0 beta catalog will not be touched. The upgrade will borrow your existing previews file, to save rendering previews all over again.

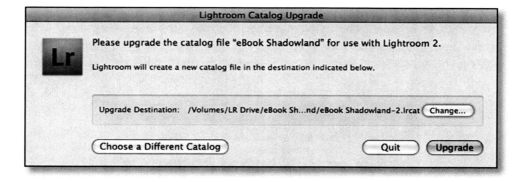

Once the upgrade has completed, Lightroom will open the newly upgraded catalog as a normal catalog.

Do I have to upgrade a catalog before I can import it into version 2 using Import from Catalog?

If you select a version 1 or version 2.0 beta catalog in the Import from Catalog dialog, it will warn you that it needs to upgrade the catalog before importing.

 See 'How does Import from Catalog work?' on page 60

You will be given a choice of saving the upgraded catalog, as if you'd opened the catalog normally and run the upgrade, or discarding the upgraded catalog if it's not needed. Either way, the original is untouched.

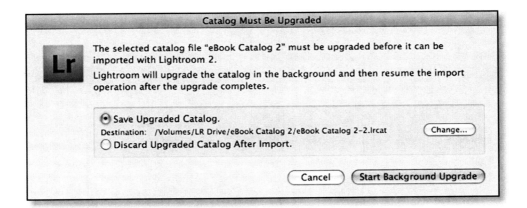

What happens if I try to upgrade a catalog that I've already upgraded?

Lightroom keeps track of which catalogs you've already upgraded, so it'll warn you and give you a choice.

You can either upgrade the catalog again, or you can open the previously upgraded catalog.

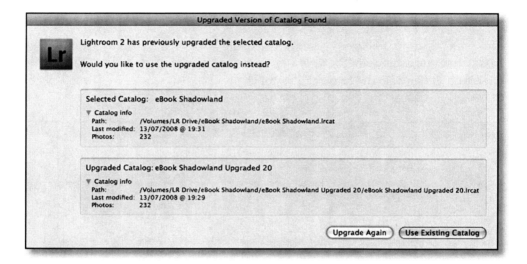

Import

Raw vs. JPEG vs. DNG

Can I use Lightroom on JPEG files as well as raw files?

Lightroom works non-destructively on JPEG, TIFF and PSD files as well as raw file formats, giving you an easy way to process batches of photos, and doesn't apply your changes until you export to a new file.

Certain controls are different – for example, the White Balance sliders change from Kelvin values to fixed values, as you're adjusting from a fixed color rather than truly adjusting white balance. You will also find that presets behave differently on JPEG/TIFF/PSD photos than they do on raw photos.

 See 'Why don't the Temp and Tint sliders have the proper white balance scale when I'm working on JPEGs?' on page 229 and 'Why do my presets look wrong when used on JPEG/TIFF/PSD files, even though they work on raw files?' on page 218

If I can use all of Lightroom's controls on JPEG files, why would I still want to shoot in my camera's raw file format?

Think of it this way... did you ever play with colored modeling clay when you were a child?

Imagine you've got a ready made little model, made out of a mixture of different colors, and you've also go separate pots of the different colors that haven't been used before. Yes, you can push the ready made model around a bit and make something different, but the colors all smudge into each other and it's never QUITE as good as if you use the nice fresh separate colors and started from scratch.

Your JPEG is like that ready made model – it's already been made into something before. You can take it apart and change it a bit, but if you try to change it too much, it's going to end up a distorted mess. Your raw file is like having the separate pots of clay – you're starting off with the raw material, and YOU choose what to make of it.

So yes, editing JPEGs is non-destructive, in as much as you can move the sliders as many times as you like and the original file isn't destroyed in the process. But when you do export to a new file, you're applying changes to ready-made JPEG image data. If you're working on a raw file format, you're making a single adjustment to the raw data, rather than adjusting an already-processed file.

You'll particularly notice the difference in changing a white balance or rescuing a very under or over-exposed photo.

Should I convert to DNG on import?

DNG is a well worn debate on every forum on the web, and there is no right or wrong answer.

A few points to consider though...

<u>File size</u>
DNG files are generally 10-40% smaller than their original proprietary format, depending partly on the size of the preview that you choose to embed.

<u>XMP Sidecars</u>
Proprietary raw formats have their XMP data stored as a sidecar XMP file, whereas DNG files have that information embedded within the single DNG file. The question is, do you find sidecar files a pro or con?

<u>Long Term Storage</u>
The DNG format is openly documented, which means that it should be supported indefinitely, whereas proprietary formats such as CR2, NEF, RAF etc. are not openly documented. Will you be able to find a raw converter in 20 years time that will convert a proprietary format when that camera model is ancient history?

<u>Manufacturer's Software</u>
Most manufacturer's own software will not read a DNG file, only their own proprietary formats. Do you ever need to open a file in the manufacturer's own software? If so, you'd want to embed the proprietary raw file - it can be extracted use the DNG Converter tool, however it does negate the file size benefits.

While there is DNG support for MakerNotes, some manufacturers don't stick to the rules, and therefore MakerNotes embedded in an undocumented format can't always be carried over to the DNG file, however if you're not sure what the MakerNotes are, you probably won't miss them.

Initial Import

How do I bring up the Import Photos dialog where I set the Import options? I just get an Open dialog?

Go to File > Import Photos from Disk – that will bring up the Open dialog. Select folders or image files and click on the Choose button.

The next dialog that appears is the Import Photos dialog where you set the Import options.

How do I import multiple folders in one go?

In the Open dialog that appears when you select which folder to import, you can Ctrl–click (Windows) / Cmd–click (Mac) to select multiple folders or you can select a higher level folder which has subfolders.

You don't have to navigate down through all of the folders to select the photos themselves. Click the 'Import All Photos in Selected Folder' button (Windows) / Choose button (Mac).

In the Import Photos dialog which appears next, you then have the option to exclude some folders or photos from the Import.

How do I select only certain photos to import?

In the initial Open dialog, select the whole folder and click Choose.

In the Import Photos dialog, you have the option to include or exclude whole folders, or just certain photos, by checking or unchecking their individual checkboxes.

Check the Show Preview checkbox in the bottom left corner of the dialog to view thumbnails of the photos.

The Check All and Uncheck All buttons can be used to mark all or none for import. Only checked photos will be imported into Lightroom.

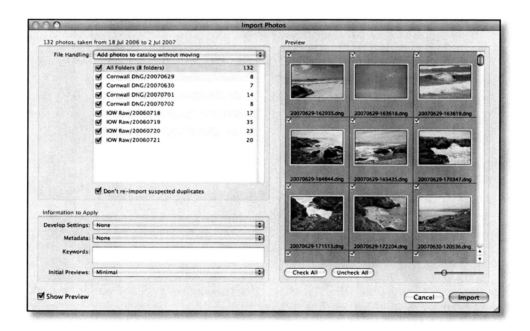

To check or uncheck a series of photos in one go, hold down Ctrl (Windows) / Cmd (Mac) while clicking on photos to select non-consecutive photos, or Shift to select consecutive photos. Once you have the photos selected (shown by a lighter grey surround), checking or unchecking the checkbox on a single photo will apply that same checkmark setting to all selected photos.

How do I stop Lightroom from launching or opening the Import dialog every time I insert a memory card?

There are 2 different factors involved – whether Lightroom opens the Import dialog if the program is already open, and whether the programs launches by itself even though it was closed – you may wish to disable either or both.

To stop Lightroom opening the Import dialog, go to Preferences > Import panel and uncheck 'Show import dialog when a memory card is detected'.

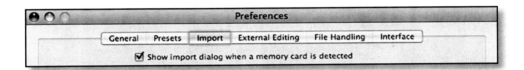

If the operating system is launching Lightroom when you insert a memory card, you'll also want to disable the auto-load.

<u>Windows</u>
You want to disable APDProxy.exe, which is the Adobe Photo Downloader.

To temporarily disable it for the current Windows session, right-click the Adobe Photo Downloader located in the System Tray to the far right of the Windows Task Bar and choose Disable or Exit.

To permanently disable it, go to Start menu > Run, type in msconfig and click OK. Select the Startup tab, uncheck apdproxy, click Apply, and then click OK. Finally, restart Windows. You may have to repeat when installing Lightroom updates.

If you don't like msconfig, you can also disable it be renaming the apdproxy.exe file. You should find it at c:\Program Files\Adobe\Adobe Photoshop Lightroom 2.0\ apdproxy.exe or a similar location.

<u>Mac</u>
Image Capture usually controls which programs respond to a memory card being inserted, so check Image Capture's preferences and change the program to 'None'.

Can I set Lightroom to delete the photos from the memory card once they've uploaded?

No, for two reasons...

1. You should verify that the data is safe before you delete the files.

2. The best place to format the cards is in your camera, as this helps prevent data corruption.

Is it possible to import from multiple cards at the same time?

No, you can import from multiple folders on the hard drive in a single import by selecting the parent folder, but not multiple hard drives or cards.

Import Options

What's the difference between 'Add photos to catalog without moving', 'Copy', 'Move', and 'Copy as DNG'?

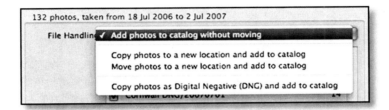

'Add photos to catalog without moving' leaves the files in their current folder structure with their existing filenames, and references them in that location.

'Copy photos to a new location and add to catalog' copies the files to a folder of your choice, leaving the originals untouched. It gives you additional options on the folder structure and allows you to rename when you import.

'Move photos to a new location and add to catalog' offers the same options as 'Copy' but removes the files from their original location.

'Copy photos as Digital Negative (DNG) and import' offers the same options as 'Copy', leaves the originals untouched, but also converts the files to DNG format while importing.

 See 'Should I convert to DNG on import?' on page 91

I've chosen 'Copy' or 'Move' – how do I organize the photos into a folder structure that will suit me?

You have 3 options...

'Into one folder' imports the photos into a single folder of your choice.

'By original folders' imports in the same parent/child folder structure as their existing structure.

'By date' gives you a choice of date based folder structure – the slash (/) creates parent/child folders so 2000/08/25 will create a folder 25 inside of a folder 08 inside of a folder 2000, not a single folder called 2000/08/25. If you want a single folder called 2000/08/25, you need to use other characters such as a hyphen (-) or underscore (_).

If you choose the date based folder structure, there are a variety of folder structures for you to choose from, for example, the 2005/12/17 (YYYY/MM/DD) structure gives you the following hierarchy:

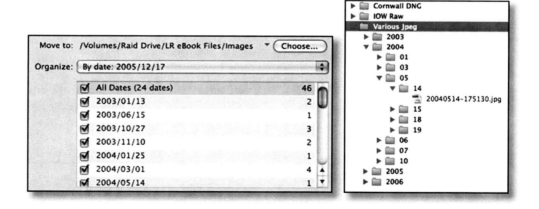

You can slowly click twice on any of the folder names to rename it (Mac only), if you'd prefer a structure other than those offered by default, but you would need to do each folder individually. You can also rename any of the folders in the Folders panel once the photos have finished importing.

What does the Backup option do?

When using one of the 'Copy' or 'Move' options, you'll notice 'Backup to:' under the list of folders.

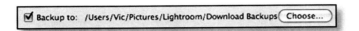

This will back up your untouched original files to a dated folder in the location of your choice. Please note though, that these are untouched files, so if you change your file naming in the Import dialog, the backed up files will still have your original filenames.

How do I set up the File Naming to my chosen format?

When choosing a 'Copy' or 'Move' option, you can also rename the files on import using a naming template of your choice.

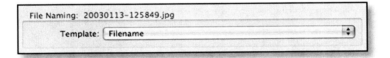

 See 'Renaming' section starting on page 139

What does 'Do not import suspected duplicates' do?

It checks the files that you're importing against those that are already in the catalog to see if you are trying to import photos which have already been imported.

To be classed as a suspected duplicate, it must match on both the original filename (as it was when imported into Lightroom), the EXIF capture date and the file length, so it won't recognize photos that you've re-saved as an alternative format, only exact duplicates.

What Develop settings, metadata, keywords and previews settings should I apply in the Import dialog?

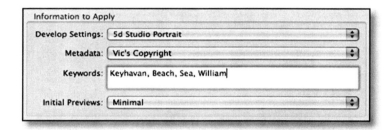

Develop Settings allows you to apply a Develop preset to the photos while importing – for example, you may always apply a preset to all studio portraits before processing as a starting point.

 See 'Presets' section starting on page 213

The Metadata section is often used for applying copyright information to all images while importing, to ensure that no images are missed.

 See 'Viewing & Editing Metadata' section starting on page 167

Keywords can also be applied while importing the photos, however remember that they will be applied to ALL of the imported images, so it's only useful for keywords that will apply to everything. Specific keywords are better applied individually once in the Library module.

 See 'Keywording' section starting on page 155

It's also worth rendering previews while importing, so that you don't have to wait for your photos to render as you browse. The size will vary depending on your browsing habits.

 See 'Previews & Speed' section starting on page 373

Tethered Shooting & Watched Folders

How do I set up Lightroom for Tethered Capture?

Lightroom doesn't currently offer camera control facilities, as there are so many different camera models available. You need to use your own camera manufacturer's software (EOS Utility, Capture NX etc.) or other remote capture software to capture the photos, and set it to drop the photographs into Lightroom's Watched Folder.

Lightroom will then collect the files from that watched folder, and move them to another folder of your choice, importing them into your Lightroom catalog, renaming if you wish, and applying other settings automatically.

You select those options in the Auto Import Settings dialog, which is accessed via the File menu.

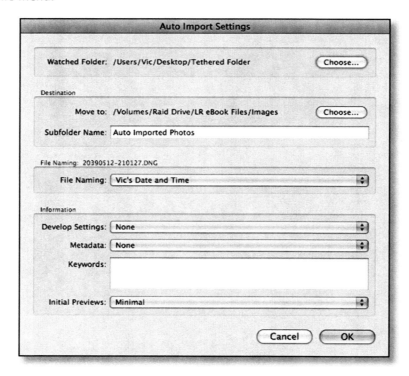

Lightroom moves the files from the watched folder to the destination folder, so there is little point in organizing the watched folder as it's just temporary holding. Also make sure your watched folder is empty.

Enable Auto Import in Lightroom by checking File menu > Auto Import > Enable Auto Import.

Test that Lightroom's auto import is working by simply copying a file from your hard drive into the watched folder. As soon as the file lands in the folder it should start the auto import and you should see it vanish from the watched folder, appear in the destination folder and in Lightroom's catalog. If that works, then you've set up Lightroom properly.

Then connect the camera to the capture software, and ensure it's saving to the right folder. Release the shutter. You should see a file appear in the watched folder, then Lightroom should take over just like in the test.

In summary:

- Have your camera control software save all photos to your watched folder, perhaps on your desktop.

- Set up Lightroom's Watched Folder to point to your watched folder, where your camera control software is saving the photos.

- Set up Lightroom's destination folder to point to your normal image storage folder.

Why isn't my watched folder working?

The watched folder needs to be empty when you initially set it up.

Make sure your camera's remote capture software (i.e. EOS Utility, Capture NX) doesn't create a dated subfolder, as Lightroom won't look in any subfolders in the watched folder.

Solving Import Problems

I shot Raw+JPEG in camera – why have the JPEGs not imported?

In Preferences, under the Import panel, is an option to 'Treat JPEG files next to raw files as separate photos'.

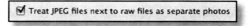

With that option checked, Lightroom will import the JPEG files alongside the raw files. If the checkbox is unchecked then the JPEGs are not imported, and it will record them as sidecar files, showing the filename as "IMG0001.CR2 + JPEG" and noting the JPEG as a sidecar in the Metadata panel.

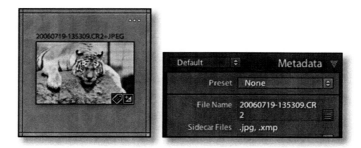

The checkbox was introduced because Lightroom could not differentiate between raw and JPEG files which, aside from the extension, had the same name.

If you have imported already, you can turn off the checkbox and re-import that folder – the raw files will be skipped as they already exist in the catalog, and the JPEGs will be imported as separate files. The raw files will still be marked as Raw+Jpeg though, and there isn't currently an easy way of changing that, other than removing them from the catalog and re-importing them, but then you may lose some of your changes in the process.

I can't see thumbnails in the Import dialog, I just see grey squares. How do I fix it?

If not all of the photos exhibit the problem, it may be that the file is corrupted or is not supported by Lightroom. Make sure you're running the latest Lightroom update – if your camera is a new release, support may have been added recently, or may be added shortly. The file may also be too large, in an unsupported color mode, or suchlike. The error message that will follow should give more information on the reasons.

 See 'Import Error Messages' section starting on page 109

If you can import the files, but only see grey squares in Grid view, it's possibly a graphics card driver issue.

 See 'Why won't my thumbnails display? I only get grey boxes in Grid view?' on page 199

Importing files that have been saved by other software may also exhibit this issue if they don't save an embedded preview.

There have also been some reports of problems importing directly from a camera, which appears to be a camera driver issue. You may be able to go ahead and upload the files anyway, in which case the previews will render once the photos are imported.

Alternatively use a card reader to import your photos, or transfer them to the hard drive using the manufacturer's software, and then import into Lightroom from your hard drive.

Lightroom can't find my camera to import the photos. How can I import?

Using a card reader is the most reliable way of transferring files, or alternatively, you could use your own camera manufacturer's software (or Explorer/Finder) to transfer those files to your hard drive and import from there.

Lightroom can't import the photos from my brand new camera – why?

Lightroom needs to be updated to read raw files from new cameras, so make sure you're running the latest Lightroom update.

You can check whether your camera is supported by the latest version of Lightroom by visiting:

http://www.adobe.com/products/photoshop/cameraraw.html

Updates are usually released every 3-4 months along with an update for ACR (Adobe Camera Raw plug-in for Photoshop/Bridge).

Is there a limit to the number of photos that can be imported in a single import?

Crashes have been reported on imports of more than around 20,000 photos at a time. If it's crashing, try importing a smaller number, and it's best to set Previews to Minimal when importing huge numbers.

Can I import CMYK files into Lightroom?

Lightroom is designed specifically for photographers, so it doesn't currently work with CMYK. It can manage RGB, Lab or Grayscale photos.

Lightroom appears to be corrupting my photos – how do I stop it?

Unfortunately it's likely that the files are already corrupted before they reach Lightroom.

The preview you may see initially (and in some other browsers) is the small JPEG preview embedded into each file by the camera. Then Lightroom reads the whole file to create a full preview, and is unable to read the whole file due to corruption.

Corrupted files are most often caused by a damaged card reader or cable. Other regular suspects include damaged flash card, problems with the camera initially writing the file, or possible a damaged hard drive at a later date.

Lightroom is changing the colors of my photos... what could be happening?

If the photos are raw files, the change in color may be down to a difference in rendering.

 See 'Raw File Rendering' section starting on page 266

There are a few other possibilities, however, which would also apply to JPEG and other formats.

Most likely a preset is being applied in the Import dialog – set it to None and see if the problem recurs on future imports.

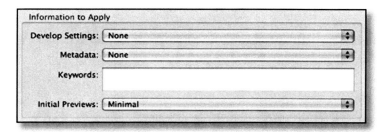

Alternatively you might have 'Apply auto tone adjustments' turned on in Preferences > Presets panel.

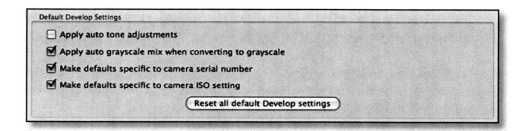

To reset the existing photos to your default settings, press the Reset button at the bottom of the right hand panel in Develop module, or select all of the photos in Grid view, right-click and choose Develop Settings > Reset from the menu.

If that doesn't solve the problem, you may have changed the default settings. Select a JPEG file in the Develop module, go to Edit menu > Set Default Settings and click Restore Adobe Default Settings.

 See 'How do I change the default settings?' on page 220

Import Error Messages

It says "Some import operations were not performed. The files appear to be unsupported or damaged."

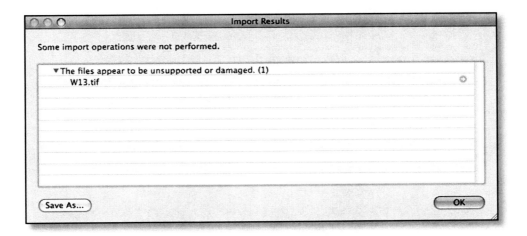

Only certain file formats can currently be imported into Lightroom's catalog. Those are currently JPEG, TIFF, PSD, DNG, and camera raw file formats.

If you're seeing an error message, the files you are trying to import may be another format, or may be corrupted. If they are the correct format, check in other programs to confirm corruption.

It says "The following photos will not be imported because they are already present in the catalog."

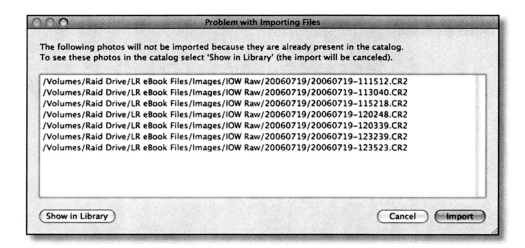

Some or all of the photos you're trying to import are already in this catalog.

Clicking Import will bring up the Import Photos dialog to import the other selected photos.

If all of the photos selected are already present in the catalog, your choice of buttons will be OK or Cancel, both of which will close the dialog.

It says "Some import operations were not performed. The files already exist in the catalog." What does this mean?

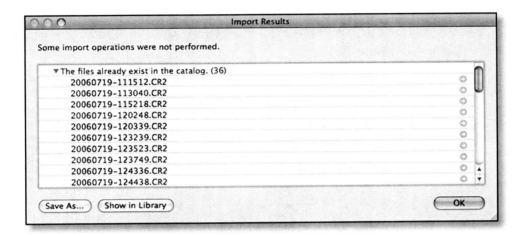

You had 'Do not import suspected duplicates' checked in the Import dialog, and these are files which Lightroom has identified as already existing in the catalog.

It also gives you the option to save that list of files to a text file so that you can refer back to it later, or show the existing photos in the Library module.

 See 'Is there a way of seeing the photos and their duplicates so that I can sort through them?' on page 135

It says "Some import operations were not performed. The files are too big."

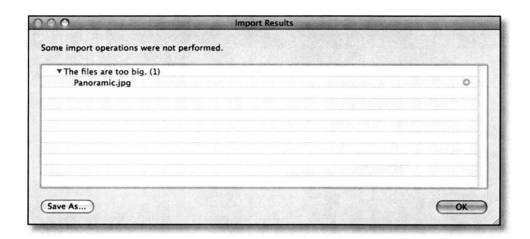

Lightroom version 2 has a file size limit of 65,000 pixels along the longest edge, increased from 10,000 pixels in version 1. The file you're trying to import is larger than that – perhaps a panoramic photo.

If your files are too big, you could create a small version of the photo to import into Lightroom to act as a placeholder.

It says "Some import operations were not performed. The files could not be read. Please reopen the file and save with 'Maximize Compatibility' preference enabled."

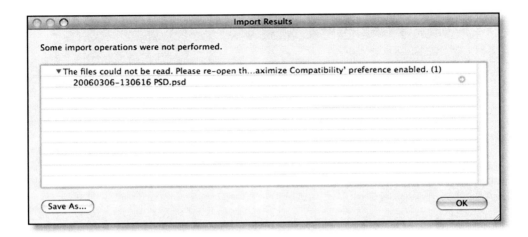

In Photoshop's Preferences dialogs > File Handling > File Compatibility section, there is an option to 'Maximize Compatibility' with other programs by embedding a composite preview in the file. It only applies to PSD and PSB format files. You'll find Photoshop's Preferences under the Edit menu (Windows) / Photoshop menu (Mac).

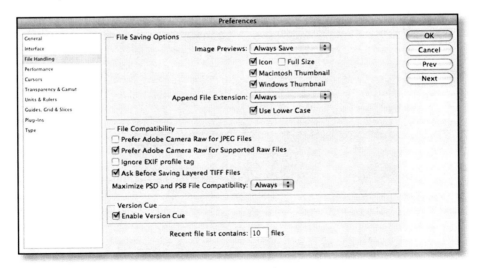

Maximize Compatibility does increase file size, but ensures that other programs can read the embedded preview even though they can't necessarily read the layered file, so it's best to set your Photoshop Preferences to 'Always'. If you set it to 'Ask', it will show this dialog every time you save a layered PSD file.

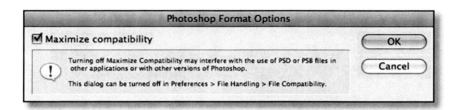

It says "Some import operations were not performed. The files use an unsupported color mode."

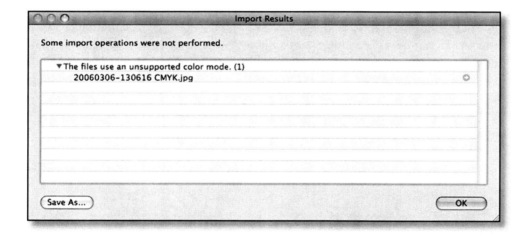

The file is in a CMYK or Duotone color space which Lightroom does not support.

Convert the photo to RGB, Lab, or Grayscale and you'll be able to import the file.

Library Module

Appearance & View Options

How can I choose the information I see in the thumbnail cells?

The thumbnail cell has various components, which you can turn on and off as you choose. There are also 3 variations of cell style, which you cycle through using the J key (or View menu > Grid View Style), including a very minimal view showing the thumbnail image only, a compact view showing the icons and minimal file information, and an extended view showing additional lines of information.

Options include the file information to show, flags, ratings, labels, badges, metadata icons, rotation, Quick Collection, index numbers, and file information.

Go to View menu > View Options and you can choose a variety of options, and the view of the thumbnails will update as you test various combinations.

What are Badges and why can't I see them on my photos?

Badges appear in the corner of the thumbnail itself.

From left to right, they mean:

Keywords have been applied to this photo. Click to open the Keywording panel.

A crop has been applied to this photo. Click to go to Crop mode.

Develop changes have been applied to this photo. Click to go to Develop module.

If you can't see them, you probably have them turned off. Go to View menu > Grid View Style > Show Badges or turn them on in the View menu > View Options dialog where they are called Thumbnail Badges.

I can see Badges in Grid view, but not in my Filmstrip. Where have they gone?

Ensure 'Show badges in filmstrip' is turned on in Preferences > Interface panel.

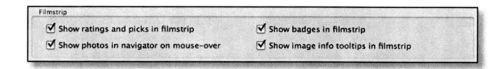

If they still don't appear, enlarge your Filmstrip by dragging the top edge of the Filmstrip – the badges disappear when the thumbnails become too small to fit all 3 badges in view at once.

What do the different metadata icons on the thumbnails mean?

 Lightroom is building previews or checking metadata to see which has been most recently updated.

 The file is missing or not where Lightroom is expecting.
Click the icon to locate that missing file.

 The file is damaged or cannot be read.

If you have 'Unsaved Metadata' icons turned on in View menu > View Options, you will also see additional metadata icons. These show the result of checking the file against any XMP data in the files or sidecars.

 Lightroom is reading or writing metadata.

 Lightroom's catalog has updated metadata which hasn't been written to XMP. Click the icon to write to XMP.

 Metadata in the XMP file has been updated by another program and is newer than Lightroom's catalog. Click the icon to read from XMP.

 Metadata conflict – both the XMP file and Lightroom's catalog have been changed. Click the icon to choose whether to accept Lightroom's version or the XMP version.

How do I turn off the overlay which says Loading... or Rendering...?

Go to View menu > View Options > Loupe Info panel and uncheck 'Show message when loading or rendering photos'.

What is the difference between the solid white arrows and the opaque ones in Folders panel, Collections panel and Keyword List panel?

 Solid white/black arrows indicates that the folder, collection or keyword has subfolders.

 Folders, collections or keywords marked with opaque arrows don't have any subfolders.

How do I zoom in on a photo quickly?

Various shortcut keys allow you to quickly zoom in or out of your photo.

Spacebar switches between your two most recent zoom settings.

The Z key does the same, except if you're in Grid view, it will toggle between Grid view and a 1:1 or greater zoom.

In Compare, Loupe or Develop, clicking directly onto the image toggles between your two most recent zoom settings.

Ctrl + and Ctrl – (Windows) / Cmd + and Cmd – (Mac) will step through each of the four main zoom ratios. Ctrl-Alt + and Ctrl-Alt – (Windows) / Cmd-Opt + and Cmd-Opt – (Mac) zoom through each of the smaller zoom ratios as well.

How do I change the zoom percentage?

Along the top of the Navigator panel are selected zoom ratios. The last zoom ratio in the series is a popup menu for selecting alternative ratios.

Your last two selected zoom ratios are saved for toggling.

Is it possible to change the fonts and other interface details?

Some interface details such as the panel end marks, background colors etc. can be adjusted in the Preferences > Interface panel.

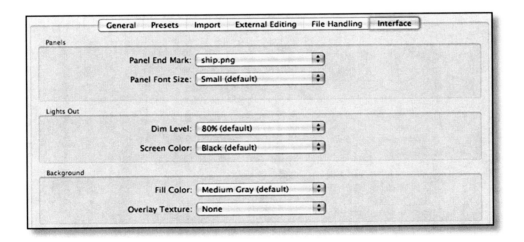

If you wish to change font sizes, extend the panel widths and make other non-standard changes, consider Jeffrey's Configuration Manager – http://www.regex.info/blog/lightroom-goodies/

Dual Displays / Dual Monitors

How do I use the new Dual Display setup?

The controls for the Dual Displays are on the top of the Filmstrip on the left.

Depending on your current full screen settings, the Secondary Display icon will either be a second monitor or a window icon.

A single click on the Secondary Display icon turns that display on or off.

A long click on each icon shows a context-sensitive menu with the view options for that display.

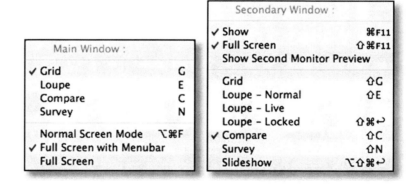

Additional options are available via Window menu > Secondary Display.

Which views are available on the Secondary Display? How are they useful?

Grid is particularly useful for gaining an overview of all of the photos whilst working on a single photo in Develop module, or for selecting photos for use in Slideshow, Print or Web modules. You can only have a Grid view on one display at a time.

Normal Loupe shows a large view of the photo currently selected on the main screen.

Live Loupe shows the photo currently under the cursor, and updates live as you move across different photos.

Locked Loupe fixes your chosen photo to the Loupe view, which is particularly useful as a point of comparison or reference photo/Shirley image.

Compare is the usual Compare view, but allows you to select and rearrange the photos in Grid view on the main screen whilst viewing Compare view on the secondary display.

Survey is the usual Survey view, but allows you to select and rearrange the photos in Grid view on the main screen whilst viewing Survey view on the secondary display.

Slideshow is only available when the Secondary Display is in Full Screen mode, runs a slideshow of the current photo view, whether that is a folder or collection, while you carry on working on the main screen.

How can I make use of Dual Displays if I work on a single screen?

If you only work on a single screen, the Secondary Display can be set to show in a floating window, which is particularly useful for those working on a very large screen.

What does 'Show Second Monitor Preview' do?

If the Secondary Display is in full screen mode, there is an additional option available – 'Show Second Monitor Preview'. If your second monitor is facing away from you, for example facing a client on the opposite side of the table, you can view and control what they see without repeatedly running round to the other side of the table. The popup menu in the top left corner controls the current view.

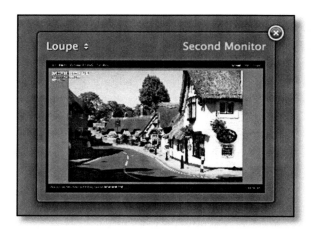

How do I move the Library Filter bar to the Secondary Display?

If you have the Grid view open on the Secondary Display, the shortcut Shift-\ or Window menu > Secondary Display > Show Filter View will move the Library Filter bar to the top of the Grid view on the Secondary Display.

Why does the Secondary Display switch from Grid to Loupe when I change the Main Screen to Grid?

Grid view can only be open on one display at a time, for performance reasons.

If you already have Grid view open on one display, and you switch the other display to Grid view, the first display will automatically switch to Loupe view.

Can I detach the panels and rearrange them?

The panels aren't detachable, but you can hide panels you don't use by right-clicking on the panel header and unchecking the panels you don't wish to see.

The alternative to consider is Solo Mode. Also in the panel header right-click context sensitive menu is Solo Mode – this closes one panel as you open another, keeping just one panel per side open at any time. You can show multiple panels while in Solo Mode by Shift-clicking on the panel to open it.

These options actually works in all modules, however it's particularly useful in the Develop module due to the number of panels.

Folders

How do the folders in Lightroom's Folder panels relate to the folders on my hard drive?

The folders in the Folders panel are references to folders on your hard drive or optical disc.

When you import photos into Lightroom, the folders containing them are added to the Folders panel.

In order to better visualize this, you may find it helpful to set your Folders panel up to show the folders in their hierarchy.

 See 'I have a long list of folders – can I change it to show the folder hierarchy?' on page 127

Only photos that you have imported into your catalog are included in the folder count – if you later add additional photos to that folder on your hard drive, you'll need to import them into your catalog by means of Import or Synchronize.

Anything you do in Lightroom's Folders panel will be reflected on the hard drive – creating, renaming or deleting folders will delete them from your hard drive. 'Removing' rather than 'deleting' removes them only from Lightroom, not from your hard drive.

The opposite doesn't work in the same way – when you remove or rename a file or folder on your hard drive, Lightroom will simply mark it as missing rather than deleting it automatically, otherwise you could accidentally lose all of your settings.

What's this new Volume Browser?

The new Volume Browser shows you each disc containing imported folders, how many photos are on each volume, whether it is online/offline, and how much space is used/available.

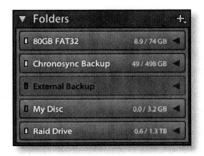

The colored rectangle on the left shows the drive space available:

- Green = drive online with space available

- Yellow = drive online but getting low on space

- Orange = drive online but very low on space

- Red = drive online but full

- Black = drive offline (and volume name becomes darkened)

Whilst the arrow is shown on the right, clicking anywhere on a Volume Bar will open it to show the contained folders.

Right-clicking on a Volume Bar brings up a menu where you can choose which information to show.

For those who choose not to show the full folder hierarchy, it gives a clear view of which folders are contained on each drive, whether a hard drive or optical disc.

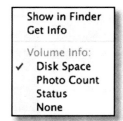

Further to that, clicking on the Folders panel + symbol gives additional path view options for the root folders.

For example, this folder is Raid Drive/LR eBook Files/Images. Depending on the option you choose, that is shown as:

'Folder name only'

'Path from Volume'

'Folder and Path'

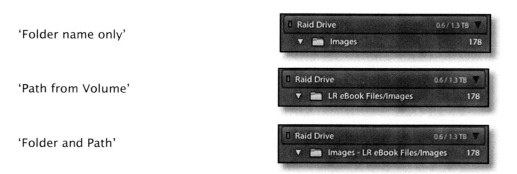

I have a long list of folders – can I change it to show the folder hierarchy?

Yes, in fact it's a very good idea to do so, and just have one or two top level folders. If Lightroom ever loses track of all of your photos, perhaps as a result of a hard drive failure, you will only need to re-link the top level folder and that will cascade through the rest.

So how do we go from this slightly nondescript tangle of folders on the left... to the tidy hierarchy on the right....?

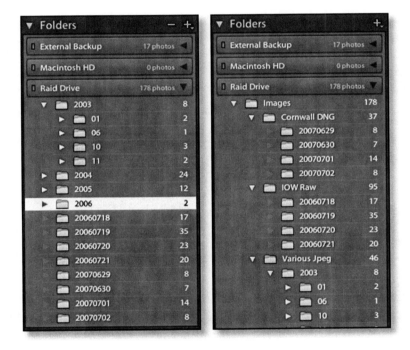

Right-click on the current top level folder and select 'Add Parent Folder'. This doesn't import new photos, just adds an additional hierarchy level to your Folders panel (and does a lot more behind the scenes...).

Keep clicking on the top level folder until you see the folder you're looking for.

If you go too far and want to remove a top level folder, right-click on that folder and choose 'Promote Subfolders'.

If you go too far and want to remove a top level folder, right-click on that folder and choose 'Promote Subfolders'.

This does the opposite of 'Add Parent Folder', and will ask for confirmation before removing that top level folder.

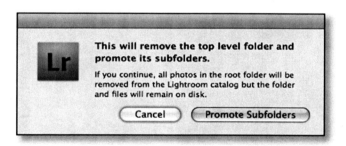

Selecting 'Remove...' from the right-click menu gives you the choice of promoting the subfolders, but also gives you the option to remove all of the subfolders and their images from the catalog too, which you wouldn't want to do when simply tidying up the hierarchy.

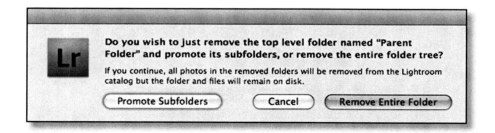

When I look at a parent folder in Grid view, I see the photos in the subfolders as well. Can I turn it off so I can only see the contents of the selected folder?

Just go up to Library menu > Include Photos from Subfolders and turn it on or off as you prefer.

In many situations it is useful to be able to see a composite view, but be aware that there are certain restrictions – you cannot apply a custom sort (user order) or stack photos in a composite view.

Lightroom thinks my photos are missing – how do I fix it?

Missing files are usually a result of files being moved or renamed outside of Lightroom, perhaps in Explorer or Finder. In this case, Lightroom loses tracks of the files.

 They can be identified by a little question mark in the corner of the grid thumbnail.

If the entire folder can no longer be found, the folder name in the Folders panel will go grey with a question mark folder icon.

When you go in to the Develop module, Lightroom will tell you that the file is offline or missing.

The file named "20040515-145437.jpg" is offline or missing.

To locate a missing file, click on the question mark icon, and the following dialog will appear.

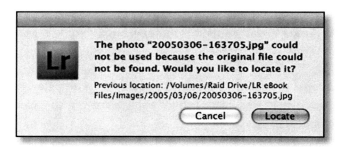

Click Locate to find the missing file.

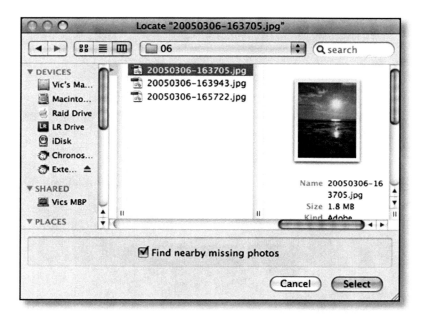

Locate the missing file and press Select. Check the 'Find nearby missing photos' checkbox shown in the dialog above in order to re-link other files in the same folder.

If you have renamed the files outside of Lightroom, each file will need linking individually.

 See 'I've renamed the files outside of Lightroom and now Lightroom thinks they're missing. I've lost all of my changes! Is it possible to recover them?' on page 386

If the whole folder is missing and the folder name has turned grey, you can right-click on the folder and select 'Find Missing Folder...'. Point Lightroom to the right folder, and it should update the links for all of the files contained in that folder.

If Lightroom appears slow to re-link related photos, restart Lightroom to force a search for file locations.

A few preventative measures, to avoid missing files in future:

Rename any files before importing into Lightroom, or use Lightroom to rename them.

 See 'Renaming' section on page 139

Set Lightroom's folder list to show the full folder hierarchy to a single root level folder. If all of the files are moved from their expected locations, they can easily be updated using the 'Find Missing Folder...' command in the top level folder right-click menu, or by using the 'Update Folder Location...' command even if they're not yet marked as missing.

 See 'I have a long list of folders – can I change it to show the folder hierarchy?' on page 127

Move any files or folders within Lightroom's own interface, simply by dragging and dropping around the folders panel. Folders can only be moved one at a time.

Where has the Missing Files collection gone? How do I find all of the missing files in my catalog now?

In version 1, there was a Missing Files collection in the Library panel, however that's been removed for version 2, for a number of reasons. It can still be created on demand though.

To do so, simply right-click on the highest level folder, and select 'Synchronize Folder' from the menu.

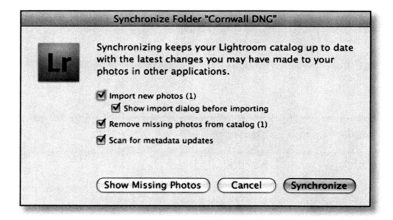

Clicking the 'Show Missing Photos' button will create a temporary collection in the Catalog panel, which you can right-click on to delete once you've finished.

 See 'How does the Synchronize Folder command work?' on page 134

I need to move some or all of my photos to a new hard drive – how can I do so without confusing Lightroom?

There are a number of options, but these are the easiest:

Option One – move in Explorer/Finder and update Lightroom's links

1. Follow the instructions on showing the folder hierarchy, to make it easy to re-link the disconnected files.

 See 'I have a long list of folders – can I change it to show the folder hierarchy?' on page 127

2. Close Lightroom and use Explorer / Finder to copy the files to the new drive.

3. Check the files have arrived safely before deleting from the original drive.

4. Open Lightroom and right-click on the highest level folder.

5. Select 'Update Folder Location...' from the list, and point it to the new location of that folder.

 See 'Lightroom thinks my photos are missing – how do I fix it?' on page 129

Option Two – move the files within Lightroom

1. Go to Library menu > New Folder...

2. Navigate to the new drive and create a new folder or select an existing folder where you plan on placing the photos.

3. That folder will now appear in the Folders panel.

4. Drag folders and/or photo onto that new location.

5. Check that the entire folder contents have copied correctly before deleting the originals – be aware that Lightroom might not move/copy files that aren't currently in the catalog.

How does the Synchronize Folder command work?

When you right-click on a folder and choose Synchronize Folder..., it searches that folder for:

Any new photos not currently in this catalog – and asks you if you wish to import them.

Gives you the option to remove missing photos from this catalog.

Checks for metadata updates – for example, you want to check that you haven't updated those photos in Bridge. The result is updated metadata icons showing conflicting XMP.

Show Missing Photos creates a temporary collection of your missing photos, which will appear in the Catalog panel. Once you've finished with this temporary collection, you can right-click on it to remove it.

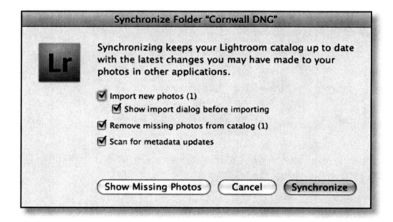

 See 'What do the different metadata icons on the thumbnails mean?' on page 117

Is there a way of seeing the photos and their duplicates so that I can sort through them?

There isn't a menu command which will search for duplicates, but there's a workaround you could try. As always, make sure you have good backups of the photos and catalogs. First, write to XMP by selecting all of the photos in Grid view and pressing Ctrl-S (Windows) / Cmd-S (Mac), so that you can see the work you've done in the comparison catalog.

Start a new catalog as this workaround is dependent on the Import command, and many of the photos may already be in your existing catalog. We'll tie it back into your main catalog once we've identified the duplicates.

 See 'How do I create a new catalog and then switch between catalogs?' on page 58

Start by trying to import all of the photos with 'Do not import suspected duplicates' checked in the Import dialog. That should import all of the single photos, and bring up a dialog warning you about the duplicate images.

 See 'What does 'Do not import suspected duplicates' do?' on page 100 and 'It says "Some import operations were not performed. The files already exist in the catalog." What does this mean?' on page 111

In that warning dialog, press the 'Show in Library' button. This will create a temporary collection of those existing photos for which duplicates exist. Select those photos and save them into a permanent collection.

Now do the import again, but this time uncheck the 'Do not import suspected duplicates' button, so that the duplicate photos are imported into your catalog. Select those photos and save them into a permanent collection.

You now have 2 collections – you could merge them into a single collection, or leave them separate. Either way, you can now sort through these 2 collections and delete whichever of the duplicates you don't wish to keep.

Returning to your main catalog, select the top level folder and choose 'Synchronize Folder...' from the menu. In the dialog that follows, press the 'Show Missing Files' button to create a temporary collection. As long as your catalog didn't have any missing files before you started, then those photos should be the deleted duplicate files which you can now remove from your catalog.

 See 'How does the Synchronize Folder command work?' on page 134 and 'Where has the Missing Files collection gone? How do I find all of the missing files in my catalog now?' on page 132

Finally, having removed the duplicates that you don't want, run an Import or Synchronize Folders to import any additional photos into the catalog.

How can I find the original file on my hard drive?

In the Metadata panel is the folder name, and clicking on the arrow alongside will select that folder in the Folders panel.

Alternatively, right-click on any photo and choose Show in Explorer (Windows) or Show in Finder (Mac).

Selections

How do I go quickly from having a number of photos selected, to having just one of those photos selected?

Hold down Ctrl (Windows) / Cmd (Mac) while clicking to select non-contiguous (non-sequential) photos.

Hold down Shift while clicking to select contiguous (sequential) photos.

Make sure you're clicking in the centre of the thumbnail when making selections, not the area around the edge.

What's the difference between the selection shades of grey?

The lightest shade of grey is the active or most-selected image.

The mid grey is also selected, but not the active photo, so only changes made in Grid mode or using AutoSync will affect these images.

The darkest shade of grey is not selected.

Why don't the rest of my photos deselect when I click on a single image?

The key is knowing where to click... clicking on the thumbnail itself will retain your current selection, however clicking on the area surrounding the thumbnail will deselect all other photos, just leaving that photo selected.

Is there a quick way of selecting all photos with a specific flag, color label or rating?

Ctrl-click (Windows) / Cmd-click (Mac) on the flag, color label or star rating in the Filters bar on the Filmstrip to select all of the photos in the current view with that flag, label or rating. The cursor will change to show that you are selecting images rather than filtering.

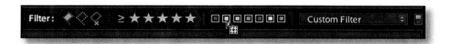

I've got multiple photos selected – why is my action only applying to a single photo?

If you are in Grid view, any actions will apply to all selected photos, however in any other mode or module, for example Loupe view, Survey view, Develop module etc., any actions will only apply to the active (most-selected) photo.

Of course, with every rule, there is always an exception, and on this occasion the exception is AutoSync, which will apply Develop changes to multiple selected photos at the same time.

 See 'How do I copy or synchronize my settings with other photos?' on page 204

Renaming

How do I rename photos?

In Grid view, select the photos you wish to rename.

Go to Edit menu > Rename... or press the F2 shortcut key.

The renaming dialog will appear.

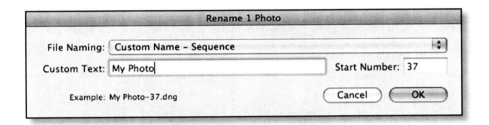

Select a preset from the list and press OK to rename the selected photos.

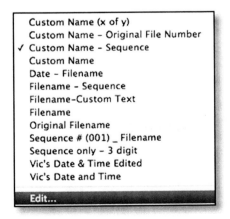

If none of the default presets are quite what you're looking for, you can create your own using the tokens provided.

Go down to Edit... at the bottom of the popup menu and launch the Filename Template Editor.

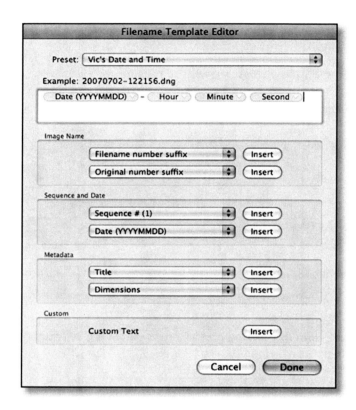

Using this dialog, you can create your own naming templates. Simply use the popup menus to combine different options into your ideal file naming setup.

Once you've finished, save the preset for next time by selecting 'Save Current Settings as New Preset...' from the popup menu at the top of the dialog. It will now appear in your list of rename presets ready for use.

How do I pad the numbers to get Img001.jpg instead of Img1.jpg?

Go to the Filename Template Editor, as in the last question, and create a preset.

To get a padded sequence number when creating your preset, choose "Sequence#(001)" instead of "Sequence#(1)" from the popup menu, and press Insert.

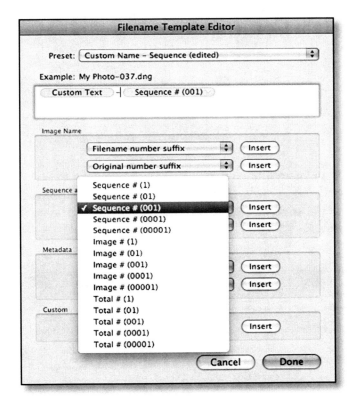

Save it for use next time!

What's the difference between Import#, Photo# and Sequence#?

Import # is a number identifying that particular import (i.e. the memory card number, which you may wish to combine with Sequence #)

Photo # is an ever increasing number that doesn't automatically reset.

Both Import # and Photo # have starting numbers set in Catalog Settings > File Handling panel, with Import Number used for 'Import #' and Photos Imported used for 'Photo #'.

Sequence # is an increasing number which starts at the number of your choice each time you use it – you set the start number in the Rename dialog. It's probably the most useful of the automatic numbers, and the variety we're most familiar with from other programs.

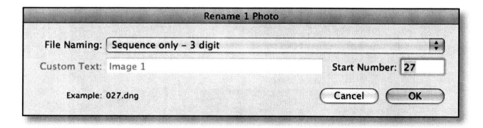

Can I have more than 5 digit sequence numbers?

A maximum of 5 digits are available directly within the Rename dialog, however if you create your preset with a 5 digit sequence number using the Sequence # (00001) option, you can then edit that preset in a text editor. You'll find your preset in the Filename Templates subfolder with the other presets.

 See 'The default location of the Presets is...' on page 396

Having opened the preset in a standard text editor, edit the line saying:

value = "naming_sequenceNumber_5Digits"

and change the 5 to either 6, 7, 8 or 9.

Is it possible to revert to the original filename?

If you've renamed a photo within Lightroom, since it's been imported into the current catalog, then Lightroom should still have a record of the original filename.

You can check by looking in the Metadata panel, and choosing All from the presets.

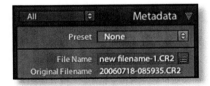

If the original filename is present in the database, you can go to Edit menu > Rename...

You'll find 'Original filename' in the Image Name section.

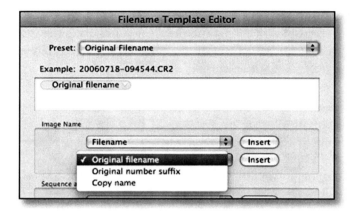

Save it as a preset for next time.

 See How do I rename photos? on page 139

Deleting

When I delete photos, am I deleting them from Lightroom only, or from the hard drive too?

The key is the difference between the word 'remove' – which removes just from the catalog – or 'delete', which moves to the Recycle Bin (Windows) / Trash (Mac).

When you press the Delete key, or use Photo menu > Delete Photo... or Delete Rejected Photos..., it will show a dialog box asking whether to Remove them from the catalog, or Delete them from the disk.

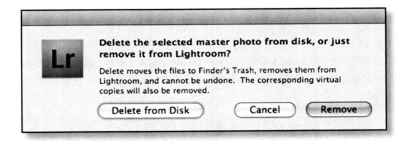

If you wish to delete the files, sending them directly to Recycle Bin (Windows) / Trash (Mac) and bypassing the dialog, use the shortcut Ctrl-Shift-Alt-Del (Windows) / Cmd–Shift–Opt–Del (Mac).

Why can't I delete photos when I'm viewing a collection?

The Delete key only gives the option to delete photos from disc in a folder view – deleting from a collection only removes from that collection.

The other shortcuts work as normal, so use Alt-Del (Windows) / Opt-Delete (Mac) to remove from the catalog, or Ctrl-Shift-Alt-Del (Windows) / Cmd-Shift-Opt-Del (Mac) to send them directly to the Recycle Bin (Windows) / Trash (Mac).

I'm deleting photos in Lightroom, set to send to Recycle Bin/Trash, so why isn't it deleting them?

Check the file permissions, as you may not have permission to delete the files.

Also check whether you're looking at the right files on your hard drive by right-clicking on a photo and selecting Show in Explorer (Windows) / Finder (Mac). It's possible that you're looking at duplicate files!

It's taking forever to delete photos – should it really take this long?

It may take a little longer than deleting directly in Explorer (Windows) / Finder (Mac), while it finds and deletes previews too, but it shouldn't be a significant difference.

If you're running the unsupported Microsoft Raw Viewer add-on, which that adds raw viewing capability to Explorer and Windows Picture and Fax Viewer, try uninstalling it. There's a known bug with that add-on that can cause file deletion issues with various programs.

And if it still doesn't work, rebooting solves most slow delete issues!

Rotating

I turned off auto rotate in the camera by accident – how can I rotate photos easily?

Set the Painter tool to rotate in one direction, and click on each thumbnail that needs rotating.

 See 'What is the Painter tool useful for?' on page 162

You can also click the rotate icon in each thumbnail, but you don't need to be as exact in hitting the right spot if you use the Painter tool.

My photos have imported incorrectly rotated and distorted – how do I fix it?

It crops up from time to time with Fuji photos, and with photos that have been rotated in other programs.

Select all of the affected photos in Grid view and write your current settings to XMP using Metadata menu > Write Metadata to Files or the shortcut Ctrl-S (Windows) / Cmd-S (Mac) so you don't lose them. Then read from XMP using Metadata menu > Read Metadata from Files.

If you then ask Lightroom to render updated previews using Library menu > Previews > Render Standard-Sized Previews, it fixes the majority of cases.

Rating & Labeling

Are there any shortcuts to make rating and labeling quicker?

The simplest option is often the number keys – 0-5 are for star ratings, and 6-9 apply colors Red, Yellow, Green and Blue. Purple doesn't have a keyboard shortcut.

Turning on caps lock or holding down shift while using keyboard shortcuts for flags (P, U, X), ratings (1-5), labels (6-9) applies that rating and then moves on to the next image, or you can also turn on Auto Advance under the Photo menu.

Alternatively, the Painter tool is a very quick way of applying ratings or labels to a large number of photos.

 See 'What is the Painter tool useful for?' on page 162

I've flagged my photos, but the flags disappear when I view these photos in another folder or collection – why?

Flags are local, unlike ratings or labels. They only apply in the context in which they were originally set. So a photo may be flagged in one collection and unflagged in another. If you need a global marker, use ratings or labels. Flags are not saved in XMP either.

If you flag photos in a folder or Quick Collection, and then create a collection from that, the collection will show the same flags. Once the collection is created, however, it becomes detached, and changes made to the flags will not be updated in other locations.

Why would I want flags to be local instead of global?

Let's say you went to the zoo, and you're taking photos which are going to be used for different things – some to send to Granny, some to submit to a competition, some to put in the family album etc.

The global star ratings are all well and good, but you may look for different things in the photo, depending on their destination. You put all of the photos into 3 collections – Granny, competition and family album, and then start sorting through those photos in their collections.

The photo of the kids sticking their tongues out at the elephant may be a reject for the competition, but a pick for the family album, and the beautiful headshot of the lion would be a firm favorite for the competition, but Granny wouldn't like it. That's when the local flags come into their own.

I gave my photos color labels in Lightroom – why can't I see them in Bridge?

Lightroom's settings are only stored in Lightroom's own catalog, which Bridge can't read.

You need to write your settings to XMP for Bridge to be able to read the changes you've made in Lightroom.

 See 'How do I write settings to XMP?' on page 283

I gave my photos different color labels in Lightroom – why are they all white in Bridge? I labelled my photos in Bridge – why isn't Lightroom showing my color labels?

If you've changed label names or are using a different label set in Lightroom and Bridge, the labels may show as white in Bridge, showing that they don't match.

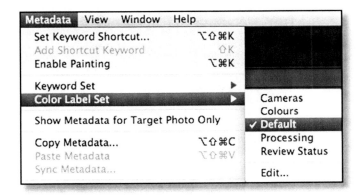

You can check Lightroom's label names by going to Metadata menu > Color Label Set > Edit...

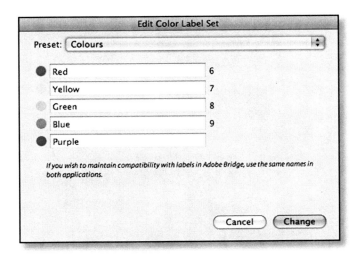

To check in Bridge, go to Preferences > Labels section.

Change them both to the same values to show in the same colors and labels.

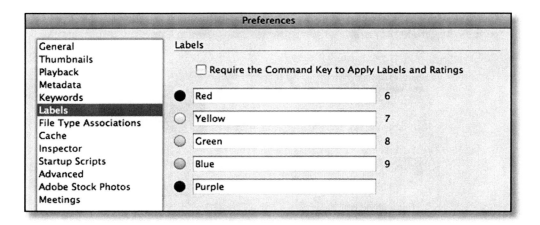

In Lightroom, you can check whether you've used 'custom' labels by right-clicking on the colors Filter bar on the Filmstrip and selecting 'Custom Label' from the menu. This will show all photos which have a label in another label set.

Is it possible to view flag/rating/color labels status when in other modules?

When you turn on the toolbar, you can choose which information to show in each module, and flag/rating/label are amongst those choices.

 See 'How do I change the tools that are shown in the toolbar?' on page 369

You can also see the flags/ratings/color labels in the filmstrip at the bottom of the screen, as long as you have 'Show ratings and picks in filmstrip' turned on in Preferences > Interface panel and 'Tint grid cells with label colors' turned on in View menu > View Options...

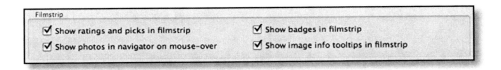

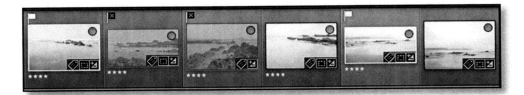

Lightroom's not quick enough to do the initial culling on a large shoot – is there anything I can do to speed it up?

Lightroom definitely likes a fast computer, however there are a few things you can do to help it along.

Work in Library module, not Develop module, as Develop reads the original raw file and is therefore slower moving from one photo to the next.

Render previews before you start – there's nothing more frustrating than waiting for a preview to become sharp. If you're going to need to zoom in, render 1:1 previews.

 See 'Previews & Speed' section starting on page 373

Resist the urge to start making Develop changes while you're sorting. If you correct one, then sync the changes with others, Lightroom has to regenerate the previews for the photos that have changed. Do your tweaking after you finished culling.

Turn on Auto Advance, either under the Photo menu or by leaving caps lock turned on – as you rate a photo, it will move on to the next photo automatically.

Use Filters to hide photos you've rejected, rather than immediately deleting.

 See 'How do I filter my photos to show... just one flag/color label/rating?' on page 183

Keywording

How do I import my keywords from Bridge?

You have 2 main options.

Option 1

Use Bridge to apply all of the keywords to one specific photo, import that photo into Lightroom, and all your keywords will show up in the Keyword List.

Option 2

1. Open the Keywords panel in Bridge and go to the little popup menu in the top right hand corner of the panel. You'll find Export in that menu, which will export the keywords to a text file.

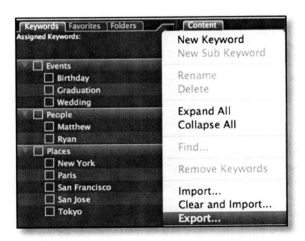

2. You can then go to Lightroom and use Metadata menu > Import Keywords to import that text file into Lightroom.

If I can import keywords from Bridge using a text file, does that mean I can create my keywords manually using a text file and then import them into Lightroom?

You certainly can, but be aware that any formatting mistakes could prevent the keywords from importing, and creating a time consuming job to figure out what's wrong.

Use a tab to show parent–child hierarchy, and no other characters.

If it won't import, you've probably got some blank lines, extraneous spaces, return feeds etc., or perhaps a child keyword without a parent.

Here's an example showing the formatting characters:

```
Animals¶
    →    Birds¶
    →    Dog¶
    →    Ducks¶
    →    Pets¶
    →        →    William¶
Places¶
    →    UK¶
    →        →    Cornwall¶
    →        →        →    Constantine·Bay¶
    →        →        →    Kynance·Cove¶
    →        →        →    Land's·End¶
    →        →        →    Mullion¶
    →        →    South·Coast¶
    →        →        →    Hurst·Castle¶
    →        →        →    Keyhavan¶
    →        →        →    Milford-On-Sea¶
    →        →        →    New·Forest¶
    →        →        →        →    Beaulieu¶
    →        →        →    Southampton¶
    →        →        →        →    Clifton·Road·Park¶
    →        →        →        →    Royal·Victoria·Country·Park¶
    →        →        →        →    Sports·Centre¶
```

How many keywords can I have?

There's not a known limit in a hierarchical structure, but around 1630 top level keywords seems to be the magic figure.

What does the plus symbol to the right of the keyword mean?

The plus symbol shows this keyword is assigned to the keyword shortcut.

Pressing Shift-K will assign that keyword to the selected photo(s). You can change the keyword assigned to the shortcut by going to Metadata menu > Set Keyword Shortcut, or by right-clicking on any keyword and choosing that option from the menu.

It also shows that this keyword is set in the Painter Tool.

What do the minus symbol, check mark, and box to the left of the keyword arrow mean?

The minus symbol shows that some of the photos you have selected have that keyword, or a child of that keyword, assigned. It can also show that all of your selected photos have a child keyword attached, but not all of the children of that keyword.

The check mark shows that all of the photos you have selected have that keyword assigned.

The box shows that the keyword over which you are hovering is not currently assigned to the selected photos, but clicking in that box will assign that keyword.

What is the small arrow after the selected keyword?

Extensive keyword filtering is available using the Library Filter bar.

 See 'How can I view all of the photos tagged with a specific keyword or keyword combination?' on page 188

As a shortcut to show the photos from just one keyword, click the little arrow that appears at the right hand end of the keyword line, after the keyword photo count.

How do I change my long list of keywords into a hierarchy? Or change the existing hierarchy?

You can pick up and drag/drop the keywords to create the hierarchy of your choice.

Drop the keyword on top of an existing keyword to make it a child of that keyword. As you drag, the new parent keyword will become highlighted.

In our screenshot below, we're making 'William' a child of 'Pets'.

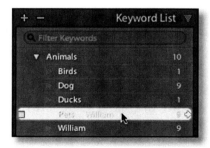

Drop the keyword between root level keywords to make it a root keyword. As you drag, a thin line will appear.

In our screenshot below, we're making 'William' a root keyword.

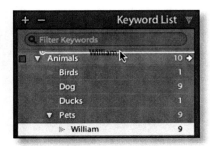

How can I keep certain keywords at the top of the list?

Adding a symbol to the beginning of the name, for example the @ symbol, will keep them at the top of the keywords list, as the list is kept in standard alpha-numeric order.

Is there a quick way of finding a particular keyword in my long list?

There's now a Keywords Filter at the top of the Keyword List panel, which will instantly filter the Keyword List to show matching keywords.

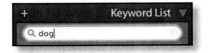

Is there any easier way to apply lots of keywords in one go, other than typing or dragging them all?

In the Keywording panel you have a number of options.

You can type the keywords directly into the main keywords field, or into the 'add keywords' field directly below if you don't wish to interfere with existing keywords.

You can make use of the Keyword Suggestions panel, which suggests keywords based on your previous keyword combinations and the keywords already assigned to photos nearby. It's remarkably powerful!

If you create a Keyword Set (Metadata menu > Keyword Set > Edit...), or multiple Keyword Sets, you can apply those keywords with a keyboard shortcut – hold down Alt (Windows) / Opt (Mac) to see which numerical keys are assigned to each word.

Alternatively you could use the Painter tool to apply one or more keywords to a series of photos quickly and easily. If you find yourself regularly using a set of keywords in the Painter tool, save the strings in a text file and copy/paste them into the Painter tool to save typing them each time.

 See 'What is the Painter tool useful for?' on page 162

I mistyped a keyword and now Lightroom keeps suggesting it – how can I clear the autofill?

Remove that keyword from the Keyword List panel and it'll stop suggesting it.

I use multiple catalogs, but I'd like to keep my keyword list identical and current across all of the catalogs – is there an easy way?

The easiest option is to use a single photo which is imported into each catalog.

1. Import the same photo into each catalog, making sure you set the Import dialog to 'Add photos to catalog without moving' so that all of the catalogs are referencing the same file on your hard drive.

2. Apply all keywords to that photo.

3. Before you close the catalog, make sure you write to XMP using Ctrl-S (Windows) / Cmd-S (Mac).

4. Whenever you open another catalog, select that same photo and go to Metadata menu > Read Metadata from File. That will update your keyword list.

5. Repeat each time you switch catalogs, to ensure they stay up to date.

Alternatively you could use Metadata menu > Import Keywords and Export Keywords each time you open and close a catalog.

This is one of the main disadvantages of using multiple catalogs.

Painter Tool

What is the Painter tool useful for?

The Painter tool, shown by a spray can icon in the toolbar, is ideal for quickly applying various metadata and settings to single, or many, photos, without having to be too careful about where you click.

The Painter tool can be used to assign keywords, labels, flags, ratings, metadata presets, settings (Develop presets), rotation, or add to the Target Collection.

Simply select the Painter tool from the Grid view toolbar - press T if you've hidden the toolbar.

Choose the setting you'd like to paint, and start spraying - click anywhere on a thumbnail image to apply the setting, or click-and-drag across a series of photos to apply the setting to all of those photos.

When you float over a photo which already has that setting applied, the spray can cursor will change to an eraser, and clicking will remove that setting instead of applying it.

Editing the Capture Time

The time on my camera was incorrect – how do I change it?

1. Make sure you are in Grid view.

2. Find a photo for which you know the correct time, and note that time down – we'll call this the 'known time' photo for the moment.

3. Select all of the photos that need the time-stamp changed.

4. Click on the thumbnail of the 'known-time' photo that we identified in step 2, making that photo the active (most-selected) photo without deselecting the other photos.

5. Go to Metadata menu > Edit Capture Time... and this dialog will appear.

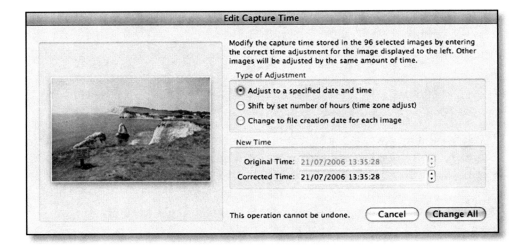

6. Choose the first option 'Adjust to a specified date and time' as this allows you to change by years, months, days, hours, minutes or seconds.

7. Now, in the Corrected Time field, input the correct time – the time you noted down earlier for the 'known-time' photo that you can see in the dialog. You can select each time-stamp section (hours, minutes etc.) individually, either by using the arrows or typing the time of your choice.

8. Click Change All.

While not entirely obvious, when changing the time stamp of a series of photos, the active (most-selected) photo will be set to the time you enter in step 7, and the rest of the photos will be adjusted by the same incremental time difference – it won't set them all to the same date and time. That applies whether your active (most-selected) photo is the first in the series or not.

For example, if you have selected 3 photos, and you know the correct time for the middle one is 16:26, that photo will be the 'known-time' photo identified in step 2. The others will be adjusted by the same time difference.

So you would have:

	Original Time	New Time
Photo 1	10:14	14:26
Photo 2	**12:14**	**16:26**
Photo 3	15:34	19:46

If you make a mistake, the original time stamp is stored in the catalog, and you can return to the original time stamp by using Metadata menu > Revert Capture Time to Original.

A couple of additional points to note when changing times in Lightroom...

The updated capture time is stored in the catalog, and if you write to XMP using Ctrl-S (Windows) / Cmd-S (Mac), it will be written to the metadata of the file too.

In version 1, for proprietary raw files, most metadata is written to an XMP sidecar file, however the updated capture time is written back to the raw file itself, changing the modified date of the file.

That shouldn't cause any problems as it's only written to the metadata file header, and doesn't affect the raw image data itself, however it is a point of concern for some people who they feel that the raw files should never be touched in any way.

For that reason, in version 2, there is a setting in Catalog Settings > Metadata panel to allow you to choose whether the updated time is stored only in the catalog, exported files, and XMP sidecar files, or whether it can be updated in your original raw files. JPEGs are updated when you write to metadata, regardless of the setting used.

What do the different options in the Edit Capture Time dialog do?

'Adjust to a specified date and time' adjusts the active (most-selected) photo to the time you choose, and adjusts all other incrementally.

'Shift by set number of hours (time zone adjust)' adjusts by full hours, useful for forgetting to adjust the time on holiday.

'Change to file creation date for each image' does exactly as what says.

How do I sync the times on two or more cameras?

The principle remains the same as adjusting the time on a single camera – you simply need to repeat the process for each camera with the wrong time stamp.

It is easiest if you have a fixed point in the day for which you know the correct time and were shooting on all of the cameras involved, for example signing the register at a wedding.

Separate each camera, so that you're working with one camera's photos at a time.

 See 'Is it possible to sort by camera?' on page 180

Run the Edit Capture time once for each camera, using the instructions for changing time stamps.

 See 'The time on my camera was incorrect – how do I change it?' on page 163

Repeat for each camera, until the time stamps match.

Viewing & Editing Metadata

How do I add my copyright information to the metadata?

Select the photo(s) in Grid view and type in the appropriate fields – it will apply to all selected photos.

To add a © symbol, hold down Alt while pressing 0, 1, 6, then 9 number keys (Windows) or Opt-G (Mac).

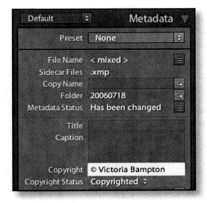

If you regularly add the same metadata, such as in the case of copyright metadata, you may wish to create a Metadata preset. You can also apply this in the Import dialog.

 See 'How do I create a Metadata preset?' on page 169 and 'What Develop settings, metadata, keywords and previews settings should I apply in the Import dialog?' on page 100

How do I add metadata to multiple photos at once?

You can select multiple photos in Grid view and add the metadata simply by typing directly into the Metadata panel, however this can be a little slow when working on a volume of photos as it updates each time you move between fields.

Alternatively you can press the Sync Metadata button below the Metadata panel (not the Sync Settings button).

Enter the details for any fields you wish to update – only checked fields will be changed. Press Synchronize when you're finished, and the photos will be updated.

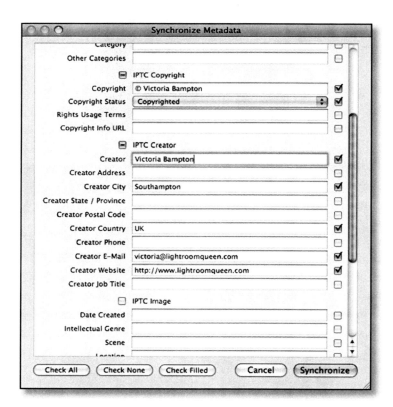

How do I create a Metadata preset?

Select 'Edit Presets...' from the Presets popup menu and enter the details in the following dialog.

Checked items will be stored as part of the preset, which can then be applied by selecting it from the Presets popup menu or applied in the Import dialog.

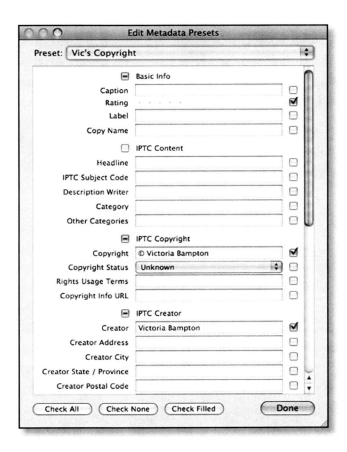

How do I select which metadata to view in the Metadata panel?

The Metadata panel in Library module can show a variety of information, much of which can be accessed using the popup menu and selecting the 'All' preset.

Should you wish to view additional metadata, or create your own view preset with information you most often use, try Jeffrey Friedl's Metadata Panel Builder: http://www.regex.info/blog/lightroom-goodies/

I renamed my photos within Lightroom – is it possible to see the original filename without renaming it?

If the file has not been removed from the catalog since you renamed it, the original filename should still be recorded.

In Library module, set the Metadata panel to the 'All' preset in the popup menu, and you'll see 'Original Filename' appear towards the top of the list, as long as that data is in the catalog.

 See 'Is it possible to revert to the original filename?' on page 143

Why can't I see the file size in the Metadata panel?

The 'Default' view preset shows basic information, but switch to the 'All' Preset to show a larger range of metadata, including the file size.

What's this WAV file in the Metadata panel?

If Lightroom finds a WAV sidecar audio file with the same name alongside the photo, it will be listed in the Metadata panel. You'll only be able to see it listed if you're using the 'All' preset.

 See 'How do I select which metadata to view in the Metadata panel?' on page 170

These audio annotation files can be played within Lightroom by pressing the arrow icon at the end of the WAV filename. It only currently works with WAV files, not MP3 format which some cameras use.

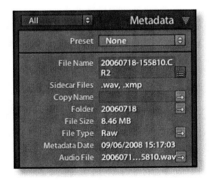

Why do some files say CR2+JPEG and some just say CR2?

The files marked as CR2+JPEG, NEF+JPEG or similar are raw photos that were imported with sidecar JPEG files (JPEGs with the same name in the same folder), and with the 'Treat JPEG files next to raw files as separate photos' preference setting turned off.

 See 'I shot Raw + JPEG in camera – why have the JPEGs not imported?' on page 104

Some of my lenses are listed twice in the Metadata filters, for example 24.0–105.0 mm and also as EF24–105 IS USM. Why?

While it is slightly irritating, different cameras record the same lens differently, and Lightroom's just reading that metadata from the file. Other than manually updating the EXIF data using tools such as Exif-Tool, there isn't an easy fix at this point in time.

Virtual Copies

Why would I want to use virtual copies?

A virtual copy is a duplicate of an existing photo, but it's virtual – it doesn't take up additional space on the hard drive, with the exception of the preview.

You can do anything to a virtual copy that you can do to a master photo. It's treated as if it's a separate photo, so they will show in Grid view alongside the master and any other virtual copies. Most use virtual copies to keep variations of photos – perhaps a color version, a black and white version, a special effect version, and a few different crops.

Information about virtual copies is only stored in the catalog – not in XMP, so if you need image variations that are stored in XMP, consider Snapshots as an alternative.

 See 'Which data is not stored in XMP?' on page 282 and 'When would I use a snapshot instead of a virtual copy?' on page 223

I've just created a virtual copy, but an empty screen appears with "no photo selected" and no copy is made – what's wrong?

In the Attribute filters on the Library Filter bar, or on the Filmstrip, try clicking the two Copy Status icons to the far right so that either both are lit or neither are lit, and see whether the virtual copies appear. The filters may be hiding your virtual copies.

Can I rename my virtual copies?

If you rename the virtual copy, the name of the master will change too – after all, it's virtual. When you export the virtual copies, they can have different names from the originals, and you have some control over that naming while still in the Library module.

In the Metadata panel of a virtual copy is a 'Copy Name' field, which defaults to 'Copy 1', but you can change to an alternative name of your choice, for example 'Sepia'. You can update a series of photos in one go by first selecting them and then editing that field.

If you've updated the Copy Name on your virtual copies, you can use that Copy Name when you export, rather than having to decide on the naming at the time of export. You'll find Copy Name as an option in the Filename Template Editor.

See 'How do I change the filename while exporting?' on page 318

Stacking

Why are the stacking menu options disabled?

Stacks only work in a single folder. It doesn't work across a composite view, or in Collections, Keywords, or special collections such as All Photographs or Previous Import. Go to a folder which doesn't have subfolders or deselect 'Include Photos from Subfolders' in the Library menu.

How do I move a photo to the top of the stack?

Selecting the photo and going to Photo menu > Stacking > Move to Top of Stack will do the trick, as will Shift-S.

Or there's a quicker way – just click the stacking number box of your favorite picture (it says 2 of 3 in our screenshot), and that photo will jump to the top of the stack.

I've moved raw photos and their resulting JPEGs into the same folder, and I'd like to Auto-Stack just like they would if they imported as Raw+JPEG together. Is it possible?

Select the files and choose Photos > Stacking > Auto-Stack by Capture Time and select a 1 second time difference. It might need a little tidying up where you've shot in really quick succession, but it should do most of the work for you.

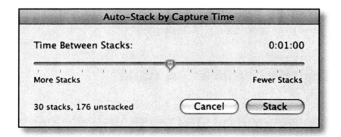

When I create a virtual copy, it should automatically stack them, but it doesn't – why not?

It's possible that they are stacked, but the stacks are all open. The surrounding is slightly different, but it's not always obvious as the thumbnail divide lines don't disappear until the photos are deselected.

Try Photo menu > Stacking > Collapse Stack and see if that solves the problem. Also, check you're viewing the folder view rather than a collection or keyword view, as they won't appear stacked in collections/keywords.

Sorting, Filtering & Finding Photos

Where have my photos gone?!

This is by far the most frequently asked question. The conversation usually goes along the lines of...

Question) Where on earth did my photos go?
Answer) Don't know, did you accidently leave a filter on?
Reply) Doh!

So that's the first thing to check!

The filters are sticky – once you've set a filter for a folder or collection, that filter remains set for that folder or collection even if you navigate to another folder and back again. Forgetting that you've set a filter is most often the cause of the confusion.

Additional information is also give in the centre of the empty screen. Alerts include:

- "No photos in selected Collection."

- "No photos match the filter."

- "No photo selected."

Can I set a default filter or sort order regardless of folder?

You can't set a default filter or sort order, however when you do set a filter or sort order for a folder, the setting is stored in the catalog and is used whenever you return to that folder or collection.

How do I choose a different sort order?

Sort options are in the toolbar in Grid view, or under the View menu > Sort.

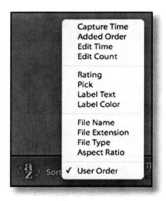

 See 'My toolbar's disappeared – where's it gone?' on page 369

Can I reverse my current sort order?

You either use the A–Z button in the toolbar or the View menu > Sort > Ascending/
Descending command.

Why can't I drag and drop into a custom sort order or 'User Order'?

Firstly, custom sort orders, correctly known as 'User Order' don't work across composite folder views, only single folder/collection views, so check that you're viewing the lowest level folder (i.e. a folder with no subfolders). Alternatively you can turn off 'Include Photos from Subfolders', which you'll find in the Library menu.

 See 'When I look at a top level folder in Grid view, I see the photos in the subfolders as well. Can I turn it off so I can only see the contents of the selected folder?' on page 129

Secondly, you need to pick up the photo by the center of the thumbnail itself, not the grey border surrounding it. As you drag, you'll see a black line appear between two photos, which shows where the photo will drop, as shown in the screenshot below.

Is it possible to sort by camera?

Camera model or serial isn't currently in the Sort Order options, however you can apply a rating or color label to each camera, and sort by those options.

You can filter by camera model and serial number using the Metadata filters bar – simply click on the required camera to view the photos.

When processing photos from a mix of various cameras at a single event, it helps to assign each camera a color label, to be able sort and filter the photos even more quickly, and synchronize settings for each camera individually.

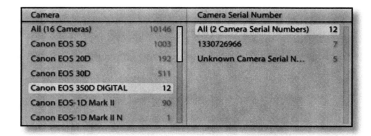

To show photos from a camera / folder combination, first select the folder and then click on the camera in the Metadata filters to filter the results further.

 See 'How do I select multiple options within the Metadata filter columns?' on page 186

How do I sort my entire catalog from earliest to latest or vice versa, regardless of which folders the photos are in?

Click on All Photographs in the Catalog panel and then select Capture Time as the sort order.

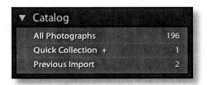

How do I filter my photos to show photos fitting certain criteria?

Version 2.0 saw the introduction of the new Library Filter bar. If this isn't visible at the top of your Grid view, press the \ key, or go to View menu > Show Filter Bar.

The filters apply to the photos in the current view, so can be used on a single folder, collection, or a larger set of photos such as All Photographs.

Clicking on each of the labels switches between the different Library Filter bar views. Shift-click on the labels to show multiple Library Filter bars at the same time. If you've already set filter options in one Library Filter bar, clicking on another will keep that bar in view whilst opening the other.

The Text filters allow you to search the metadata of each photo for the text of your choice, and replaces the Find panel from version 1.

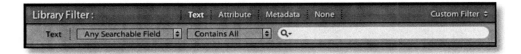

The Attribute filters allow you to filter by flag status, star rating, color label, or master/virtual copy status.

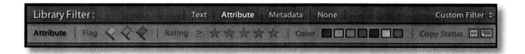

Those Attribute filters can also still be found on the Filmstrip for easy access. If your Filmstrip Filter options are collapsed, simply click on the word Filter to expand to show the full range of options.

The Metadata filters allow you to drill down through a series of criteria to find exactly the photos you're looking for.

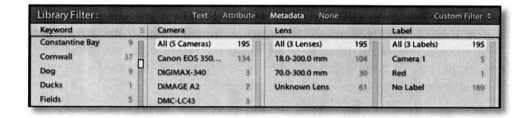

To disable the filters, select the None option, use the keyboard shortcut Ctrl-L (Windows) / Cmd-L (Mac), or the menu command Library menu > Disable Filters.

How do I filter my photos to show... just one flag/color label/rating?

Use the options in the Attribute filter bar, or on the Filmstrip Filters bar.

They are toggle switches, so click the red icon once to add the red photos to your filter and click again to remove those red labeled photos from your filter.

You can combine the various filters, for example, to show red and yellow labeled photos with exactly three stars, you would set it up as follows:

How do I filter my photos to show... photos with no color label?

Right-click on the color labels in the Filmstrip Filters bar and select 'No label' from the menu.

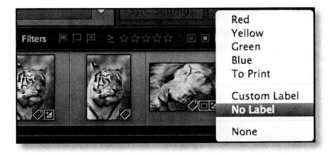

How can I use the Text filters to do AND or OR filters?

Select 'Contains All' from the popup menu for an AND filter such as all photos with both 'dog' and 'cat' keywords.

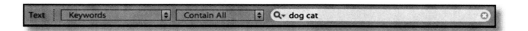

Select 'Contains Any' from the popup menu for an OR filter, such as all photos with either 'dog' or 'cat' keywords.

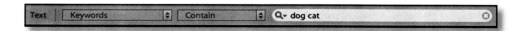

Select 'Don't Contain' from the popup menu for a NOT filter, such as all photos without the keyword 'mouse'.

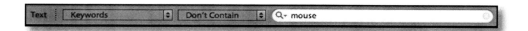

To combine AND or OR searches with NOT searches, add the exclamation mark symbol (!) before the NOT word in the filter bar, for example to show all photos with the keyword 'mouse', but without 'dog' or 'cat', you'd use:

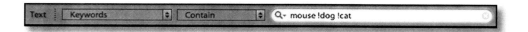

There are some special characters to remember, particularly when creating complex Text filters – a space is 'AND', ! is a 'NOT', a leading + is 'Starts With', and a trailing + is 'Ends With'. They only affect the adjacent word, so you'd use 'dog !cat !mouse' to find images with dog but not cat or mouse.

How do I change the Metadata filter columns?

Clicking on the name of each column in the header brings up a popup menu of options, and you can choose your own columns by selecting from that list.

Hover over the right hand end of each column to show a small popup menu which allows you to add and remove additional columns. You can have up to 8 columns.

You can save your combination of columns as a preset for use later.

Certain columns, such as the date and keyword columns, offer additional options in that popup menu, including a Flat or Hierarchical view.

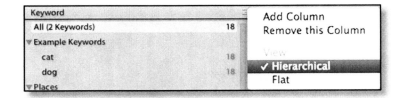

Finally, if you need a bit more space, drag the bottom edge to resize it.

How do I select multiple options within the Metadata filter columns?

Selecting across multiple columns gives an AND filter. So to search for all photos with both a cat and a dog, you'd have 2 columns, and select 'cat' in one, and 'dog' in the other.

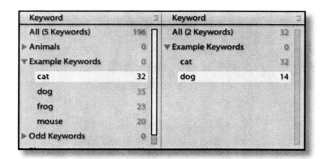

Ctrl-selecting (Windows) / Cmd-selecting (Mac) or Shift-selecting in the same column gives an OR filter. So to search for all photos with either a cat or a dog, you'd have a single column, and you would select 'cat' and then hold down the Ctrl (Windows) / Cmd (Mac) key while clicking on 'dog' as well, so that they are both selected. Holding down Shift instead of Ctrl/Cmd will select consecutive keywords rather than separate keywords.

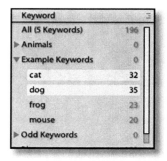

To filter within a folder or collection, first select the folder or collection, and then use the Metadata filters to filter the photos further.

Can I combine Text filters, Attribute filters, and Metadata filters?

Yes, as with most tasks in Lightroom, there are multiple ways of achieving this. For example, if you wanted to find all of the photos with the word 'dog' somewhere in the metadata, with a red, yellow or green color label, shot in 2006, on a Canon 350d, with 70-300mm lens, and changed to black and white, you'd combine all 3 filter types.

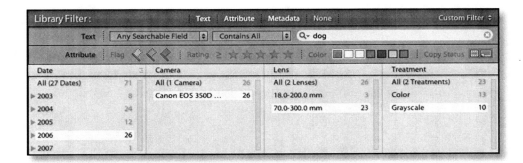

The criteria will filter down in order, from top to bottom, and from left to right, and this could be narrowed down further by starting off in a specific folder or collection view.

Even more extensive filtering is available via the new Smart Collections.

 See 'What are Smart Collections?' on page 192

How do I search for a specific filename?

To go directly to a photo that you know the name of, simply type that filename into the Text filter bar and set it to the Filename option.

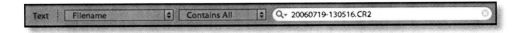

How can I view all of the photos tagged with a specific keyword or keyword combination?

There are multiple ways to filter by keyword, the easiest being the Text or Metadata filters in the Library Filter bar.

 See 'How do I select multiple options within the Metadata filter columns?' on page 186 and 'How can I use the Find panel to do AND or OR filters?' on page 184

To quickly show the photos from just one keyword, click the little arrow that appears at the right hand end of the keyword line, after the keyword photo count. The Library Filter bar will open, with that keyword already filtered for you.

Is it possible to display all of the photos in a catalog that are not already keyworded?

There's a ready-built Smart Collection called 'Without Keywords', or you can use a Text filter set to Keywords > Are Empty.

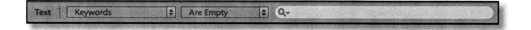

Can I save the filters I use regularly as presets?

At the right hand end of the Library Filter bar is a popup menu of ready-made filter presets, and you can add your own by selecting the filter options and then saving it as a preset.

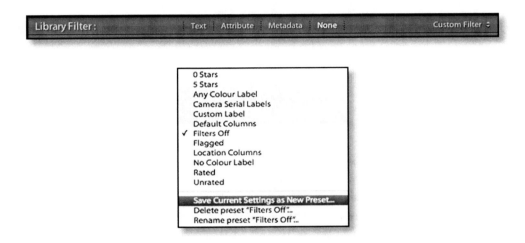

Can I delete the filter preset I created accidentally?

Select the preset from the popup menu, and then the Rename and Delete Preset options will appear at the bottom of the list.

Collections

How are Collections different from Folders?

Collections are a way of grouping photos in one place without actually moving them on your hard drive.

Grouping photos in folders, on the other hand, actually moves them between folders on your hard drive.

Photos can belong to multiple collections at the same time, but can only be in one folder on your hard drive.

Collections are most often used to group photos for different outputs, for example a collection of photos for a slideshow, as it will retain the sort order and settings of any output (slideshow, print or web). Collections can easily be reselected at any time simply by clicking on them, and double-clicking on any module-specific (Slideshow, Print or Web) collection will take you directly to that module.

Collections can be nested into Collection Sets for organization purposes, and can be sorted by name or type via the Collections panel popup menu.

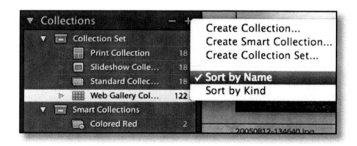

Smart Collections are saved search criteria, smart folders or rules.

What are the different icons for Collections?

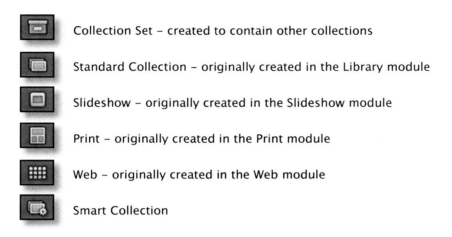

Collection Set – created to contain other collections

Standard Collection – originally created in the Library module

Slideshow – originally created in the Slideshow module

Print – originally created in the Print module

Web – originally created in the Web module

Smart Collection

What is the Quick Collection?

The Quick Collection is a special collection for temporarily holding photos of your choice.

By default it is the Target Collection, so pressing the shortcut key B or pressing the little circle icon on the thumbnail will add to this collection. It permanently lives in the Catalog panel, along with other special collections (All Photographs, Previous Import, etc.)

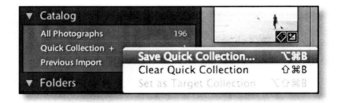

Having added photos to the Quick Collection, you can choose to convert it to a Standard Collection by right-clicking on Quick Collection and choosing 'Save Quick Collection...'

Is there a shortcut key to add to a collection?

The shortcut key B adds to the Target Collection, as does clicking in the small circle in the top right hand corner of each thumbnail image.

The Target Collection is marked by a + symbol next to the collection name. By default this is the Quick Collection, however you can change the Target Collection to the collection of your choice by right–clicking on that collection and choosing 'Set as Target Collection'.

Can I add to a collection from another module?

The shortcut key B and the circle in the thumbnail work across all modules to add to/remove from the Target Collection.

In the Slideshow, Print and Web modules, as well as the Library module, you can also drag and drop photos into existing collections or make new special collections (Slideshow, Print and Web collections).

What are Smart Collections?

Smart Collections are like Saved Searches, Smart Folders, or Rules in other programs. They offer more extensive filtering than the Filter presets. They automatically update as files meet, or stop meeting, the criteria you've set.

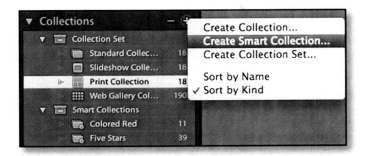

To create a Smart Collection, go to the popup menu on the Collections panel and choose Create Smart Collection... and select your chosen combination of criteria.

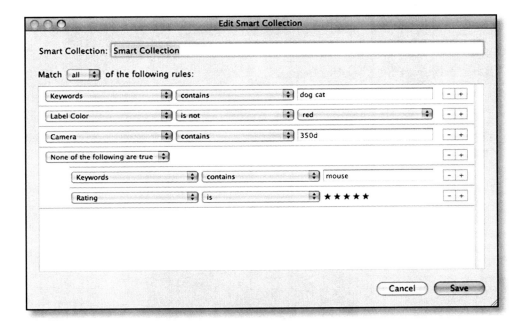

You can add additional criteria by clicking the + button at the end of each row.

Hold down Alt (Windows) / Opt (Mac) while clicking on the + button to fine-tune it further with conditional rules (see the indented section in the screenshot above).

How do I transfer Smart Collection criteria between catalogs?

Smart Collections, like other collections, are stored within the catalog, so if you want to use them in other catalogs, you need to create them in each catalog. If they use complicated criteria, that could take a while, so Import and Export Smart Collection Settings has been added to the right-click menu, allowing for easy transfer.

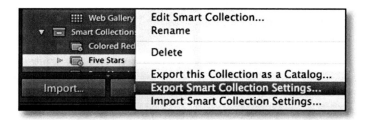

Can I have a hierarchy of collections?

Collections can only contain photos. Collection sets can contain collections or other collection sets, but not photos – note the lack of a photo count on the collection sets in the screenshot.

Therefore you can have a hierarchy of collection sets which can each contain collections of photos.

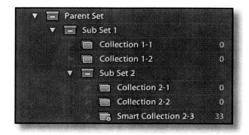

What will happen to my existing hierarchical collections when I upgrade my catalog from version 1?

Since version 2 doesn't allow collections to contain other collections, and doesn't allow collection sets to contain photos, the collections are rearranged on upgrading, so that you can easily tidy up without losing any of your collection data.

The screenshots below shows the hierarchy in version 1, and the same hierarchy upgraded to version 2. You can see that each parent collection has become a Collection Set, and any photos that were held directly in that collection have been transferred into a new collection with square brackets to show the original collection name.

Before upgrading:

After upgrading:

Why won't it delete the photo?

Delete works slightly differently in collections, assuming that you want to remove the photo from that collection, rather than from the hard drive, but there are shortcuts to delete directly from the hard drive while viewing a collection.

 See 'Why can't I delete photos when I'm viewing a collection?' on page 146

Is there any way to tell which collections a photo is in?

Right-click on any photo and choose Show in Collection – that will show you a list of your collections containing that photo.

If you're checking a large number of photos, switch to Grid view and hover the cursor over the collections individually and if the photos are in that collection a white border will appear around the photo.

Alternatively, decide which collection the photos should be in and drag them in to that collection. If the photos are already in that collection, nothing will happen.

Is there an easy way to see which photos in a catalog do not belong to any collection?

1. Select All Photographs in Grid view.

2. Select all of your collections by Ctrl-clicking (Windows) / Cmd-clicking (Mac) on the collection names.

3. Select all of the photographs.

4. Click back on All Photographs, and invert the selection using Edit menu > Invert Selection.

5. You now have all the photos not in a collection selected. You can then add a keyword, or create a new collection of those photos.Quick Develop

Why is the Quick Develop panel so useful?

The Quick Develop module offers RELATIVE corrections.

For example, imagine you have processed a series of photos, each with different settings, and then you decide you'd like them all 1 stop brighter than their current settings. The first photo is currently at –0.5 exposure, the next is at 0 exposure, and the third is at +1 exposure.

You could use Synchronize, but that would move the sliders of the selected photos to the same fixed value as the active (most–selected) photo.

However, if you selected those photos in Grid view and pressed the >> exposure button in Quick Develop, it will add +1 exposure to the existing settings – giving you +0.5 for the first photo, +1 for the second photo, and +2 for the third.

The same applies to the rest of the Quick Develop panel – they are all relative adjustments, relative to the existing settings.

Can I adjust Sharpening or Saturation using Quick Develop?

If you hold down the Alt (Win) / Opt (Mac) key, the Clarity buttons temporarily change to Sharpening, and the Vibrance buttons temporarily change to Saturation.

Why am I missing some Quick Develop buttons?

The full Quick Develop panel looks like the screenshot on the left, however by default part of the panel is hidden.

Click the small arrows down the right hand side to open it up and show all of the available options.

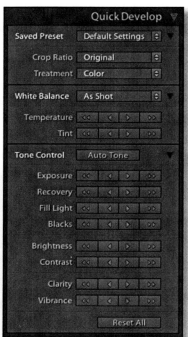

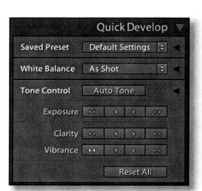

Errors

Why won't my thumbnails display? I only get grey boxes in Grid view?

Most likely the photos are offline (for example on an external hard drive which is not turned on) and Lightroom was unable to retrieve or create previews before the drive was disconnected.

Alternatively the original file may have been renamed or moved outside of Lightroom before it was able to create the previews.

In either scenario, there should be a small question mark icon in the corner of the thumbnails. Reconnect the drive or update the link to the file and the previews should update.

A corrupt monitor profile can also cause previews to not be displayed.

 See 'Lightroom thinks my photos are missing – how do I fix it?' on page 129 and 'Lightroom doesn't show me a preview of my PSD file in Grid view – why not?' on page 390

Develop Module

Working with Sliders

The slider movements are too coarse – how can I adjust them?

You can drag the panel to become wider, which will lengthen the sliders, making them easier to adjust.

You can also hover over the slider (no need to click) and use the up and down keys to move the slider. Adding Shift or Alt (Windows) / Opt (Mac) changes the increments.

Additional new shortcuts were added in 2.0 – the most selected slider is highlighted, and using the + / – keys adjusts that sliders. Adding Shift or Alt (Windows) / Opt (Mac) changes the increments. The ; key resets that slider to its default position, and , and . move up and down through the sliders.

For speed, I choose to use a Wacom Graphics Pen in one hand to float over the sliders, and a Contour Shuttle Pro 2 (http://www.contourdesign.com/) dial programmed to up/down keys when I turn the dial, and the buttons programmed to other useful shortcuts.

This is my current Shuttle setup for processing:

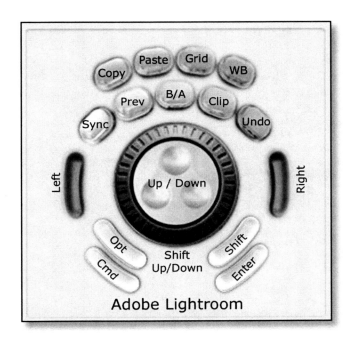

How do I get individual Auto checkboxes back, like ACR had in CS2?

Individual checkboxes are no longer available, but there is a workaround for specified Auto settings.

Initial setup:

1. Reset a photo to its default settings using the Reset button at the bottom of the Develop module right hand panel.
2. Decide which sliders you'd like to set back to default values, and which you'd like on the Auto settings (i.e. blacks)
3. Save a preset, unchecking any sliders you wish to have on their Auto setting (i.e. blacks in our screenshot)

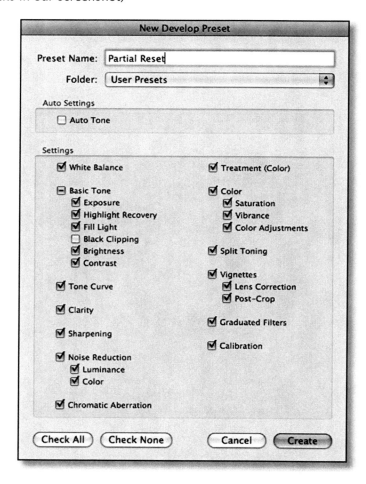

 See 'Presets' section starting on page 213

To run:
1. Select the photo.
2. Press the Auto button in the Basic panel to apply Auto adjustments.
3. Select your 'Partial Reset' preset you've just created.
4. The result will be that the Auto setting remains on some sliders – like checking the Auto checkbox in earlier ACR versions while the default setting remains on other sliders – like unchecking the Auto checkbox in earlier ACR versions

This can also be applied on a larger scale to all selected photos, using the Auto Tone button from the Quick Develop panel while in Grid view, followed by selecting your 'Partial Reset' preset in the same panel.

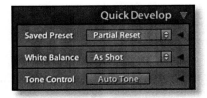

Adjusting Multiple Photos

How do I copy or synchronize my settings with other photos?

As with most things, Lightroom gives a number of different options, so you can choose the one that suits you best at the time:

Copy/Paste option

1. Adjust the first photo.
2. Ctrl-C (Windows) / Cmd-C (Mac) to copy those settings, or use the Copy... button at the bottom of the left hand panel in Develop module.
3. Move on to the target photo.
4. Ctrl-V (Windows) / Cmd-C (Mac) to paste onto the selected photo, or use the Paste button at the bottom of the left hand panel in Develop module.

Copy/Paste allows you to select which settings to copy.

Previous option

1. Adjust the first photo.
2. Move on to next photo.
3. Ctrl-Alt-V (Windows) / Cmd-Opt-V (Mac) to apply all of the settings from the previous photo, or use the Previous button at the bottom of the right hand panel in Develop module.

The Previous option copies all of the settings from the most recently selected photo (not the previous photo in the current view) to the next photo you select, with one

exception. If you are moving from a photo with no crop, to a photo with an existing crop, the crop will not be reset.

<u>Sync option</u>

1. Adjust the first photo.
2. Keeping that photo active (most-selected), select the other photos by holding down Ctrl (Windows) / Cmd (Mac) or Shift key while clicking on their thumbnails.
3. Ctrl-Shift-S (Windows) / Cmd-Shift-S (Mac) brings up a dialog so you can choose which settings to Synchronize, or use the Sync... button at the bottom of the right hand panel in Develop module to do the same.

Ctrl-Alt-S (Windows) / Cmd-Opt-S (Mac) will synchronize the settings while bypassing the dialog, or holding down the Alt (Windows) / Opt (Mac) button while pressing the Sync button to do the same. If you're bypassing the dialog, just make sure you've got everything ticked the first time as it will use the last used checkbox settings.

<u>AutoSync option</u>

The AutoSync behavior matches the behavior of ACR – when you have multiple photos selected, any slider adjustments are applied to all of the selected photos.

1. Select multiple photos.
2. Holding down Ctrl (Windows) / Cmd (Mac) changes the Sync button to AutoSync – click it once so that it remains labeled AutoSync.
3. As you adjust the photos, all of the photos will update with that slider adjustment at the same time.

4. Hold down Ctrl (Windows) / Cmd (Mac) and click again to change back to normal Sync mode when you've finished with AutoSync.

It can be confusing to switch between standard Sync and AutoSync, so you may find it easiest to leave it turned on at all times.

When you have AutoSync turned on, you can still use the keyboard shortcuts for the other sync options such as Previous, Paste or standard Sync, and these will then apply to ALL selected photos, not just active (most-selected) photo.

AutoSync can be slow for large numbers of photos, particularly when used with the Crop or Straighten tools.

What does 'Match Total Exposure' in the Settings menu do?

Match Total Exposure is intelligent adjustment of the exposure value on a series of photos. Where photos were shot in the same lighting, but on Av, Tv or P, it results in varying camera exposure settings. This command adjusts the exposure on all selected photos to end up with the same overall exposure value.

To use it, correct a single photo, then select other photos taken at the same time. In the Develop module, go to Settings menu > Match Total Exposure, and the photos will all be adjusted to match the exposure of the active (most-selected) photo, taking into account the variation in camera settings. It doesn't adjust for the sun going behind a cloud though...

Before / After Views

Can I toggle a Before / After view, like the Preview checkbox in ACR?

The shortcut you need is \ to toggle between a before/after view.

Can I see a Before / After view side-by-side?

Click the Before / After previews button in the toolbar – the one with a Y on it – for a variety of options. And logically the keyboard shortcuts are all variations on the letter Y too.

Can I change the 'Before' state to something other than the Import state?

By default, the Before view is last Read from Metadata – usually the Import state.

You can choose any history step or snapshot to be the Before view – just right-click on the history step or snapshot, and choose 'Copy History Step Settings to Before' or 'Copy Snapshot Settings to Before'.

If you want to update a whole set of photos to show their current state as 'Before', but don't want to do it by hand on every photo, there's a quick solution...

1. Go to Grid view.
2. Select the photos, and press Ctrl-S (Windows) / Cmd-S (Mac) to write the settings to metadata.
3. Once it's finished, with those photos still selected, select Metadata menu > Read Metadata from Files.
4. That automatically updates the 'Before' state to the current settings.

Can I turn off the effect of a whole panel's settings, to see the preview with and without those settings?

Most Develop panels have a switch to the left of the panel label, which allows you to temporarily disable any panel for that specific photo only, without resetting the slider values. That also now applies to the Spot Removal, Red Eye Correction, Graduated Filter and Adjustment Brush tools, which have a switch at the bottom left of the their options panel.

File Information & Panel Views

Is it possible to see camera setting information while in Develop module, rather than constantly switching back to the Metadata panel?

Just under the Histogram is always basic file information about your camera settings, which are visible whenever your mouse is not hovering over the photo itself.

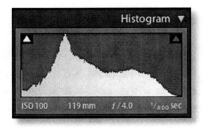

Additional information can be shown in the Info Overlay, which you show using the shortcut key I, or selecting View menu > Loupe Info > Show Info Overlay.

20060719-130516.CR2
$^1/_{800}$ sec at f / 5.0, ISO 100, 190 mm (70.0-300.0 mm)
Canon EOS 350D DIGITAL

You can select the information shown in the Info Overlay using the View menu > View Options dialog.

Histogram & RGB Values

Why does the Histogram look different when I open the exported sRGB photo in Photoshop? Why are my highlights clipping in Photoshop but not in Lightroom?

The histogram in Lightroom, and therefore the clipping, is working in the internal MelissaRGB color space, which is a much larger color space than sRGB. A color which is still within gamut in MelissaRGB may therefore have slipped out of gamut when changing to a small space such as sRGB.

To see this in practice, take one of the photos, and open it in ACR. Set the color space to the largest available – ProPhoto RGB in ACR – and look at the histogram and clipping. And now change it to sRGB and look at the histogram. Can you see how it's changed? You'll most often notice it where the red channel is close to clipping in Lightroom and then blows when you convert to a smaller color space.

Let's illustrate with this fire truck... the saturated reds make it clear to see the difference.

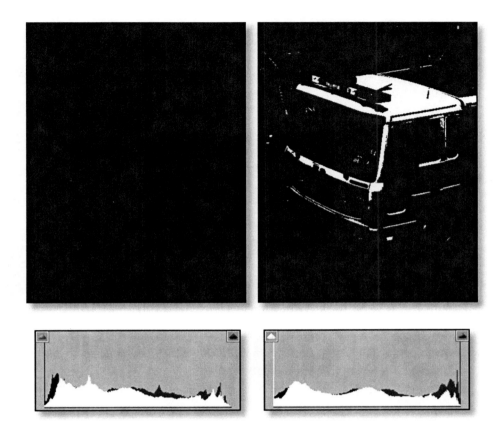

On the left, we have the ProPhoto RGB version, with clipping warnings turned on, and the image is unclipped as expected – this is very close to Lightroom's histogram.

On the right, we have the sRGB version, with clipping warnings turned on, and it's clear to see, both from the clipping warning and the histogram, that the red channel is clipped.

If you must use sRGB, just be aware that certain colors, particularly skintones on highly saturated photos, may clip when sending to sRGB, so don't push them quite as close to the end when you're editing.

Can I see RGB values as I hover over the photo?

They've moved from the toolbar below the photo in version 1, and they're now just below the histogram.

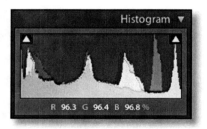

Can I change the RGB values from percentages to a normal 0-255 scale?

Lightroom works in 16-bit, and the 0-255 scale which you're used to seeing is an 8-bit scale, so it wouldn't be technically correct.

Is it possible to see clipping warnings?

The triangles in the top-left and top-right corners of the histogram turn the clipping warnings on and off, and also change color when a channel is clipped.

They are turned on and off by clicking directly on those triangles, or by using the keyboard shortcut 'J'.

Alternatively they can be accessed temporarily by holding down the Alt (Windows) / Opt (Mac) key while dragging the Exposure/Recovery/Blacks sliders.

Presets

How do I install Develop presets?

Automatic installation

1. Unzip the presets if they are zipped.
2. Go to Develop module Presets panel, right-click the User Presets folder and choose Import...
3. Navigate to the unzipped folder, select the presets and press Import.

Manual installation

1. Unzip the presets if they are zipped.
2. Find the Develop Presets folder in Explorer (Windows) / Finder (Mac).
3. Drag the presets into that folder.
4. Restart Lightroom.

 See 'The default location of the Presets is...' on page 396

How do I create my own Develop Presets?

Go into Develop module and adjust a photo to the settings you wish to save as your preset.

Press the + button on the Presets panel to show the New Develop Preset dialog.

Check or uncheck the sliders you wish to save as your preset.

If your preset is just for Calibration settings, for example, uncheck the other checkboxes, otherwise your existing slider settings will be overridden when you apply the preset.

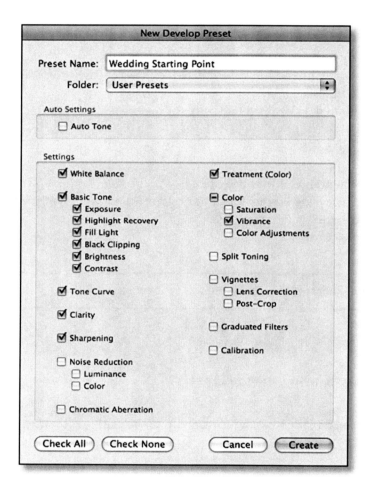

Name the preset and choose a folder, and then press the Create button.

Your preset will now appear with the others for use on any photos.

How can I organize my presets into folders or groups?

You can create folders for the presets by right-clicking on any existing preset or preset folder and choosing New Folder. Then it's simply a case of dragging and dropping the presets into your chosen folders.

You can also create and select folders at the time of creating your presets by choosing the folder from the popup menu.

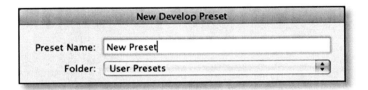

How do I rename Develop presets?

To rename a preset, go to the Presets panel, and select Rename... from the right-click menu.

Renaming the preset file manually in Explorer (Windows) / Finder (Mac) doesn't work – the preset name is embedded in the file itself. It's possible to edit the preset with a text editor, but a minor error could corrupt the preset, so be careful!

How do I remove the default Develop presets?

They're embedded in the program files – just close the folder and ignore them! It's safest not to dig around in the program files.

How do I uninstall Develop presets?

To delete a preset, go to the Presets panel, right-click on the preset and choose Delete.

You can also navigate directly to the Develop Presets folder using Explorer (Windows) / Finder (Mac) and delete/move multiple presets in one go.

Where does Lightroom store presets? Why are they not in the default location?

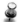 See 'The default location of the Presets is...' on page 396

If your presets aren't in the default location, it's probably because you've ticked 'Store Presets with Catalog' in Preferences > Presets panel. If your presets are stored with one catalog, they aren't available to any other catalogs.

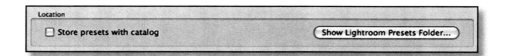

That option works well if you have a single catalog, and that catalog is used on multiple different machines, as your presets will always go with you. It's also useful if you do 3 very different styles of photography, each with their own catalog, and your presets are specific to that particular style of photography, but for most people, it's better to have your presets available globally.

Where can I download Develop presets?

There are many sources of free presets, or you can create your own.

These are the most well-known free preset websites:

http://www.inside-lightroom.com/
http://www.ononesoftware.com/photopresets-wow.php
http://www.lightroomkillertips.com/

and the Lightroom Exchange is a great place to find all sorts of new plug-ins, presets and other goodies: http://www.adobe.com/cfusion/exchange/index. cfm?event=productHome&exc=25

How do I apply a preset to multiple photos in one go?

Select all of the photos in Grid view and choose your preset from the Quick Develop panel or from the right-click > Develop Settings menu. Anything you do in Grid view applies to all of the selected photos.

If you wish to stay in Develop module, you can apply the preset with AutoSync turned on, or you can apply to one image and then use Sync to copy to the rest.

 See 'How do I copy or synchronize my settings with other photos?' on page 204

Can I apply multiple presets to the same photo, layering the effects?

If Preset A only adjusts, for example, the Exposure and Brightness sliders, and Preset B only adjusts the Vibrance slider, then they can be applied cumulatively.

If they are 'absolute' presets, i.e. they change all sliders, then the changes made by the first preset will be overwritten by the second preset.

I have some Develop presets that I use in ACR in CS3 – can I use them in Lightroom?

Lightroom's presets are saved in a Lightroom only format (.lrtemplate), so they're not directly interchangeable.

If you want to be able to use an ACR preset in Lightroom, apply that preset to a raw file, and then import that raw file into Lightroom. Once in Lightroom, save the settings as a Lightroom Develop preset for future use.

The same works in the opposite direction, sharing Lightroom presets with ACR.

Why do my presets look wrong when used on JPEG/TIFF/PSD files, even though they work on raw files?

The processing on JPEG/TIFF/PSD files is completely different from the processing on a raw file, as raw files are linear and the others are not.

Certain settings have different effects – JPEGs start at 0 for brightness and contrast and linear for tone curve, whereas raw files need 50 brightness, 25 contrast, medium tone curve etc. as a starting point.

Your best option is to create two sets of presets which give a similar result – one set for raw files, and one set for everything else.

Is there a way to add a keyboard shortcut to a preset?

No, sorry, not at the moment. You can use the Painter tool to apply Develop presets quickly though.

 See 'What is the Painter tool useful for?' on page 162

For those high volume users who are particularly keen on using keyboard shortcuts for as many commands as possible, including applying presets and other commands for which standard keyboard shortcuts are not available, you could consider RPG Keys, a commercial product designed specifically for Lightroom. I have no affiliation with the company, however it does fill a need for some users, so you can decide whether it's for you. The website is: http://www.rpgkeys.com

Defaults

Why would I change the default settings instead of using a preset?

You can set new default settings for your photos, and these will automatically apply to any newly imported photos.

The defaults can be set by camera model only, or by camera serial number/ISO combination.

 See 'Why would I want different defaults for each ISO and serial number combination?' on page 221

The default settings will also affect the settings that are applied when you press the Reset button, which applying a preset in the Import dialog does not.

How do I change the default settings?

Go into Preferences > Presets panel and decide whether you want 'Make defaults specific to camera serial number' and 'Make defaults specific to camera ISO setting' turned on or off.

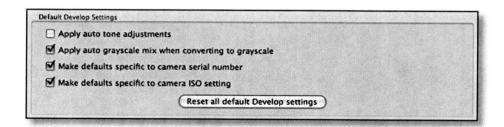

Select a photo and select your new default settings.

Go to Develop menu > Set Default Settings...

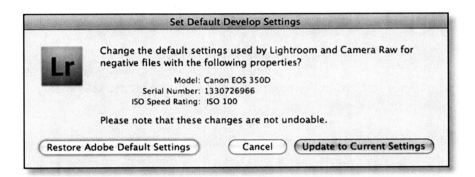

Press 'Update to Current Settings'.

Repeat with a sample photo from each camera, and each combination of ISO/Serial No if those options were selected in Preferences.

While that dialog gives the warning that the changes are not undoable, you can return to that dialog at any time to restore the Adobe Default Settings.

 See 'Why would I want different defaults for each ISO and serial number combination' on page 222

Why would I want different defaults for each ISO and serial number combination?

These are just a few examples of scenarios that may warrant different default settings:

ISO – different noise settings for different ISO ratings.

Serial number – different calibration settings for different cameras, possibly different contrast, saturation etc.

ISO & Serial Number – any combination of above.

Does changing the default settings in Lightroom affect ACR?

Yes, the defaults you set in either program are shared by both.

Snapshots

When would I use a snapshot instead of a virtual copy?

A snapshot is a special history state, which captures the slider settings at the moment of snapshot creation.

You can make changes to your photo, save it as a snapshot, make more adjustments, and then easily go back to the earlier snapshot state.

A photo can only be in a single snapshot state at any one time, and is treated as a single photo – unlike virtual copies, where each copy is treated as a separate photo. A photo with multiple snapshots will only appear as one photo in Grid view.

Snapshot states are saved in XMP, unlike virtual copies.

 See 'Why would I want to use virtual copies?' on page 173 and 'Which data is not stored in XMP?' on page 282

History & Reset

How do I reset a single slider to its default setting?

Double-click on the slider label to reset a single slider to default.

How do I reset a panel to its default setting?

Hold down Alt (Windows) / Opt (Mac) and a reset button will appear in each panel, resetting just the sliders in that panel.

How do I reset an image back to default settings?

Use the Reset button at the bottom of the right hand panel in Develop module.

If you've change the default settings, you can reset the image to Adobe's default settings by holding down shift to change the Reset button to Reset (Adobe).

 See 'Defaults' section starting on page 220

How do I reset multiple photos back to default settings? The Reset in Develop only works on one photo?

There are a few easy options, so take your pick...

- Switch back to Library Grid view, select the photos, and press the Reset All button in the Quick Develop panel.

- Switch back to Library Grid view, select the photos, right-click and select Develop Settings > Reset.

- Staying in the Develop module, turn on AutoSync, select the photos, and then press Reset.

- Still in Develop module, reset one photo, and then Sync that with the other photos.

If I don't like the last adjustment I made, can I just undo that step, rather than using Reset?

You can press Ctrl-Z (Windows) /Cmd-Z (Mac) to step back through each and every action. Be aware that it affects all actions, not just the actions to the currently selected photo, so it will step back through module changes, moving between photos, etc.

The history panel is a handy record of the changes you've made to each individual photo, so you can go back to an earlier point when you were happy with the settings.

Just click on the history state that you were happy with, and continue editing – a new history will be written from that point on, replacing the steps that followed.

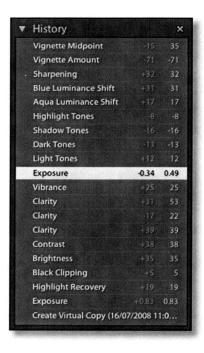

Can I undo multiple steps?

To go back to an earlier stage, simply click on the stage you were happy with, and continue working. Newer steps will be overwritten.

How long do the adjustments stay in the History panel?

It stays there for as long as the photo stays in the catalog and you don't press the Clear button (X in the corner).

Is the history saved in a sidecar XMP file?

No, history isn't saved to XMP, it's only saved in the catalog. If you remove the photo from the catalog, the history of Develop changes will be lost.

 See 'Which data is not stored in XMP?' on page 282

White Balance

Where should I be clicking with the White Balance Eyedropper?

Ideally you want to click on something that should be neutral grey (but probably isn't if the white balance is wrong).

Light grey works better than dark grey.

However, you need to be careful about this. Remember that white objects will take on a color cast if they get reflected light from another object – so a glossy white hat outdoors under a clear blue sky should probably look slightly blue, not white.

Also remember that you want to choose something bright for the best accuracy, but not so bright that any of the channels are clipped. Specular highlights (highlights with no detail) are no good either, however nice and white they look!

The White Balance Eyedropper disappears every time I click anything – how do I keep it turned on?

While you have the White Balance Eyedropper active, there's a check box for 'Auto Dismiss' in the toolbar. With that checkbox unchecked, the Eyedropper will remain on screen until you intentionally dismiss it.

If you can't see the toolbar beneath the photo, press T.

Why don't the Temp and Tint sliders have the proper white balance scale when I'm working on JPEGs?

Kelvin values wouldn't mean anything – on JPEGs Lightroom is just shifting colors from a fixed point as the white balance has already been set and applied in camera, whereas raw files can use a Kelvin scale as you are actually shifting the white balance setting.

Where have the other White Balance presets gone, such as Cloudy and Flash?

When working with raw files, there are a number of White Balance presets for coomon lighting conditions. These aren't available for other file formats, such as JPEG, as the white balance has already been set and applied in camera.

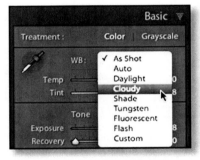 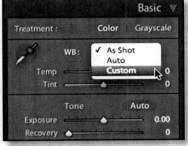

 See 'Why don't the Temp and Tint sliders have the proper white balance scale when I'm working on JPEGs?' on page 229

Why is Lightroom showing different Kelvin values than I set in my camera custom white balance?

The camera usually stores white balance values as the camera color space co-ordinates, rather than as a Kelvin value, and the resulting Temp/Tint values will depend on the profile (and raw converter) used.

The appearance of the color temperature is matched, not the numeric Kelvin value.

Other Sliders

What's the difference between Exposure and Brightness?

Exposure is a linear adjustment, lightening everything by the same amount.

Brightness lightens on a curve, preventing the highlights from clipping, and has the greatest effect on the midtones.

Generally you would use the Exposure slider to set the white point and then use the Brightness slider to adjust the midtone brightness.

Fill Light drops the contrast too far – is there an easy solution?

Use the Fill Light slider sparingly, or increase the Blacks slider to compensate – that will offset the drop in contrast without blowing the highlights, whereas increasing the contrast slider will affect the highlights too.

What's the difference between Vibrance and Saturation?

Saturation adjusts the saturation of all photo colors equally, so some colors may clip as they reach full saturation.

Vibrance adjusts the saturation on a non-linear scale, increasing the saturation of all lower-saturated colors more than higher-saturated colors. Vibrance also helps to prevent skin tones from becoming over saturated.

Why are Contrast & Brightness set to 25 & 50 by default, instead of 0?

Those are just arbitrary numbers. 25 for Contrast and 50 for Brightness has always been the default in ACR since the early releases, and that's carried over into Lightroom.

The default is 0 for JPEGs, but they've already had some processing in-camera, whereas raw files benefit from the additional contrast and brightness.

What does the Clarity slider do?

Clarity, also described as 'Punch', is an effect similar to a low-amount high-radius USM in Photoshop, adding local contrast.

As a general rule, it's best to use a low setting for portraits, as it can accentuate lines and wrinkles. Set to a negative amount, it adds a gentle softening effect, particularly useful on close-up portraits.

Clarity at 0:

Clarity at 100 (just to show the effect – you probably won't want it that high on most images!):

Clarity at –100 – the same image is used to show the difference, however negative values work best on faces:

Why doesn't the Vignette adjust to the Crop boundaries?

The original Vignette is for correcting lens vignetting, not for effect, and therefore is not affected by the cropping.

However we now also have a Post-Crop Vignette with additional options.

How do the Post-Crop Vignette sliders interact?

Screenshots are the best way of illustrating the differences, so following are a few examples of combinations of settings...

Amount logically affects the amount, with –100 being very dark and +100 being very light.

Midpoint controls how close to the center the vignette affects, ranging from 0 affecting the center and 100 barely touching the sides.

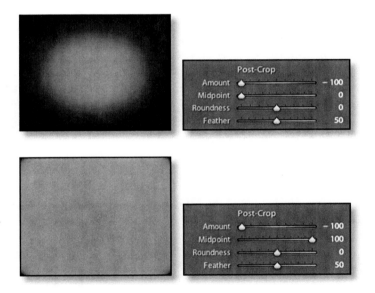

Roundness runs from −100 which is almost rectangular, to +100 which is circular.

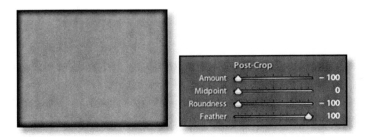

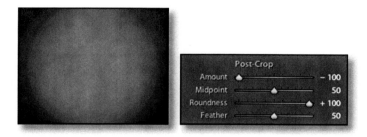

Feathering runs from 0 to 100, with 0 being no feathering at all, and 100 being very soft.

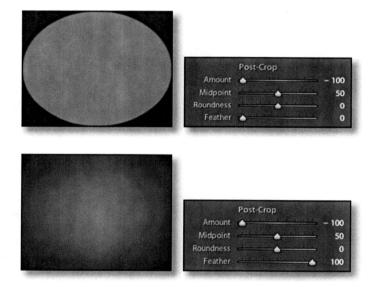

I want to use a Point Curve, but only Parametric Curves are available in Lightroom. Is it possible?

If you apply a point curve to a photo in ACR, and then import that photo into Lightroom, Lightroom can read that Point Curve and apply it correctly.

You could also save a selection of these Point Curves as presets for use on other photos too.

If you play with the little sliders at the bottom of the Parametric Curve Grid, you can change which areas are affected by your adjustments.

What do the three triangular sliders docked at the base of the Tone Curve display do?

They adjust how much of the tonal range is affected by each of the sliders for Shadows, Darks, Lights and Highlights.

Double-clicking on any of those triangular sliders resets the slider to its default position.

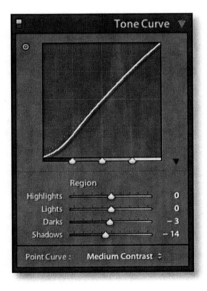

There are some hot pixels on my sensor in other programs, but I can't see them in Lightroom. Where have they gone?

Lightroom automatically maps out hot pixels, as does ACR.

Sharpening & Noise Reduction

I've turned sharpening right up to the maximum, but it doesn't seem to be doing anything – why not?

You have to zoom in to 1:1 to view the effect of the sharpening. You'll find it's the same in ACR too.

There is a small Detail Preview 1:1 view in the Detail panel, and by selecting the icon in the top left hand corner and clicking on the main preview, you can choose which part of the photo to show in that Detail Preview. This means that you can watch the 1:1 view of a particular area of the photo – perhaps an eye in a portrait – whilst viewing another area in the main preview.

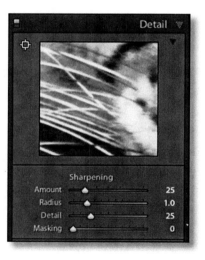

Why isn't Lightroom's Develop module sharpening very strong?

Sharpening in Lightroom's Develop module is designed to be capture sharpening, intended to offset the inherent softness caused by digital capture and the demosaicing that's done by the raw converter.

Creative sharpening is usually applied to specific parts of the photo, for example the eyes in a portrait. The Clarity slider may be described as creative sharpening, although the effect is global rather than localized. The sharpening in the Local Adjustments would also be described as creative sharpening.

Output sharpening is the last stage, depending on whether the photos will be viewed on screen, inkjet print, photographic print or a variety of other presentation options. The sharpening applied in the Export dialog or Print module would be classed as output sharpening, as it's calculated based on the output size and type.

Check Bruce Fraser's writings for more information on multiple pass sharpening.

These are just a couple of articles to get you started:
http://www.creativepro.com/article/out-gamut-two-pass-approach-sharpening-photoshop
http://www.creativepro.com/article/out-of-gamut-thoughts-on-a-sharpening-workflow

Why can't I view sharpening in Fit to Screen mode?

Develop module renders the preview on-the-fly, and therefore doesn't apply sharpening or noise reduction at less than 1:1 view, otherwise there would be a big speed hit. You have to view the image at 1:1 view to see the sharpening and noise reduction.

There's an exception to that rule. When a 1:1 preview is rendered, either by zooming in or choosing Library menu > Previews > Render 1:1 Previews, the sharpening and noise reduction are applied to that preview. If you later view that same preview in Library Loupe view at Fit to Screen, you are viewing a down-sampled version of that fully processed preview, complete with sharpening and noise reduction. Be aware that this is interpolated data though, so it's not 100% accurate.

How do the sharpening sliders interact?

Amount is quite logically the amount – like a volume control. It runs from 0–150, with a default of 25. The higher the value, the more sharpening that is being applied. You won't usually want to use it at 150 unless you're combining it with the masking or detail sliders which suppress the sharpening.

Radius affects the width of the sharpening halo, as it would for USM. It runs from 0.5–3, with a default of 1.0.

Detail allows you to suppress the halos and concentrate on edge sharpening. It runs from 0–100, with a default of 25. 100 behaves in a similar way to USM. As you increase Detail, you'll generally want to turn the Amount slider down, and vice versa. A low setting is ideal for portraits, whereas you may want a slightly higher setting for landscapes.

Masking creates a mask on-the-fly, protecting pixels from sharpening. It runs from 0–100, with a default of 0 (no masking). It's particularly good for close-up portraits, allowing higher sharpening settings for the eyes, but protecting the skin from over-sharpening.

Zoom in to 1:1 to view the effect of the sliders – sharpening doesn't show at less than 1:1.

Hold down the Alt key (Windows) / Opt key (Mac) while moving the sharpening sliders (still zoomed to 1:1) to view a grayscale mask of the effect. This can help you determine the best value for each slider individually.

Why can't I see the effects of the noise reduction?

For exactly the same reasons as you can't see sharpening until you zoom in to 1:1.

 See 'Why can't I view sharpening in Fit to Screen mode?' on page 239

Is it possible to use plug-ins such as Noise Ninja or Neat Image to reduce noise?

Develop plug-ins aren't currently possible in Lightroom, but you have a few options...

• Set the files to automatically open in Noise Ninja / Neat Image after exporting.

• Automatically run a noise reduction action using a droplet on export.

• Set standalone versions of these programs up as Lightroom's Additional External Editor.

 See 'Can I run a Photoshop Action from Lightroom?' on page 323 and 'Can I have more than 2 External Editors?' on page 292

TAT tool (Targeted Adjustment Tool)

How do I use the TAT tool?

This rather unobtrusive little tool is a real gem! Appearing in the Tone Curve, Hue, Saturation, Luminance and Grayscale panels, it allows you to directly control the sliders by dragging on the photo itself.

For example, if you select the TAT tool from the Tone Curve panel, and click and drag upwards on an area of the photo, that area will get lighter, as the Tone Curve for that particular spot on the histogram is affected.

If you prefer, rather than clicking and dragging, you can float over an area, and use the Up/Down keys to make adjustments.

Whichever your preference, this little TAT tool enables you to adjust the photo while focusing on the photo itself, rather than what the sliders are doing.

How do I turn off the TAT tool when I've finished using it?

The official shortcut is Ctrl-Alt-Shift-N (Windows) / Cmd-Opt-Shift-N (Mac) or you can just press Escape. You can also return the tool to it's usual location in each panel.

What can the TAT tool be used for?

Once you start playing, you'll find plenty of uses, however it's particularly good for adjusting grayscale photos – both the Grayscale panel sliders and also the Tone Curve.

My favorite use of the TAT tool is for a quick blue sky fix. When brightening an photo causes those beautiful blue skies and white fluffy clouds to become too light, try setting the HSL panel to Luminance, selecting the TAT tool, and dragging downwards on the blue sky. Don't go too far, as you'll start to introduce noise, but it's a very quick fix.

Cropping

Where did the Crop options go?

They've moved to the new Tool Strip under the Histogram.

Why does the crop go in the wrong direction when I try and move the grid around?

Lightroom's crop is the opposite to Photoshop's crop – it does take some getting used to, but most seem to feel it's actually better once you get used it!

Think of it as moving the photo underneath the crop overlay, rather than moving the grid. And you can turn the grid off if you are happier without it.

How do I crop a vertical portion from a horizontal photo?

Drag the corner of the crop until the grid flips over to vertical. Alternatively, unlock the ratio lock in the Crop options panel and adjust to the crop of your choice. You can also drag a crop freehand, just as you would in Photoshop.

How can I change the default crop ratio?

You can't change the default, but there are two easy workarounds:

1. Go to Grid view.

2. Select all of the photos.

3. Choose the ratio you want from the Quick Develop panel.

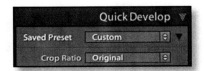

Alternatively, crop the first photo in normal Crop mode, and Synchronize that with all of the other photos.

Beware – either option will reset any existing crops.

 See 'How do I copy or synchronize my settings with other photos?' on page 204

Either way, it's intelligent enough to rotate the crop for the opposite orientation photos.

Then just go through and adjust the crop as normal.

How do I set a custom crop aspect ratio?

In the Aspect popup menu, which you'll find in the Crop options under the Tool Strip, you can select Enter Custom... and choose your own fixed crop ratio, or you can unlock the crop ratio to draw a custom crop by clicking on the padlock icon.

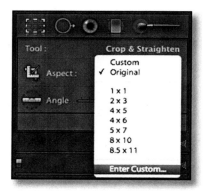

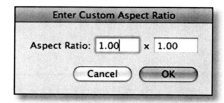

How do I delete a custom crop aspect ratio?

You can't delete them manually, but they work on a rolling list of 5, so only your most recent 5 custom ratios remain in the list, and as you add a new one, the oldest one is removed from the list.

How do I set my crop grid back to thirds or bring the Crop Overlay back when it goes missing?

Press O to cycle through a variety of useful (and slightly unusual!) overlays.

Is it possible to change the Crop Overlay color?

No, but you can enter Lights Out mode (press L twice) to get a better view of the crop as you adjust it. Keep pressing L until you get back to normal.

How do I straighten a photo?

1. Select the Crop tool from the Tool Strip, or use the keyboard shortcut R.

2. Select the Straighten tool from the Crop options panel under the Tool Strip.

3. Click on the horizon and drag along the line of the horizon.

4. Lightroom will automatically rotate the photo to straighten the horizon line you've just drawn.

If you prefer, you can manually adjust the degree of rotation by moving the Straighten slider in the Crop options panel, perhaps in conjunction with the Overlay Grid.

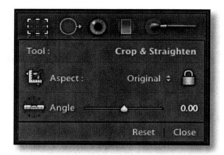

Alternatively, as you hover around the outside edge of the crop boundary, the icon will change to a curved double-headed arrow, showing that you can drag to rotate up to 45 degrees in either direction.

Can a crop be saved in a preset?

No – but why would you want to?

Is there a way to see what the new pixel dimensions are (without interpolation) of a cropped photo before it's exported?

Go to View > View Options... and you can set the Info Overlay (press I in Loupe or Develop mode) to show 'Cropped Dimensions' which is the cropped pixel dimensions without any resampling.

The problem with that is it isn't real-time – you have to switch between photos before it will update.

Red Eye Reduction Tool

How do I work the Red-Eye Reduction tool?

Drag from the centre of the eye, to encompass the whole eye. It will automatically search for the red eye within that area.

Lightroom's Red Eye Reduction tool can't lock on to the red eye - is there anything I can do to help it?

Try temporarily increasing the red saturation in the HSL panel and try again. Once it locks, you can set the HSL back to normal.

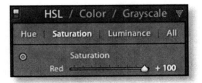

Why doesn't the Red Eye Reduction tool work properly on my dog's red eye?

Animals have different colored red-eye, so it doesn't find the red it's looking for.

Spot Removal – Clone/Heal Tools

How do I adjust the cursor/brush size?

In the Spot Removal options panel under the Tool Strip is a brush size slider, or you can use the [] keyboard shortcuts or your mouse scroll wheel to adjust the size.

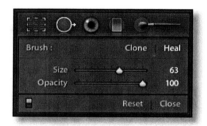

How do I adjust the size of an existing spot?

Hover over the edge of an existing spot and the cursor will change – you can then drag that edge to adjust the size. Alternatively you can select the spot by clicking on it and then adjust the slider in the Spot Removal options panel.

How do I adjust the opacity of an existing spot?

Click on the spot to select it, and then adjust the Opacity slider in the Spot Removal options panel.

How do I move an existing spot?

When you hover over the center of an existing spot, the cursor will change – you can then drag to move the spot.

How do I delete a spot?

Click on the spot to make it active, and press the Delete key on your keyboard.

Can I copy or synchronize the clone/heal spots?

You can copy or synchronize clone/heal spots in the same way as you synchronize any other settings.

 See 'How do I copy or synchronize my settings with other photos?' on page 204

This is particularly useful when using the spot tools to remove sensor dust in a clear area of sky – the Synchronize command is intelligent enough to adjust for orientation.

Local Adjustments – Graduated Filter & Adjustment Brush

How are the Local Adjustments different from Lightroom's other controls?

Most of Lightroom's controls are global – they affect the entire photo. The Local Adjustments allow you to paint a mask on the photo, either by means of a brush or gradient, and apply adjustments just to that masked area.

What effects are available in the Local Adjustments?

The Local Adjustments can make localized changes to Exposure, Brightness, Contrast, Saturation, Clarity, Sharpness, or apply a Color Tint.

For example, making use of the Exposure adjustment is similar to dodging and burning in Photoshop or in a traditional darkroom. Settings such as Sharpness and Clarity are ideal for retouching portraits. Color is useful when adjusting for mixed lighting situations. Settings can be combined, so a combination of perhaps Exposure, Saturation and a blue tint can make a dull sky much more interesting.

Why would I use the Graduated Filter & Adjustment Brush rather than editing a photo in Photoshop?

When you edit a photo in Photoshop, you have yet another large photo file to store, whereas using Lightroom's Local Adjustments stores the adjustment information non-destructively in metadata. That leaves you with a tiny amount of text information which is stored as part of the catalog, and you can always go back and change your adjustments without damaging the original file.

This doesn't mean that Lightroom entirely replaces Photoshop – there are still many pixel based adjustments that would require Photoshop – however it does mean that you can make many more adjustments within Lightroom's own interface and save them non-destructively without vast storage requirements.

What does the Amount slider do?

Amount increases or decreases the strength of the adjustments on the selected mask.

For example, the following screenshots show the Amount set to Exposure. +4.0 brightens the exposure by +4.0 as in the white screenshot, +1.0 brightens the exposure by +1.0 as in the grey screenshot, and –4.0 darkens the exposure by –4.0, as shown in the black screenshot.

Chapter 5: Develop Module

If you switch back to button mode, having made adjustments to multiple sliders in slider mode, and then adjust the Amount slider, all of the sliders will be adjusted by the same percentage of change. When applied to multiple sliders, you could call it a 'Fade' slider. You can access the same Amount control without having to switch back to button mode – simply click on the pin and drag left and right and you'll see all of the sliders move.

How are the buttons different from the sliders?

Using the toggle switch to the right of the presets popup menu, you can switch between a basic button mode and a more advanced slider mode.

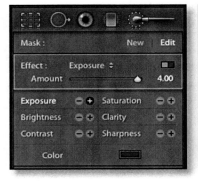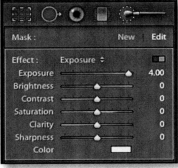

When using the buttons, adjustments can only be made to a single highlighted slider, and the +/− buttons toggle between the last two slider settings used on that effect.

The advanced slider mode allows a greater level of control, allowing you to apply a combination of adjustments to the same mask.

How do I create a new brush mask?

When you select the Adjustment Brush, it will automatically be ready to start a new mask. Select your brush characteristics and the effect you wish to apply and simply start painting!

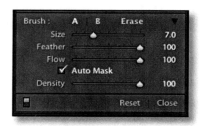

In some cases, you may find it helpful to paint with the effect setting turned up higher than usual, or with the mask overlay turned on, in order to clearly see where you're painting. Holding down the Shift key whilst you paint will draw the stroke in a straight vertical or horizontal line.

 See 'How do I show the mask I've created?' on page 263

What do Size and Feather do?

Size logically affects the size of the brush, and feather is the hardness of the brush edge.

You can see the effect of the feathering set to 0 (top, hard), 50 (center), and 100 (bottom, soft).

The brush cursor changes depending on the size of the brush and the amount of feathering, with the cursor on the left showing feathering at 0, and the cursor on the right showing the same size brush but with the feathering setting at 100.

You can also use the [and] keys to increase and decrease the size of the brush, and Shift-[and Shift-] keys to increase and decrease the feathering.

What's the difference between Flow & Density?

Flow controls the rate at which the adjustment is applied.

With flow at 100, the brush behaves like a paintbrush, laying down the maximum effect with each stroke. You can see this in the screenshot, where the effect is applied equally with each stroke.

With flow at a lower value such as 25, the brush behaves more like an airbrush, building up the effect gradually. Each stroke adds to the effect of the previous strokes, giving the effect shown in the screenshot, where areas that have multiple brushstrokes are stronger than those with a single stroke.

Density controls the maximum strength of the stroke. Regardless of how many times you paint that stroke or the settings used, it can never be stronger than the maximum density setting. In the screenshot, the top line – the one that you can't see – is set to 0. The center line is set to 25 and the bottom line is set to 100.

To fully understand these controls, try creating a single 50% grey file and testing different combinations of sliders – it's easier to see the differences when you're not distracted by a photo.

Is the Adjustment Brush pressure sensitive when used with a graphics pen tablet?

Yes, the pressure sensitivity on your graphics pen tablet controls the opacity of the stroke.

What does Auto Mask do?

Auto Mask confines your brush strokes to areas of similar color, helping to prevent your mask spilling over into other areas of the photo.

How do I reselect an existing mask?

The mask pins have 2 states – selected or not selected.

Not selected is shown by a white pin, and clicking on the pin will select that mask, turning the pin black.

Where have my mask pins gone?

Under View menu > Tool Overlay, you have the option to 'Auto Show' which only shows the pin when you float nearby, as well as 'Always Show', 'Show Selected' and 'Never Show'.

The H key hides the pins, so press H again to return them. It toggles between 'Auto Show' and 'Never Show'.

How do I add to an existing brushed mask?

If you select an existing pin, the Adjustment Brush options panel will automatically switch into Edit mode and you can make additional brush strokes, erase existing brush strokes, and adjust the effect.

How do I erase from an existing brushed mask?

When you are editing any brushed mask, you can select the Erase tool in the Brush Settings panel and erase existing brush strokes.

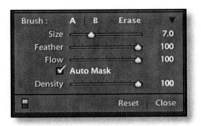

You can temporarily switch to the Erase tool by holding down the Alt (Windows) / Opt (Mac) button while you paint.

How can I tell whether I'm creating a new mask or editing an existing mask?

When you select the Adjustment Brush or Graduated Filter tool, Lightroom will automatically be ready to start a new mask – to edit an existing mask you must first click on the mask pin.

You can check whether you're in New or Edit mode by looking at the Adjustment Brush options panel or checking which pin is currently selected.

How do I create a new gradient mask?

When you select the Graduated Filter tool, it will automatically be ready to start a new mask. Select the effect you wish to apply, click at your gradient starting point, and drag to your gradient end point.

Having created the gradient, you can go back and adjust both the rotation and length of the gradient, as well as the effect that you're apply.

How do I adjust an existing gradient?

Re-select the gradient using the pin, just as you would with a brush mask. The gradient lines will appear, allowing you to make adjustments. You'll find you have more control if you move to the outer ends of the lines.

When you float over the central line – the one with the pin – the cursor will change to a double-headed arrow, enabling you to adjust the rotation of the gradient.

When you float over the outer line – the one without the pin – the cursor will change to a hand tool, enabling you to adjust how far the gradient stretches.

How do I show the mask I've created?

Making sure the mask is selected, press the O key to toggle the mask overlay on and off, or float over the pin and the mask overlay will appear.

Can I change the color of the mask overlay?

Press O to first show the overlay, and then Shift-O will cycle through a series of different overlays (red, green, lighten and darken) until you find an overlay that can be clearly seen against your photo.

Can I fade the effect of an existing mask?

If you reselect the existing mask by clicking on its pin, you can change any of the sliders.

If you've used the advanced slider mode to combine different sliders, the Amount slider in button mode will behave like a 'Fade' slider, reducing the effect of all of the sliders by an equal percentage.

 See 'What does the Amount slider do?' on page 254

Can I layer the effect of multiple masks?

You can create as many different masks as you like, and they can be overlapped and layered, with the effect being cumulative.

Can I invert the mask?

Not at the moment, however you can use a large brush to paint over everything, and then use a small brush to erase from that mask.

Can I synchronize my settings with other photos?

You can copy or synchronize Local Adjustments in the same way as you synchronize any other settings.

 See 'How do I copy or synchronize my settings with other photos?' on page 204

Troubleshooting

I've somehow removed the toolbar with the Crop/Red Eye Reduction/Spot Removal tools from the Develop module and can't find a way to get them back where they should be. Help?

You can press T to get the Toolbar back... however in version 2, the Crop, Red Eye Reduction and Spot Removal tools have moved up to the Tool Strip just beneath the histogram, along with the new Local Adjustment tools.

Raw File Rendering & DNG Profile Editor

Raw File Rendering

Why do my photos change color? When the first preview appears, it looks just like it did on the camera, and then that disappears and it applies other settings. How do I turn that off?

The initial preview you're seeing is the JPEG preview embedded in the file by the camera. That JPEG preview has the manufacturer's own processing applied in-camera, just as if you'd set your camera to shoot a JPEG rather than a raw file format.

A raw file is not a photo file like a JPEG or a TIFF. You can't look at it – there's nothing to see. You need some software to process it into a photo.

The camera manufacturer's don't share their processing secrets, so each raw converter creates its own interpretation of the sensor's data. There is no right or wrong – it's just different.

So how do you get your file in Lightroom to look like that original camera JPEG preview?

In version 1, your best option was to shoot a series of files as Raw+JPEG, and import all of those files into Lightroom. Try to adjust each raw file to look like the matching JPEG file. Your aim is to find your ideal default settings for your raw files. Having found your ideal settings, save them as a Develop preset for easy application to your photos, and or update Lightroom's default settings to use your new preferred settings.

 See 'How do I change the default settings?' on page 220 and 'Lightroom is changing the colors of my photos... what could be happening?' on page 107

However it gets better than that... Adobe have been listening to the user's cries, and have created a new profiling system, the public beta for which was released at the same time as Lightroom 2.0.

This new DNG Profile Editor allows the creation of much more detailed profiles than have ever been available to ACR and Lightroom before.

 See 'DNG Profile Editor' section starting on page 272

Whilst most users will never worry about creating their own profiles, Adobe have created ready-made profiles to emulate the most popular in-camera JPEG rendering for many Pro-level SLR's, and contrary to the way the name makes it sound, these profiles can be used on proprietary raw files as well as DNG files.

 See 'New Adobe Standard & Camera Style Profiles' section starting on page 270

I set my camera to black and white. Why is Lightroom changing them back to color?

Only the manufacturer's own software, or those using the manufacturer's SDK, can read the in-camera settings.

The only parameter that is recognized and interpreted by all converters is white balance. i.e. if you had set your camera to 'Cloudy' and have your converter's white balance set to 'As Shot' it would use the white balance set in the camera, however this is also an interpretation by the software's programmers.

 See 'Why is Lightroom showing different Kelvin values than I set in my camera custom white balance?' on page 230

How do other programs like iView, PhotoMechanic, Apple's Preview, Windows Explorer, Breezebrowser etc. get it right?

They're reading the embedded preview which is embedded in every raw file, or they're using the manufacturer's SDK.

While Lightroom could use the manufacturer's SDK rather than its own ACR engine, it would only have basic controls, and it wouldn't be possible to add the other tools that we now have available in Lightroom.

My Canon raw files exhibit an odd shift particularly in the red tones – can I fix this?

This is due to excess infrared and the difference between how digital cameras seen deep red compared to the human eye. A camera simply sees the world differently from humans.

As a result, the standard profiles for ACR are shifted from technically perfect color to a more pleasing color.

Many people looking for a more technically correct color have played with the Calibration sliders, resulting in a different look.

Calibration scripts such as those created by Thomas Fors, Simon Tindeman and Rags Gardner would fall into this category, however this can't be corrected completely using a simple calibration.

All is not lost though – the new DNG Profile Editor allows for extremely complex profiles to be created, adjusting for this issue, amongst others.

 See 'DNG Profile Editor' section starting on page 272

Adobe have used the new DNG Profile Editor to create camera emulation profiles for the most popular DSLR's, which have been released as a public beta at the same time as Lightroom 2.0 final release. These, even at default settings, provide a very close match to the in-camera JPEG rendering, and can be downloaded free of charge.

 See 'New Adobe Standard & Camera Style Profiles' section starting on page 270

New Adobe Standard & Camera Style Profiles

What do the new profiles do?

The Adobe Standard profiles are an alternative to the existing ACR 4.4 and other profiles.

The Camera Style profiles emulate the manufacturers own standard rendering and Picture Styles, giving a very close match to a camera JPEG file.

Where do I download the profiles?

The profiles have been released as a public beta at the same time as Lightroom 2.0 was released.

You can download them from the Adobe Labs website at:
http://labs.adobe.com/wiki/index.php/DNG_Profiles

How do I install the profiles?

The new Adobe Standard and Camera Standard profiles are provided as a full program installer which automatically installs the profiles to the correct location.

Restart Lightroom to make the profiles available.

How do I use the profiles?

Once installed, the profiles appear in the Profile popup menu in the Camera Calibration panel.

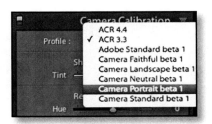

Which are the profiles for my camera?

Any of the profiles in the Profile popup menu are the correct profiles for your camera – it won't show you profiles for other cameras.

Why does my Nikon D300 have D2X profiles?

That simply refers to the D2X style, not the camera of the same name. It's Nikon's naming convention.

DNG Profile Editor

What's the purpose of the DNG Profile Editor?

Everyone has their own preferences on raw conversion – some like the manufacturer's own rendering, others like a variety of raw converters. Often you hear people say "I prefer the colors from XXX raw converter" or "Why doesn't my raw file look like the camera rendering?"

Until now, there was no way of accurately replicating a look from another manufacturer. That changes today!

Using the DNG Profile Editor, it's possible to create complex profiles that simply weren't available until now.

It's now possible to closely match the color rendering of any camera manufacturer or raw converter using Lightroom, whilst enjoying all of the other tools that Lightroom has to offer.

Why is this DNG Profile Editor better than the Calibration sliders?

The calibration sliders didn't allow for different adjustments for different saturations of the same color, so when you adjusted, for example, the reds, you affected all of the reds in the photo. The new DNG Profile Editor allows you to separate those saturation ranges, adjusting each in a different direction.

For example, reds with low saturation values, such as skin tones, may be too red and the reds with high saturation values, such as a fire truck, may be too orange. That couldn't be corrected with any combination of the previous sliders, and yet can be easily adjusted with the new DNG Profile Editor.

Can I use the profiles on proprietary raw files, not just DNG?

It's called the DNG Profile Editor because the profile format is described in the new DNG specification. The DNG Profile Editor itself will be restricted to reading DNG files, however the resulting profiles can be used on any raw file format.

Why doesn't it use ICC profiles?

In short, these new profiles are much newer technology than ICC profiles, and offer a better result.

These profiles are much smaller than full ICC profiles, allowed multiple profiles to be embedded in DNG files without noticeable file size increases, which would quickly add up over a volume of files.

The profiles also allow two calibrations to be included, interpolated by color temperature, which ICC profiles can't do.

What does the DNG Profile Editor look like?

These are the panels of the DNG Profile Editor beta, released at the same time as Lightroom 2.0.

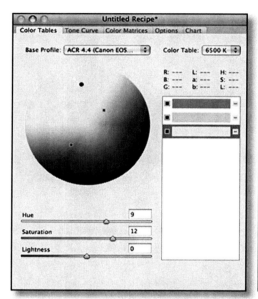

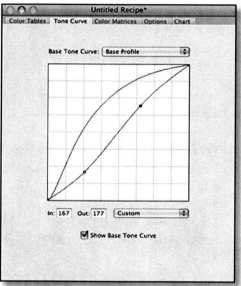

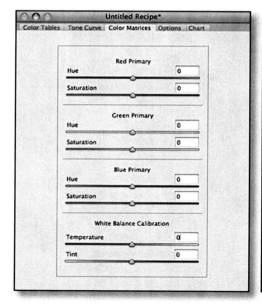

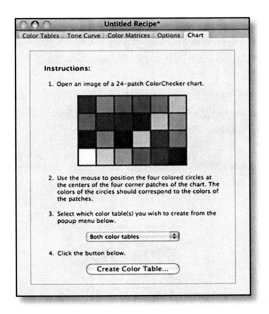

Where do I download the DNG Profile Editor?

The DNG Profile Editor was released as a public beta at the same time as Lightroom 2.0 final release.

You can download it from the Adobe Labs website at: http://labs.adobe.com/wiki/index.php/DNG_Profiles:Editor

How do I use the DNG Profile Editor? It looks complicated!

Adobe isn't expecting most users to use the DNG Profile Editor to create their own profiles. The facility is available for those who do wish to use it, and those users will no doubt share or sell their profiles to other users.

There's a comprehensive tutorial with the download, so we'll just go through the basic idea, and a few extra tips:

Correct the white balance before you start, if you haven't already – a right-click switches from a standard Eyedropper to the White Balance Eyedropper, and the white balance values will be shown in the photo window title.

Create color control points by clicking on the photo. You can use color control points to fix specific colors to stop that color from changing, as well as creating color points to shift the colors.

The color control points then appear in the Color List Box to the right of the Color Wheel.

The checkbox to the left of your new color rectangle enables and disables the adjustment, showing as black when enabled. It's useful for previewing the changes.

The – icon to the right of the color rectangle removes that color control point, as does Alt-clicking (Windows) / Opt-clicking (Mac) on the color control point on the Color Wheel. You can select a different color control point by either clicking directly on the point on the Color Wheel, or by clicking on the color rectangle in the Color List.

Adjust the sliders below the Color Wheel, and you'll see the photo preview update live based on your adjustments. You'll also see the color rectangle in the Color List Box split in half, showing the before and after color.

In addition to adjusting the colors on the Color Wheel, you can also adjust the other panels such as the Tone Curve. The Tone Curve adjustments will be relative to the base tone curve you select. You won't usually need to use the Color Matrices panel.

A few other quick hints:

1. You can have multiple photos open at the same time, and they'll all update, so you can see how your changes will affect a variety of different photos.

2. If you have multiple photos from different cameras open at the same time, both photos will still update based on your current profile settings. You can save the profile for use with both cameras – the File menu > Export Profile... command is updated to the name of the currently selected photo (i.e. Export Canon EOS 5D Profile...)

3. You can load any other profile as a starting point, including the camera emulation profiles, and then tweak to your taste, or you can start from a blank canvas. To load another profile as a starting point, select your profile from the Base Profile popup menu, and all adjustments will be made relative to that profile.

4. Using the Chart tab, you can run an automatic profile creation, which replaces the calibration scripts you may have used with earlier ACR versions. The settings created automatically from your 24-patch ColorChecker Chart will appear as if you'd created the color control points manually. You can either accept these adjustments and save the profile, or you can go on to tweak further. It also

allows you to shoot 2 different lighting conditions (2850K and 6500K) and create a single profile with both sets of adjustments, ready for interpolation between the two.

Once you've finished, save your Profile Recipe by selecting File menu > Save Recipe... That doesn't create the profile – it just saves your current list of changes so that you can come back and change it again later without having to start again.

When you're ready to save your profile, use File menu > Export Profile... Profiles will be saved with a .dcp extension, and are usually camera–specific.

Save the profile into the Camera Profiles directory. You'll need to restart Lightroom/ ACR before the new profile will be available.

 See 'The default location of the Adobe Camera Raw Profiles is... on page 397 and 'Your custom Camera Raw Profiles can also be installed to the User folders...' on page 397

Calibration

I have old calibration settings in ACR which I'd like to use in Lightroom. How do I import them?

Apply those calibration settings to a raw file, and then import that raw file into Lightroom, or you could just write them down and apply them to a photo in Lightroom manually.

Once applied to a photo in Lightroom, save the settings as a Lightroom Develop preset for future use.

You can apply that preset in the Import dialog or update the default settings if you wish to automatically apply them.

See 'Presets' section starting on page 213 and 'Defaults' section starting on page 220

If you're feeling adventurous, those old calibration settings can be converted into a full profile using the DNG Profile Editor.

See 'DNG Profile Editor' section starting on page 272

The ACR version number in the Calibration section is an old version – how do I update it?

Older numbers, such as 3.1, are the version of ACR that was current when the camera support was officially released.

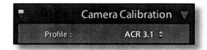

If there's a newer version listed in the Calibration Profile popup menu, you can select that instead, however be aware that your Develop settings may render differently with the alternative Camera Profiles.

If you've installed the new camera profiles, you will have a choice of profiles in that popup menu.

 See 'New Adobe Standard & Camera Style Profiles' section starting on page 270

XMP & ACR Compatibility

XMP

What is XMP?

XMP is either a sidecar file for a proprietary raw file, or a section in the header of JPEG, TIFF, PSD or DNG files. It holds data such as Develop settings, star ratings, color labels, and keywords, amongst other things.

How do XMP files relate to the catalog?

All of the adjustments you make in Lightroom are stored in the catalog – a database.

That database is always assumed to be correct, whether XMP files exist or not.

When reading from XMP, you are updating that database with the information from the external XMP file.

Why would I want these settings written to XMP?

Any changes you make in Lightroom are stored within Lightroom's catalog. This means that the changes are not available to other programs such as Bridge. In order to make the changes available to other programs, you need to write to XMP.

 See 'How do I write settings to XMP?' on page 283

This XMP data can be used as an additional backup of settings in case your Lightroom catalog becomes corrupted. It can also be used to transfer settings between catalogs. Please note that certain information is not stored within XMP though.

 See 'Which data is not stored in XMP?' on page 283

Which data is not stored in XMP?

Flags, virtual copies, collection membership, Develop history, stacks, Develop module panel switches and image pan positions are not stored in the XMP.

Where does Lightroom store the XMP sidecar files?

XMP sidecar files are placed in the same folder as the raw files.

Where are the XMP files for my JPEG/TIFF/PSD/DNG files?

The XMP for JPEG/TIFF/PSD/DNG is written to a section in the header of the file itself. Changes don't affect the image data, and therefore it doesn't degrade the quality of the photo, even when writing every time the metadata changes.

In Lightroom beta versions prior to the 1.0 release, XMP data was written to sidecar XMP files for JPEG/TIFF/PSD files, however this data could not be read by any other programs. The standard for interchangeable metadata is that it's written back to the original file, and Lightroom follows that standard in the release versions.

How do I write settings to XMP?

Select the files in Grid view and press Ctrl-S (Windows) / Cmd-S (Mac) to write to XMP, or go to Metadata menu > Write Metadata to Files.

You can also turn on 'Automatically write changes into XMP' in Catalog Settings, which will update the XMP every time a change is made to the photo.

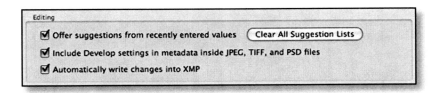

Should I turn on 'Automatically write changes into XMP'?

There is an argument for leaving auto-write turned on, however there is a slight performance hit due to the constant disc writes every time you make changes to a photo. That said, it's much less noticeable than it was in early releases.

If you do decide to turn it on, a few suggestions:

- Making changes to large numbers of photos (i.e. thousands) may be noticeably slower with auto-write turned on, due to the sheer volume of individual files that need to be written.

- Avoid turning auto-write off and on again too often, as every time you turn it on, it has to check every file for changes.

- When you first turn auto-write on, performance may drop considerably while it writes to XMP for all of the photos in the catalog. Once it's finished doing so, it should speed up again, so you're best just to leave it to work for a while.

If you do find it slows you down, particularly on older hardware, then consider the alternative – when you finish a session, simply go to All Photographs, select all of the photos in Grid view and manually write to XMP. It will only update the XMP that has changed.

What's the difference between 'Write Metadata to Files' and 'Update DNG Preview & Metadata'?

In the Metadata menu for DNG's are 2 different write options.

'Save Metadata to File' just updates the XMP metadata, as it would with any other kind of file.

'Update DNG Preview & Metadata' does the same, but it also updates the embedded preview, so that viewing the file in other programs will show the preview with your Lightroom adjustments applied.

While updating the DNG Preview, can I change the size?

Using the 'Update DNG Preview & Metadata' command will also update the size of the embedded preview if you've changed it in Preferences > Import panel.

Should I check or uncheck "Include Develop settings in metadata inside JPEG, TIFF, and PSD files"?

There's an extra option in Catalog Settings > Metadata panel with regard to XMP.

Editing
- ☑ Offer suggestions from recently entered values [Clear All Suggestion Lists]
- ☑ Include Develop settings in metadata inside JPEG, TIFF, and PSD files
- ☑ Automatically write changes into XMP

It controls whether Lightroom writes your Develop settings to the XMP metadata section when it writes the other metadata.

It was originally designed to stop Bridge CS3 from opening those files in ACR, although both Bridge and Photoshop now have a switch to prevent that now too.

Personally, I'd leave it turned on in case your catalog ever becomes corrupted – you can read back your adjustments from the XMP data as you would with raw files and their XMP sidecars.

Can I view the content of my XMP sidecar files?

XMP files will open in any text editor in a readable format – just be careful that you don't corrupt them accidentally while editing.

XMP has been updated on another program or computer. Why don't the changes show in Lightroom?

Lightroom will always assume its own catalog is correct.

If you want to force it to read the data from the XMP, go to the Metadata menu > Read Metadata from Files. It will ask you to confirm:

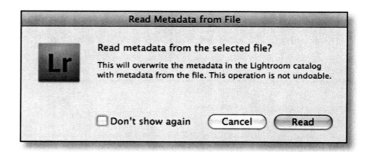

It should also show a 'metadata dirty' icon, showing that the metadata in the XMP is newer than Lightroom's own data.

 See 'What do the different metadata icons on the thumbnails mean?' on page 108

Clicking on this icon will request confirmation:

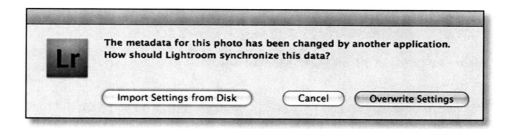

'Import Settings from Disk' – replace Lightroom's data with the external XMP metadata

'Cancel' – don't do anything

'Overwrite Settings' – replace the external XMP metadata with Lightroom's data
Does that mean it's possible to share settings between computers using XMP?
It's basic at best, but yes.

 See 'Is it possible to use XMP files to allow some degree of sharing across the network?' on page 74

ACR

What is ACR?

ACR is the Adobe Camera Raw plug-in for Adobe Bridge and Photoshop, which allows those programs to read raw file formats.

Updates are released on a regular basis, usually at the same time as a Lightroom update.

If I use ACR to convert, having created XMP files, will the result be identical to Lightroom?

If you are using a fully compatible version, the results will be identical. It uses exactly the same processing engine.

Which ACR version do I need for the settings to be fully compatible?

For full compatibility, you need a version released at the same time, or newer.

For example, you'd need Lightroom 2.0 and ACR 4.5 (CS3) or newer.

Newer ACR versions are backwards compatible, so using ACR 5.0 (CS4) with Lightroom 1.4.1 or 2.0 will be fine.

Not all of Lightroom 2.0's new controls are available in the ACR interface for ACR 4.5, but where Lightroom settings for those controls are found in the XMP, those settings will still be applied correctly as the 2 are fully compatible. The interface for the additional controls will likely to be added in CS4.

Which settings are not backwards compatible for CS2?

If you're still using CS2, there is SOME compatibility with ACR 3.7.

ACR 3.7 in CS2 will be able to read any sliders you can see in ACR 3.7 plus the highlight recovery and fill light settings which don't have sliders.

If you've used any of the other new sliders or controls, it will just ignore those settings, which could result in a different appearance.

You'd also need to set the Lightroom calibration profile to one of the earlier options (i.e. not 4.4 or the new emulation profiles) for files to render identically. This can be found in the Develop module > Camera Calibration panel.

Errors

Lightroom throws an error saying it can't write to XMP – how do I fix it?

Check your operating system for the folder and file permissions – it's most likely that those files are read-only.

I deleted the XMP sidecar files and now Lightroom won't write new ones – how do I force it to write them?

If Lightroom thinks that it's already written an up-to-date XMP sidecar file, it won't write to XMP again, so we need convince it otherwise.

Select the files in Grid view, and press one of the Quick Develop buttons, or make another change that you can easily undo.

With the files still selected, force it to write to XMP by using Metadata menu > Write Metadata to Files, or the shortcut Ctrl-S (Windows) / Cmd-S (Mac).

Now press the opposite Quick Develop button, or otherwise undo the change you made to the files, and write the metadata to the files again, this time with the correct information.

Export & Editing in Other Programs

Editing in Other Programs

What's the difference between Export and Edit in...?

Export creates a file in the location of choice, and additional actions can be run on those files by means of Export Plug-ins.

Edit in... opens the file into the image editing software of your choice, such as Photoshop. It can open the file directly into CS3 10.0.1 with ACR 4.5 or later, or by means of an interim TIFF or PSD file for other software. The resulting files will automatically be stacked with the original.

Export is more often used on a large number of photos, whereas Edit in... is more often used on single photos.

How do I change my Edit in… file settings?

External Editing settings are chosen in the Preferences > External Editing panel. In that dialog you choose file format, color space, bit depth, resolution and compression, as well adding additional External Editors.

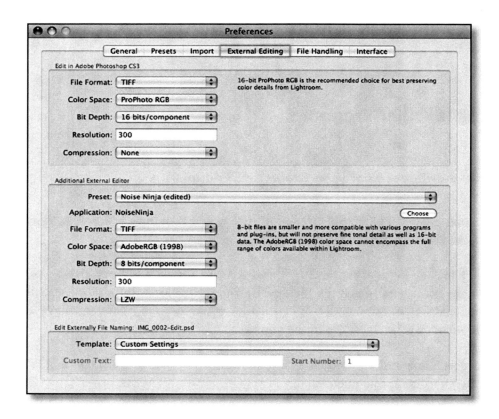

Can I have more than two External Editors?

While there are still two main External Editors, you can now create additional presets using the same Preferences > External Editing dialog.

Choose your settings in the Additional External Editors section, and then select 'Save Current Settings as New Preset' from the Preset popup menu. You can create as many presets as you like, and they will appear in the menu for Edit in...

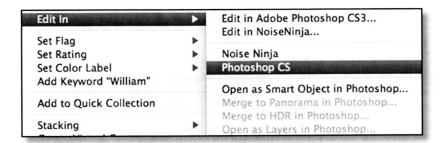

The preset you currently have selected in the Preferences > External Editing dialog (Noise Ninja in our screenshots) will become the main Additional External Editor shown at the top of the list and assigned the secondary keyboard shortcut which is Ctrl-Alt-E (Windows) / Cmd-Opt-E (Mac).

What do the new options in the Edit in... menu do?

In version 1.x, each time you used the Edit in... command, an interim PSD or Tiff file would be created – you couldn't open directly into Photoshop.

As of version 2, you can now open the file or multiple files directly into Photoshop CS3 10.0.1 or later without first saving an interim file.

> Open as Smart Object in Photoshop...
> Merge to Panorama in Photoshop...
> Merge to HDR in Photoshop...
> Open as Layers in Photoshop...

Open as Smart Object in Photoshop does exactly what it says. In the case of a raw file, this means that you can go back and edit the raw file settings in ACR, however remember that those Develop settings will not be updated in your Lightroom catalog.

Merge to Panorama in Photoshop only becomes available when you have multiple photos selected. It opens the files directly into the File > Automate > Photomerge dialog in Photoshop.

Merge to HDR in Photoshop also only becomes available when you have multiple photos selected. It opens the files directly into the File > Automate > Merge to HDR dialog in Photoshop.

And finally, Open as Layers in Photoshop also only becomes available when you have multiple photos selected. It opens the files directly into Photoshop and places those photos into a single file as multiple layers.

Why can't I access the new options in the Edit in... menu?

The new options require Photoshop CS3 version 10.0.1 or later for compatibility, and won't work with earlier versions.

 See 'Which ACR version do I need for the settings to be fully compatible?' on page 288

Can I open a raw file directly into ACR without creating an interim file. Is it possible?

You can't open into ACR directly, but then, why would you want to, as almost all of the controls are available in Lightroom anyway.

If you do want to open into ACR, you have a couple of options. You can select the file and press Ctrl-S (Windows) / Cmd-S (Mac) to save the settings to XMP. Having done so, you can either browse to the file in Bridge or Photoshop and open in those programs, or right-clicking on the file in Lightroom and choosing Show in Explorer (Windows) / Finder (Mac) will take you directly to the file for you to double-click to open in Photoshop, saving you browsing to find it.

If you have CS3 10.0.1 and ACR 4.5, you can use 'Open in Photoshop as Smart Object' and then double-click on the Smart Object to open that into ACR. Be aware that any Develop settings you change will not be reflected in Lightroom if you do that though.

If you have Photoshop CS3, you can open a raw file directly into Photoshop, bypassing the ACR dialog, by using Edit in Photoshop. For this to work correctly, you must be using Photoshop CS3 10.0.1 or later, with ACR 4.5 or later.

 See 'Which ACR version do I need for the settings to be fully compatible?' on page 288

If you're running Photoshop 10.0.1 with an earlier version of ACR, it will warn you that the version is not fully compatible, and offer a couple of options.

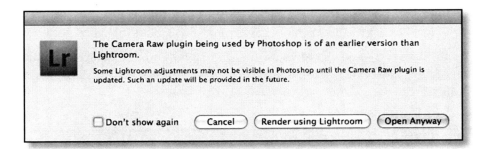

Render using Lightroom uses Lightroom's own processing engine to render a new file which it can then open into Photoshop, just as it behaved in version 1. This does mean that an additional TIFF or PSD file is created, depending on your preferences, however all of your Lightroom adjustments will be applied correctly.

Open Anyway uses the older version of ACR to convert the file. This opens without creating an interim file, however the resulting file may not have all of your adjustments applied, particularly the newer adjustments such as Local Adjustments.

I'd prefer to let Bridge run the conversion to JPEG using Image Processor. Is it possible?

Certainly, you can use Lightroom to work through your photos, and then save the settings to XMP, browse to them in Bridge, and convert using Image Processor.

There isn't an advantage to doing so, and you would have to make sure you're using a fully compatible version of ACR, otherwise your adjustments may be converted differently.

 See 'How do I write settings to XMP?' on page 283 and 'Which ACR version do I need for the settings to be fully compatible?' on page 288

Why is Bridge not seeing the raw adjustments I've made in Lightroom?

The adjustments you make to your photos in Lightroom are stored in Lightroom's own catalog, and other programs such as Bridge can't read that catalog. In order for Bridge to read the settings, you need to write to XMP.

 See 'How do I write settings to XMP?' on page 283

If you've done so, and the XMP files are alongside the raw files, then you may find that Bridge hasn't yet updated its previews. You can force Bridge to update its previews by going to Tools menu > Cache > Build and Export Cache...

File Type

What's the equivalent of a JPEG quality....

Lightroom uses a different scale (0-100 rather than 0-12), so there isn't a direct match. Here's a rough guide though:

Photoshop quality 8 – approx. 65 in Lightroom
Photoshop quality 10 – approx. 80 in Lightroom
Photoshop quality 12 – approx. 100 in Lightroom

How do I set Lightroom to a JPEG level 0-12 so that Photoshop doesn't ask me every time I save?

You can use a droplet to re-save all of the files with a Photoshop quality 12 tag, if you're going to be working through them manually.

If you're going to be batching the files, you can include the quality tag into your action by including a 'Save As' in your action rather than a standard 'Save'. Even if you override the save location when setting up the batch, it'll still use the quality tag that you used when setting up the action. As this is a Lightroom book, rather than a Photoshop book, we won't go into any more detail, but you'll get the general idea from the droplets question.

 See 'Can I run a Photoshop Action from Lightroom?' on page 323

If a photo is imported as a JPEG, and it's not edited it any way, is what I am exporting identical to what I imported?

If you choose 'Original' as the Export File Format in the Export dialog, you'll create a duplicate of the original file.

The file size may be slightly different as Lightroom may update the metadata (unlike an operating system duplication) but it won't re-compress the image data.

In the Edit in... options, should I choose TIFF or PSD?

In terms of functionality, there's no longer a difference between the two – you can save everything to a TIFF that you can to a PSD. TIFFs are more efficient when updating metadata.

Adobe are generally recommending TIFFs now, but both are lossless formats, so it's largely down to personal choice.

Why won't Photoshop allow me to save my Lightroom file as a JPEG?

If you've opened your photo into Photoshop directly from Lightroom using Edit in Photoshop..., the photo may be 16-bit, and you can't save a 16-bit photo as a JPEG.

You can either convert the photo to 8-bit, in which case you can save as a JPEG, or you can save your 16-bit photo as another format such as TIFF or PSD.

If you wish to convert from 16-bit to 8-bit, go to Photoshop's Image menu > Mode > 8 bits/Channel.

Should I choose 8-bit or 16-bit?

16-bit ProPhoto RGB is the officially recommended choice for best preserving color details from Lightroom.

In the real world, it's not always quite so clear cut. 16-bit files can only be saved at TIFF or PSD, not JPEG, and the file sizes are much bigger than an 8-bit quality 12 JPEG, often with very little, if any, visible difference. A Canon 5d file could be around 73mb for a 16-bit TIFF, but less than 3.5mb for a quality 12 8-bit JPEG. That's a big difference on a large volume of files!

So the reality is that you may wish to weigh it up on a case-by-case basis. If you're doing a one-off fine art print, 16-bit would be an excellent choice to preserve as much detail as possible. If you're going to take a file into Photoshop and make massive tonal changes, 16-bit would be an excellent choice, giving a greater latitude for adjustments.

On the other hand, if you're processing a series of 1000 photos for a wedding, and they're only going to be small photos in an album with no major additional changes to be made, 8-bit JPEG could be a far more efficient choice. You can always re-export from Lightroom as a 16-bit file if you find a photo which would benefit, such as a photo exhibiting banding in the sky, or suchlike.

The choice is yours!

I am a high volume photographer (weddings etc.) – do I HAVE to convert to PSD or TIFF for light retouching, or can I use JPEG?

As with the 8-bit vs. 16-bit debate, there is no fixed answer – it depends on your situation.

JPEG is a lossy format, which means that if you open, re-save, close and repeat that enough times, you will eventually start to see the compression artifacts. TIFF and PSD, on the other hand, are lossless formats.

Some high volume photographers, such as wedding photographers, are using 16-bit TIFFs for everything, simply because they've been told that's best. And technically, that is absolutely true.

However we do live in the real world, and, as with everything, there is a trade-off – TIFF and PSD formats are much larger than JPEGs. High volumes of these files will rapidly fill your hard drive, and they will take longer to open and save due to the larger file sizes.

If you're dealing with a small number of photos, that's not a problem, but for photographers working with thousands of photos every week, it becomes a question of ultimate quality vs. real-world efficiency.

So, questions to consider...

- What are you doing to these files once they've left Lightroom? Major color/density shifts? Or a little light retouching before printing? If you're doing major adjustments, a 16-bit TIFF or PSD may be the best choice, but ideally you'd be making those adjustments within Lightroom using the raw data.

- Do you want to keep layered files? If so, you could consider using TIFF or PSD for your working files, and then converting to high quality JPEG once you're ready to archive.

- How big are the photos going to be printed? A photo which is going to be printed as a poster-size fine art print may be best as a 16-bit TIFF or PSD, whereas you

may choose to compromise and use JPEGs on photos that are only going to appear as smaller photos in an album.

- How often are you going to need to re-save this file? Are you going to keep coming back to it and doing a bit more retouching, or is it a one-touch? If you are just opening, doing a little retouching, saving and closing, there's very little visible real-world difference – and the space saving is HUGE.

Test it for yourself – how many times can you open a file/save/close/reopen and repeat before you can find any visible differences? At quality 12? Even at quality 10? Don't take someone else's word for it – check it for your own peace of mind.

You can save as many times as you like while the file remains open, without any additional compression – it's only saving the file after closing and reopening that will re-compress it.

Only you can decide whether you're comfortable with that compromise, having checked the facts for yourself.

Color Space

Why do my photos look different in Photoshop?

Usually a mismatch in colors is due to either incorrect color profile settings or a corrupted monitor profile.

For example, a ProPhoto RGB photo mistakenly rendered as sRGB will display as desaturated and flat.

ProPhoto RGB photo correctly displayed as ProPhoto RGB:

ProPhoto RGB photo incorrectly displayed as if sRGB:

First, check your color settings.

In Photoshop, go to Edit menu > Color Settings to view this dialog.

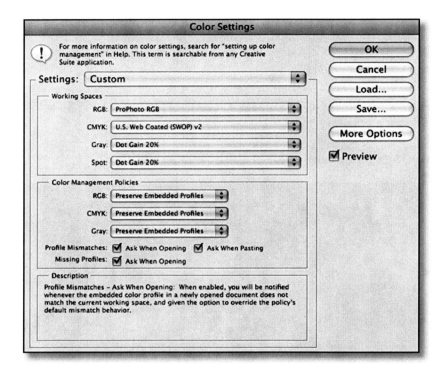

The RGB Working Space is your choice, but whichever you choose to use, you are best to set the same in Lightroom's External Editor preferences and Export dialog. We'll come to that in a moment.

 See 'Which color space should I use?' on page 308

Selecting 'Preserve Embedded Profiles' and/or checking the 'Ask When Opening' for Profile Mismatches in that same dialog will help prevent any profile mismatches.

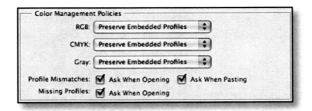

'Preserve Embedded Profiles' tells Photoshop to use the profile embedded in the file regardless of whether it matches your usual working space. 'Ask When Opening' for Profile Mismatches shows you a warning dialog when the embedded profile doesn't match your usual working space, and asks you what to do.

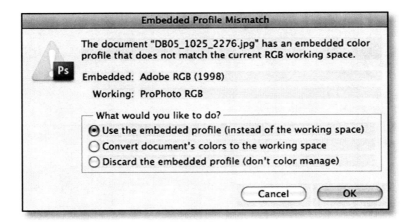

You also need to set your External Editor settings in the Lightroom Preferences dialog. It is simplest to use the same color space as you have chosen in Photoshop.

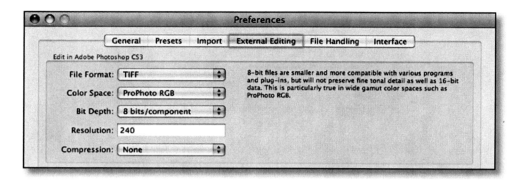

You'll also want to check the color space that you're using in the Export dialog, and again, choose the same color space for photos you are going to open in Photoshop.

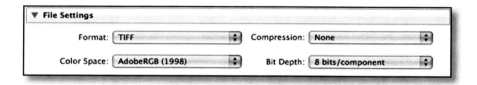

As long as your Photoshop and Lightroom color settings match, or you have Photoshop set to use the embedded profile, your photos should match between both programs.

Other mismatches when the color settings match correctly can also be due to a corrupted monitor profile.

 See 'Everything in Lightroom is a funny color, but the original photos look perfect in other programs, and the exported photos don't look like they do in Lightroom either. What could be wrong?' on page 388

Why do my photographs look different in Windows Explorer or on the Web?

Having checked your Photoshop color settings, you may still find that your photos look incorrect in other programs such as web browsers.

This is due to the fact that most web browsers, and other programs such as Windows Picture and Fax Viewer in Windows XP are not color managed. They assume that your photos are sRGB, resulting in an incorrect appearance for Adobe RGB or ProPhoto RGB tagged photos.

Photos destined for the web or other screen display should be exported as sRGB – this will ensure that the rendering will be at least close as possible to the photo you're viewing in Lightroom. Remember that sRGB is not actually 'better' (the color space is actually smaller), but these browsers assume the photos are sRGB, so photos will display as expected.

Can I export with a custom ICC profile?

Yes, custom ICC profiles were introduced in version 2.0. Selecting 'Other' in the Export dialog Color Space popup menu will bring up a dialog box allowing you to choose which other custom ICC profiles will be available in the Color Space popup menu.

Which color space should I use?

Which color space is a huge question, and it's best to have a clear understanding of what that actually means. Jeffrey Friedl wrote an excellent article on color spaces, which you will find at:
http://regex.info/blog/photo-tech/color-spaces-page0/

A very basic summary in the meantime though...

sRGB is a small color space, but fairly universal. You'll want to use sRGB for any photos that you're outputting for screen use (web, slideshow, digital photo frame), and most non-pro digital print labs will expect sRGB files.

Adobe RGB is a slightly bigger color space. Some pro digital print labs will accept Adobe RGB files. It's also a good choice for setting in-camera if you choose to shoot JPEG rather than the raw file format.

ProPhoto RGB is the largest color space that Lightroom offers. Putting an Adobe RGB or ProPhoto RGB file in a non-color-managed program such as most web browsers will give a flat desaturated result.

 See 'Why do my photos look different in Photoshop?' on page 303

So your chosen color space will depend on the situation. If you're exporting for the web or another screen, use sRGB - it's as close as you'll get. If you are sending a raw file to Photoshop using the Edit in... command, ProPhoto RGB will usually be a better choice, retaining as wide a range as possible. You can always convert to a smaller space suited to your output later - whether sRGB for the web, a printer profile for your inkjet printer, etc.

Whichever color space you choose to use, always embed the profile. An file is just a collection of numbers, and a profile defines how those numbers should be displayed. If there is no profile, the program has to guess - and usually guesses incorrectly.

Sizing & Resolution

What's the difference between Width & Height, Dimensions, Longest Edge & Shortest Edge?

Width & Height behaves like Fit Image and Image Processor in Photoshop. It fits the photo within a bounding box in their current orientation.

This setting is width/height sensitive – settings of 400 wide by 600 high will give a 400×600 vertical photo, but only a 400×267 horizontal photo. To create photos of up to 400×600 of either orientation, you'd have to enter a square bounding box of 600×600.

Dimensions works slightly differently. It still fits your photo within a bounding box, but it's a little more intelligent. It takes into account the rotation of the photo, and it will make the photo as big as it can within your bounding box, even if it has to turn the bounding box round to do so.

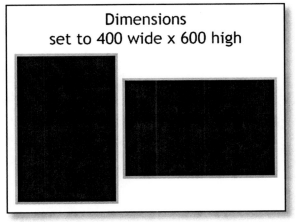

The Dimensions setting is not width/height sensitive – settings of 400 wide by 600 high will give a 400×600 photo, whether it's vertical or horizontal. If your photo is a different ratio, it will still make it as big as it can within those boundaries. To create photos of up to 400×600, you simply enter 400×600.

Longest Edge sets the length of the longest edge, as the name suggests. A setting of 10 inches long would give photos of varying crop ratios such as 3×10, 5×10, 7×10, 8×10, 10×10.

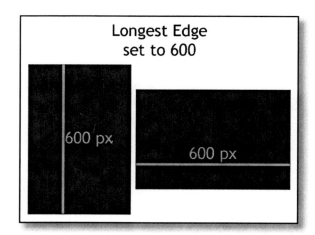

Shortest Edge sets the length of the shortest edge, as the name suggests. A setting of 5 inches along the shortest edge would give varying crop ratios such as 5×5, 5×8, 5×10, 5×12.

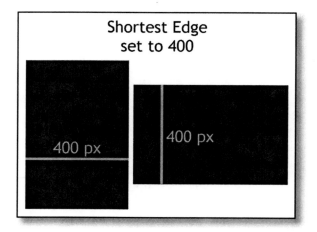

Bear in mind that these measurements do still fall within the ACR limits of 65,000 pixels along the longest edge, so if your photo will fall outside of this range according to the measurements you've set, Lightroom will simply make the photo as big as it can.

When I enter 4x6 as my output size, why do the vertical photos become 4x6 but the horizontal photos become 2.5x4?

You've got Export Resizing set to 'Width & Height', which fits the photo within a bounding box without rotating. Change it to 'Dimensions' and it will work as you're expecting.

What does the 'Don't Enlarge' checkbox do?

This will prevent small photos from being upsized, while still downsizing photos which are too large to fit your chosen dimensions.

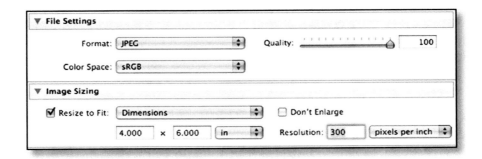

What PPI setting should I enter in the Export dialog?

The PPI setting, or Resolution, is generally irrelevant as long as the overall pixel dimensions are correct.

We won't go into a lot of detail as a web search on 'resolution' will produce a multitude of information, but you are simply defining how to divide up the photo.

Imagine you have a cake – you can divide it into 4 fat slices, or 16 narrow slices. The overall cake size doesn't change. Your photo behaves the same way – the PPI setting just tells other programs how fat you've decided the slices should be, but there is the same amount of data.

The PPI setting becomes more useful when resizing in inches or cm rather than in pixels. For example, when sending photos to a lab for printing, you may decide against sending them the full resolution file, and choose to downsize to a smaller file size.

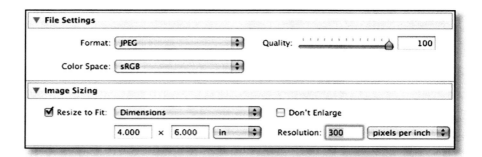

Selecting a photo size of 4"x6" at 300ppi will give a pixel dimension of 1200x1800, which is plenty for most labs. On the other hand, sending a photo of 4"x6" at 72ppi will give a pixel dimension of just 288x432 – far too small to get a good quality print from most labs.

I set the export PPI to 300 – why is it 72ppi when I open it in Photoshop?

If you specifically need the PPI tag, don't check the 'Minimize Embedded Metadata' checkbox in the Export dialog as that wipes the Resolution tag.

How do I change the PPI setting for Edit in Photoshop?

It's fairly irrelevant as long as you have the correct number of pixels overall, however in version 2, it's an option in Preferences.

 See 'What PPI setting should I enter in the Export dialog?' on page 311

If you forget, you can change it once the file is open in Photoshop...

Once the file is open in Photoshop, go to the Image menu > Image Size.

Uncheck the 'Resample Photo' checkbox at the bottom of the dialog.

Now type your preferred PPI tag in the Resolution field.

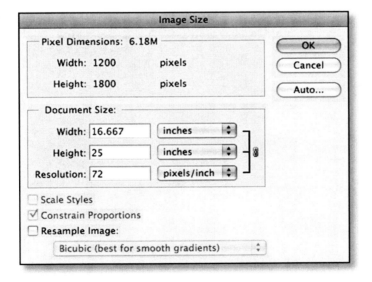

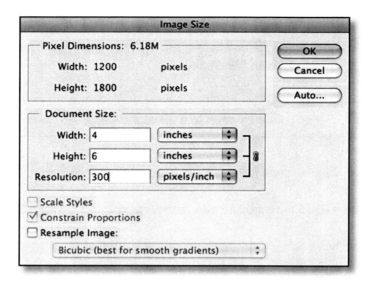

You will note that the overall pixel dimensions at the top of the dialog remain the same. That's correct. We don't wish to resample, as that would either throw away or create pixels. We are just changing the PPI tag, redefining the way the photo is divided.

Press OK and you're done.

When I crop to 8x10 in Lightroom and then open in Photoshop, why is it not 8"x10"?

When you're cropping in Lightroom, you're cropping to a ratio, not a fixed size. Because you're not throwing away pixels in your non-destructive Lightroom workflow, that crop can be output to a number of different sizes – for example, your 8x10 crop could also be output as 4"x5" or 400x500 pixels for the web, all without having to go back and re-crop the photo.

When you come to export, you then define the size that you wish to export, either as pixel dimensions or as inches/cm combined with a resolution setting.

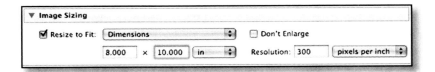

Is it better to upsize in Lightroom or in Photoshop?

When Lightroom resizes, you don't get a choice of interpolation method, unlike Photoshop which offers Nearest Neighbor, Bilinear, Bicubic, Bicubic Smoother and Bicubic Sharper.

Mark Hamburg, original creator of Lightroom, is however quoted as saying: "Lightroom is using a Lanczos kernel interpolation method. But the really big difference is it resamples in linear space. Depending on the image, this can create a huge difference. For example, with a Photoshop resampling, if you look closely, you can see a darkening around edges, because Photoshop doesn't generally work in linear. Which results one likes for resampling are in part a matter of taste and also depend on the image content. In general, Lightroom should be at least as good as Photoshop and in some cases—such as up-sampling—it should be clearly better."

Can I export to multiple sizes in one go?

You can't export multiple sizes in a single export, however you can export a high resolution image and use a droplet to save smaller versions.

 See 'Can I run a Photoshop Action from Lightroom?' on page 323 and 'What Export Plug-ins are currently available?' on page 329

Alternatively you can run multiple exports simultaneously – I often have 4 or 5 going at a time, whether exporting to different sizes or different photos entirely. Simply start one export running, then another, then... well, you get the idea.

There have been some reports of the Windows version not working correctly with more than 5 exports running at the same time, although many people run more than 5 exports with no trouble.

Save Locations

Can I set Lightroom to automatically export back to the same folder as the original, or a subfolder of the original folder?

In the Export dialog you can set Lightroom to export into either a 'Specific folder' or 'Same folder as original photo', and place them either directly within that folder or within a named subfolder of your choice.

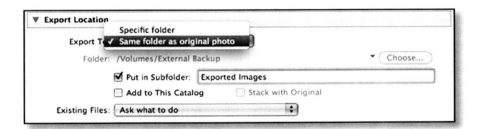

Can I set Lightroom to overwrite the original when exporting?

No, version 2 won't allow you to overwrite the source file, as it could get stuck in a loop – trying to read the original source file but having already overwritten the part it needs, which could result in corrupted files.

If you attempt to overwrite the source files that you are exporting, it will ask whether to skip or to use unique names.

How do I change the filename while exporting?

Rather than having to rename and then export the files, or vice versa, you can use the File Naming in the Export dialog. This won't affect the original photos in your catalog – it will only set the names of your exported photos.

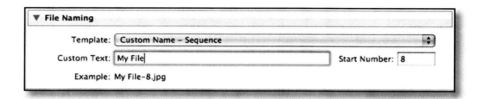

The dialog used for the File Naming Template is the same dialog that is used both for renaming while importing and later in the Library module.

 See 'How do I rename photos?' on page 139

Can I stop Lightroom asking me what to do when it finds an existing file with the same name?

In the Export dialog you can set a default action, so that when it finds existing files, it doesn't stop and wait for your decision. By default it will still ask what to do, however you can choose to allow it to adjust the filename, overwrite the existing file, or skip exporting this file.

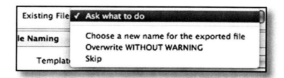

Export Sharpening

Can you 'Apply sharpening to preview photos only' like you can in ACR?

There isn't a checkbox to turn sharpening on and off, as there is in ACR.

Most prefer to leave the capture sharpening turned on, as it offsets the softening inherent in digital capture and the demosaicing added by Lightroom.

 See 'Sharpening & Noise Reduction' section starting on page 238

If you wish to turn it off, however, the solution is to use a preset. Create a preset which sets the sharpening to 0 and doesn't affect other sliders. Just before you export, select all of the photos and apply that preset. Export as usual, and then immediately press Ctrl-Z (Windows) / Cmd-Z (Mac) to undo, changing your sharpening back to its previous setting.

 See 'Presets' section starting on page 213

If you wish to turn the sharpening off permanently, you can change the defaults, or apply a preset in the Import dialog.

 See 'How do I change the default settings?' on page 220 and 'What Develop settings, metadata, keywords and previews settings should I apply in the Import dialog?' on page 100

Why does the Export Sharpening only have a few options? How can I control it?

Lightroom's sharpening controls are based on Bruce Fraser's multiple pass sharpening.

 See 'Why isn't Lightroom's Develop module sharpening very strong?' on page 238

The Output sharpening found in the Export, Print and Web modules is based on the complex algorithms created by the team at Pixel Genius, who created the well-known Photoshop plug-in PhotoKit Sharpener.

Based on the information you provide – the output size and resolution, the type of paper, and the strength of sharpening you prefer – it automatically adjusts the sharpening to create the optimal result.

To get the best out of the automated output sharpening, you do need a properly capture sharpened photo, so the sharpening settings in the Develop module are still essential.

Which Export Sharpening setting applies more sharpening – screen, matte or glossy?

The difference between Matte and Glossy is barely noticeable on screen, but there is a difference between each of the settings. At a glance you'll see that the Screen setting sharpens the high-frequency details less than the Matte or Glossy settings, but there are a lot more technicalities behind that.

As a general rule, pick the right paper type, and you'll be about right. Sending matte sharpening to a glossy paper will look worse than sending glossy sharpening to matte paper. Avoid over-sharpening in the Develop module, otherwise the Export Sharpening will make it look a lot worse. Screen sharpening may look a little soft on CRT monitors as it's optimized for LCD screens.

Export Actions

Can I set Lightroom to automatically re-import the exported files?

There is an option in the Export dialog to automatically add the exported photos back into your catalog, bypassing the Import dialog.

If the exported files have been exported to the same folder as the original photos, you can also automatically stack them.

How do I get Lightroom to attach the exported files to an email?

Windows:

As Lightroom doesn't currently have the ability to attach multiple photos to emails, Steve Sutherland wrote a clever little program to do the job.

You can download this donation-ware program from his website at:
http://www.sbsutherland.com/downloads.aspx

He writes:
"It is a simple program which will accept a list of files on the command line and then it uses the MAPI API to invoke the system's default email program. It opens a new email with all of the passed files attached. Once the email is sent (or cancelled), the passed temporary photos are deleted automatically.

"MapiMailer is mostly installed automatically into Lightroom and adds a new item called 'Mapi Mailer' to Lightroom's 'Export Post-processing', 'After export' list of actions. To complete the installation, you will need to follow a few simple steps outlined in the Readme.txt file."

Mac:

To attach files to a new email on the Mac version of Lightroom, you need to add an alias to the email application to the Export Actions folder.

Open the Export dialog, and in the Post Processing Actions popup menu at the bottom of the screen, select 'Go to Export Actions Folder Now'.

Drop an alias to your email application into that folder by holding down the Cmd and Opt keys, while dragging your Mail application icon to the Export Actions folder. You'll note the alias arrow appears on the icon as you drag, showing it is creating an alias rather than moving the application.

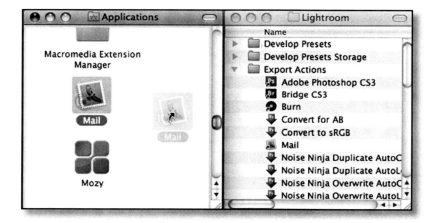

When you return to the Export dialog, your Mail alias will appear in the Post Processing popup menu.

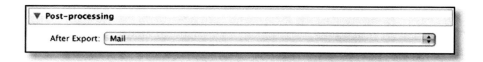

Selecting that Export Action when exporting should create a new email and attach your exported photos.

Can I run a Photoshop Action from Lightroom?

Lightroom is not designed to be a file browser, so it doesn't work quite like Bridge, but it's still possible to run Photoshop Actions on your exported photos without user intervention.

The solution involves creating a droplet in Photoshop from an existing action, and then telling Lightroom to run the droplet once it's exported the photos.

Create the Action

1. In Photoshop, you need to have already created an Action – if you're not familiar with creating Photoshop Actions, there are plenty of web resources which will take you through step-by-step.

 If you are going to run this on JPEGs, it must include a Save As step to set the JPEG quality, otherwise it'll ask for a quality setting for each and every photo, defeating the object of automating it! To do so, when running the Save As while recording the Action, just press OK without changing the filename or location, and make sure you choose your quality setting – you'll override the location in the Droplet dialog.

 The resulting Action will look something like this... this is a simple re-save as quality 12 action.

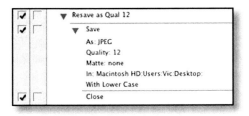

 See 'How do I set it to a JPEG level 0–12 so that Photoshop doesn't ask me every time I save?' on page 289

Create the Droplet

2. Go to File > Automate > Create Droplet and this dialog will appear:

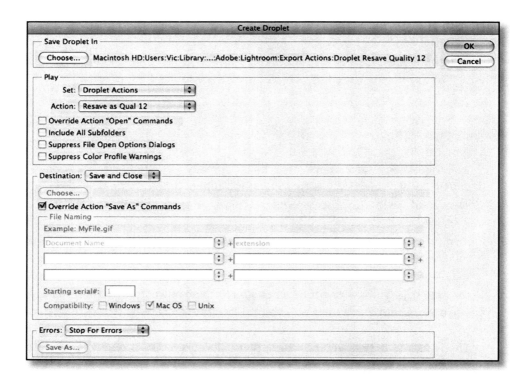

3. Save your droplet somewhere safe with a logical name, and make sure you've set the save location to either Save and Close to overwrite the exported file, and tick the 'Override save location' box. If you don't wish to overwrite the exported file when running the droplet, set your destination folder instead. Click OK to create your droplet.

Add the Droplet to Lightroom

4. Open Lightroom, select a photo, and go to Export. At the bottom of the dialog you will see the 'After Export' popup menu. Click 'Go to Export Actions Folder Now' at the end of the popup menu to show you that folder in Explorer (Windows) / Finder (Mac). Drop a shortcut/alias to your droplet in the folder

which appears. If you'd prefer, you can place the droplet itself into that folder, rather than a shortcut/alias. Close the Export dialog box.

Export Actions

5. When you reopen the Export dialog box to export your photos from Lightroom, your droplet will appear in that 'After Export' popup menu.

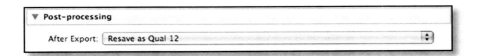

6. Export your photos from Lightroom, with your new droplet selected, and once the photos have finished exporting they should automatically open Photoshop and run your action.

You can also use droplets to save to another location – you don't have to save over the top of the exported file. See how many droplet ideas you can think of!

The droplet runs, but it doesn't save – what have I done wrong?

If you can see Photoshop is opening the photos and running the action correctly, but simply isn't saving the changes, you've probably correctly checked the 'Override Action "Save As" Commands' checkbox in the Droplet dialog, but your action didn't include a Save As.

Alternatively you might find that you set your droplet or action up to save to another location.

Either way, try creating your action and droplet again!

The droplet runs, but it keeps asking what JPEG compression to use – what have I done wrong?

You forgot to include a Save As in your action to set the JPEG quality.

Try re-creating the droplet, paying special attention to step 1 in the instructions.

 See 'Can I run a Photoshop Action from Lightroom?' on page 323

The droplet doesn't run at all – why not?

Most likely the problem is with the droplet itself – you can check whether the droplet works by dropping files directly onto the droplet icon. If it doesn't run, try re-creating your action and droplet, following the instructions carefully. If it still doesn't run, it would suggest that you have problem with your Photoshop installation, and reinstalling should fix it.

The droplet only works on some of the photos and then stops – what's wrong?

When Lightroom tells Photoshop which files to run the action on, it passes it a string of file paths which looks something like:
"c:\documents and settings\your username\desktop\image1.jpg; c:\documents and settings\your username\desktop\image2.jpg;"

The maximum allowable length of that string is limited.

If the files you're sending are buried deep in the folder structure, you'll use up the available string length far quicker than a short file path such as:
"d:\image1.jpg, d:\image2.jpg"

Don't be fooled into thinking that 'Desktop' or 'My Pictures' are short length paths – on both Windows and Mac operating systems, they're actually shortcuts to folders buried much deeper in the folder structure.

Droplets aren't ideal for huge numbers of photos, but if you find it's cutting out too early, you could try exporting to a root level folder to keep that string as short as possible.

In my droplet I used a Save for Web instead of a standard Save As – why won't it overwrite the original file?

Save for Web is not a standard Photoshop save – it's an export action, so anything you change in the Droplet dialog or anywhere else won't help with that one.

If you want to use Save for Web, set your droplet to Save for Web as part of the action, sending to a standard location (maybe an 'Automated' folder on your desktop), don't put any other Save As in the action, and set the Droplet Destination to None.

You'll have to delete the files created by the Lightroom Export once the action has completed, as they won't have been overwritten by your Save for Web photos.

Export Plug-ins

How do I install Export Plug-ins?

Simply navigate to File menu > Plug-in Manager to bring up the Plug-in Manager dialog.

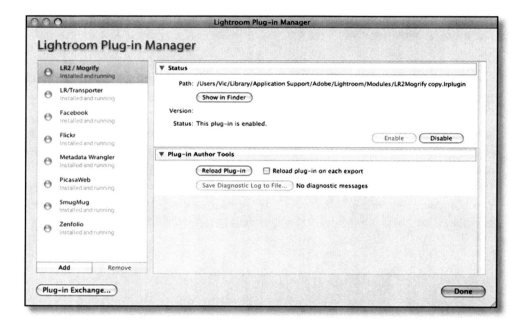

Click on the Add button in the lower-left, and navigate to the ".lrplugin" or ".lrdevpluginin" folder for the plug-in you'd like to install.

You may prefer to keep all of your plug-ins in one place, to make them easy to find, update, transfer or delete. Generally it's suggested that creating a Plug-ins folder alongside the other presets folders would be an ideal place.

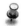 See 'The default location of the Presets is...' on page 396

Why can't I remove this Export Plug-in?

To remove any plug-ins that you've installed by means of the Add button, simply select it and press the Remove button.

That Remove button is not available for plug-ins not currently stored in Lightroom's own modules folders – in case you want to reinstall them later. For those plug-ins, press 'Show in Explorer/Finder' and move the plug-in to another folder or delete it. It will disappear from the Plug-in Manager dialog when you next restart Lightroom.

What Export Plug-ins are currently available?

Tim Armes – LR2/Mogrify – borders & copyright watermarks, etc.
> http://www.timothyarmes.com/lr2mogrify.php

Tim Armes – LR/Enfuse – blending multiple exposures
> http://www.timothyarmes.com/lrenfuse.php

Tim Armes – LR/Transporter – text files of metadata
> http://www.timothyarmes.com/lrtransporter.php

Jeffrey Friedl – Zenfolio, SmugMug, Flickr, Picasa Web, Facebook uploads
> http://www.regex.info/blog/lightroom-goodies/

Jeffrey Friedl – Metadata Wrangler – choose which metadata to strip or include
> http://www.regex.info/blog/lightroom-goodies/

Eugene Berman – iStockPhoto upload
> http://www.berman-photo.com/lrplugins

The list of Export plug-ins is growing all the time – a simple Google search will bring up many new options, and the Lightroom Exchange is a great place to find all sorts of new plug-ins, presets and other goodies: http://www.adobe.com/cfusion/exchange/index.cfm?event=productHome&exc=25

How do I use Export Plug-ins?

Once you've installed the Export Plug-in, it's ready to use.

The way you access the plug-in depends on the individual plug-in, but each plug-in should come with instructions.

Some plug-ins that export directly to a different destination show up in the bar at the top of the Export dialog. It usually just says 'Files to Disk', but becomes a popup menu where you can select the Export Plug-in of your choice.

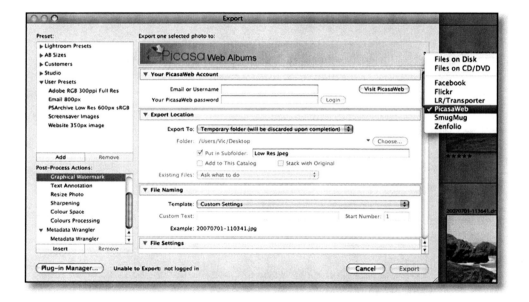

Some, such as LR2/Mogrify and Metadata Wrangler, appear in the Post-Process Actions section of the Export dialog. From there, you can choose which options you wish to make available for your current export.

In addition to the standard Export option panels, additional options then become available.

Certain other Export Plug-ins, such as LR/Enfuse have a menu listing under the File menu instead, and Jeffrey's Zenfolio, SmugMug, Flickr, Picasa Web, Facebook store additional information under that menu too.

Copyright & Watermarking

How do I enter the details for the copyright watermark?

Add the information to the Copyright section of the Metadata panel – that information is used for the copyright watermark in the Export dialog.

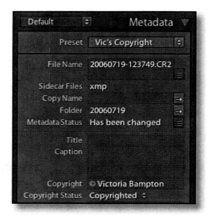

 See 'How do I add my copyright information to the metadata?' on page 167

How do I change the font or size for the copyright watermark, or use a graphical watermark instead?

You can't change it within Lightroom at this point in time, however Tim Arme's LR/Mogrify plug-in offers plenty of options, including a variety of watermark options.

 See 'What Export Plug-ins are currently available?' on page 329

Other Export Questions

Why does Lightroom move my Edit in... photo to the end of the sort order?

If your sort order is set to User Order, Edit Time, etc., Lightroom will put the edited file at the end of the series of photos. If you have it set to Stack with Original in the Edit dialog, it will also move the original photo to the end.

If you wish to keep to your existing sort order, use a sort order such as 'Capture Time' or 'Filename'.

Can I strip the metadata from my files, like Save for Web in Photoshop?

The 'Minimize Embedded Metadata' checkbox in the Export dialog will strip most of the metadata from the exported file, leaving the copyright information and color space tag.

If you wish to be a little more selective, Jeffrey Friedl's Metadata Wrangler Export Plug-in allows you to choose which metadata to remove and which to keep. You can download it from: http://www.regex.info/blog/lightroom-goodies/

 See 'Export Plug-ins' section starting on page 328

Do I have to wait for Lightroom to finish updating the previews before I can export?

No, the previews have no effect on the exported files, so go ahead and export them. The previews will continue to build in the background.

Can I save my Export Settings as a Preset?

A few presets are already included by default, but it's useful to save your own settings for easy access.

Simply set up your Export options, and then press the Add button in the Presets panel of the Export dialog to save it for future use.

You can organize them into folders for easy access, as with any other preset.

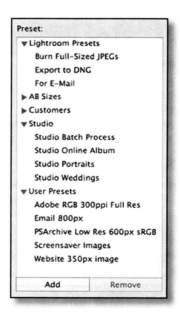

Do I have to use the Export dialog every time I export?

Having set up Export presets, you can easily access these through File menu > Export as Preset, or through the right-click context sensitive menu for any image.

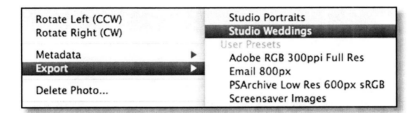

Why is Lightroom flattening my layered file?

If you apply Lightroom Develop settings to a layered file, they will be applied to the composite file, and the result will be a flattened file when you export.

If you need to export the layered PSD or TIFF file, with only your metadata changes applied (time stamp, ratings, etc.), but no Develop changes, you can either press Ctrl-S (Windows)/ Cmd-S (Mac) to write those changes to XMP in the original file, or you can set the Export file type to 'Original', which will create a duplicate of the file with your metadata changes saved.

Why does my Edit with... PSD file not have a preview when it's returned from Photoshop to Lightroom?

You must ensure that you save your PSD file with 'Maximum Compatibility' turned on, otherwise Lightroom won't be able to read it.

 See 'It says "Some import operations were not performed. The files could not be read. Please reopen the file and save with 'Maximize Compatibility' preference enabled."' on page 113

Export Troubleshooting

Lightroom can't find Photoshop to use Edit in Photoshop – how do I fix it?

When Lightroom starts up, it checks to see if Photoshop or Photoshop Elements are installed, and if it can't find them, then Edit in Photoshop is disabled.

Uninstalling and reinstalling Photoshop will usually fix it.

Alternatively you can fix it by editing the registry key (Windows) or deleting Photoshop's plist file (Mac).

There's more information on the official tech note at:
http://www.adobe.com/go/kb401629

It gives an error message – "Some export operations were not performed. File does not exist." What went wrong?

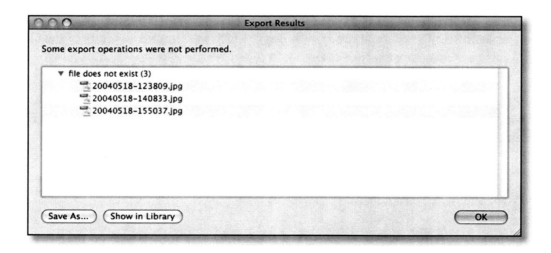

Usually this error is a result of missing files – where the original file is offline or has been moved/renamed.

Clicking 'Show in Library' will take you to a 'Error Photos' temporary collection, so you can see the photos in question.

If they have a question mark in the corner, then the mystery is solved – Lightroom thinks the files are missing.

Click on the question mark and locate the original file, and run the export again.

 See 'Lightroom thinks my photos are missing – how do I fix it?' on page 129

If the files don't have a question mark in the corner, then Lightroom was unable to write the files for another reason. Check that your Export folder is not read-only (or possibly a parent of the Export folder) and that you have plenty of disc space on that drive.

The files appear in the export folder and then disappear again. Why is Lightroom deleting them?

If the files do seem to appear in the Export folder and then immediately disappear again, it's because Lightroom isn't able to write to that folder.

Most likely you've run out of hard drive space, or are at least running very low. Try exporting to another hard drive or clearing some space.

Slideshow Module

Styles & Settings

How do I save my settings as a template for use on other photos?

Having arranged the slideshow settings to suit, use the + button on the Template Browser panel, just as you would with Develop presets.

Name your template, and place it in the User Templates folder or another folder of your choice.

That template will then appear in the Template Browser panel for use on any photos in the future.

As with all presets, you can update your User Templates at any time by changing your settings and then right-clicking on the template and choosing Update with Current Settings.

Can I save my settings for a specific slideshow?

If you create a slideshow from a collection, your slideshow settings will be stored with that collection, including the sort order, background colors, music choice and so forth.

When you return to that collection later, all of that collection's slideshow settings will be applied, regardless of what you've done in the Slideshow module since.

Can I add Intro and Ending slides?

You can set plain Intro and Ending slides in the Titles panel, and this can include an identity plate. If you'd like more complicated title pages, you can design them in Photoshop and save them as an image format (i.e. JPEG) and then you'll be able to import them into Lightroom and add them to your slideshow as another photo.

How do I add captions to the slides?

You can set a specific caption for each photo in the Metadata panel in Library module, and then have that displayed on the slideshow. To show that caption, press the ABC button on the toolbar and choose Caption from the popup menu.

That will only show a caption on the photos for which you've set a caption, and others will be blank.

You can also select options such as Filename from that popup menu, or create your own combination of data to show as the slide text.

Why can't Lightroom find all of my music?

The Windows version can only play MP3 format, and you browse to a folder to find them.

If you wish to create a playlist of sorts, put the required tracks into a folder together and rename them to change the sort order. Having iTunes installed makes no difference on the Windows installation, and it won't play MP4 (AAC) format songs.

The Mac version looks for iTunes and lists your playlists. It can play any format that iTunes can play. There have been a few reports of Lightroom not being able to find iTunes library if it's not in the default location – a Symbolic Link often helps in that situation.

 See 'Can I move the previews onto another drive?' on page 377

Can I advance the slides manually, but still have them fade from one to the next?

No, Lightroom assumes that if you advance to the next frame manually, you don't want to wait for the set slide duration, so you also don't want to wait for the fade either.

Can I rate photos while a slideshow is running?

Yes, you can use the 0–5, 6–9 and P, U, X shortcut keys to mark the photos with star ratings, color labels or flags while the slideshow is running.

Export

Can I export my slideshow to run in a DVD player?

No, the only slideshow export options available at this point in time are Export to PDF and Export to JPEG, however that Export to JPEG option does give you the option to create the slides in Lightroom, export them to JPEG, and then use those nicely bordered slides in other software which is specifically designed to create DVD slideshows – your CD/DVD burning software may have that capability.

Can I export my slideshow for viewing on the web?

You can't export a slideshow created in the Slideshow module for use on the web, but you can create flash slideshows in the Web module.

Can I export with my choice of music?

You can't export with music in the Slideshow module at this point in time, however some Web Galleries allow slideshows with music, for example the TTG Monoslideshow gallery offers this facility, as does SlideshowPro, and these will run on any web browser with Flash installed.

Alternatively, if you own Acrobat Pro, it would be possible to embed the soundtrack into the PDF file once it's been created by Lightroom.

 See 'Where can I download additional web galleries?' on page 365

I exported to PDF, but it doesn't automatically start the slideshow when I open it. Why not?

Check the 'Automatically show full screen' checkbox in the Export Slideshow to PDF dialog in order to automatically run it as a full screen slideshow when opening the PDF.

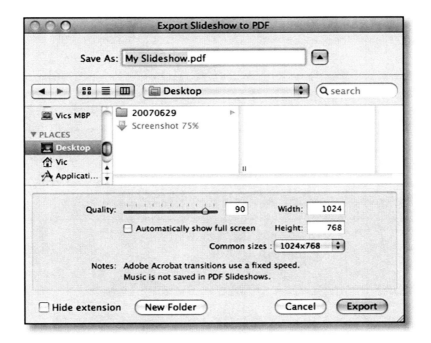

It only runs as a slideshow in certain PDF software though, for example a current version of Adobe Reader.

Errors

Why does it get part way through the slideshow and then start back at the beginning?

The first thing to check is whether the slideshow is set to show just the selected photos, or all of the photos in the current view (i.e. folder or collection). You'll find this under Play menu > Content.

If that's set correctly, the other possibility is a lack of rendered previews, particularly if the slideshow is showing you the photos but they are blurred. Select the photos in Grid view and choose Library menu > Previews > Render Standard-Sized Previews and wait for it to finish. Once the previews have been rendered, the slideshow should run correctly.

 See 'Previews & Speed' section starting on page 373

Why is my Noise Reduction not applied to the slideshow?

Noise Reduction and Sharpening are only applied to 1:1 Previews, not Standard-Sized Previews.

Select the photos in Grid view and choose Library menu > Previews > Render 1:1 Previews and wait for it to finish.

Once the previews have been rendered, run the slideshow again and your noise reduction and sharpening should have been applied.

Everything appears to be running correctly, then the screen just goes plain grey or black when I try to running the slideshow.

Problems with the slideshow not running are usually an issue with the graphics card driver – check with the card's manufacturer for an updated driver.

Print Module

Contact Sheet/Grid

How can I change the order of contact sheet photos?

The contact sheet photos will display in the current sort order, so you can rearrange the sort order in Grid view before creating the contact sheet.

If you are going to need to reprint the contact sheet, it may be best to save the photos in a collection. This will retain the sort order, as well as your Print module settings.

 See 'Why can't I drag and drop into a custom sort order or 'User Order'?' on page 179

Picture Package

How is Picture Package different from Contact Sheet/Grid?

Contact Sheet/Grid is a fixed grid – all of the photos have to be the same size – whereas Picture Package is not constrained by a grid and can therefore have a mixture of sizes.

Contact Sheet/Grid uses a series of different photos, whereas Picture Package repeats the same photo.

How do I use Picture Package?

You can create your own package using the Cells panel.

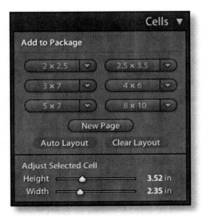

Clicking any of the size buttons will create a cell of that size. The buttons have a popup menu allowing you to create buttons for custom sized cells.

If you wish to resize an existing cell, you can use the sliders in the Cells panel, or drag the edges of the bounding box.

Holding down Alt (Windows) / Opt (Mac) while dragging an existing cell will duplicate that cell.

Clicking the Auto Layout button will arrange the cells on the page to waste as little paper as possible, or you can drag and drop them into a layout that you prefer.

Can I use Picture Package to design albums and books?

Not at this point in time – Picture Package is currently multiple copies of the same photo on each page. It's useful for printing multiple sizes of a photo, particularly for school style packages.

Styles & Settings

How do I put the filenames and a copyright watermark on my photos?

At the bottom of the Overlays panel there is a 'Photo Info' checkbox – check it and choose Filename or anything other information you wish to show on the contact sheet.

If you select Edit... from the popup menu of options, you can combine options to create your own label, using a dialog similar to the 'Filename Template Editor' used when renaming photos.

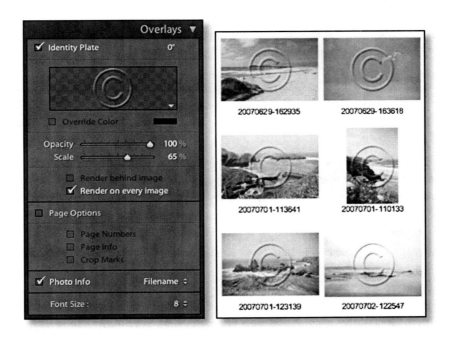

In the Overlays panel you can select an Identity Plate to place on each photo.

PNG files created in Photoshop, such as the copyright symbol shown on the previous page, are ideal for a watermark.

 See 'How do I create identity plates?' on page 371 and 'How can I overlay a graphic such as a border onto my print?' on page 350

How can I overlay a graphic such as a border onto my print?

Technically Lightroom isn't currently designed to overlay graphical borders, however there is a popular workaround using Identity Plates.

Make a series of PNG files using Photoshop – they're know as TPI's or Transparent PNG Images, and then save these as identity plates.

 See 'How do I create identity plates?' on page 371

Although the Identity Plate dialog says it requires a maximum height of 57 pixels, this doesn't apply to Identity Plates that you'll use for overlaying on photos. These need to be the correct ratio for the prints you'll use them on, and if you're going to use them for printing, they'll need to be a high enough resolution.

You can have several Identity Plates saved, and then just choose the one you want to overlay.

If you print one photo per page, you can reposition the identity plate, or rotate it as needed, and adjust the opacity too. If you're printing multiple photos on the same page, you can't reposition it, but you can still adjust the size and opacity.

There's a few more ideas and TPI's to download here:
http://web.mac.com/sidjervis/iWeb/Lightroom%20Extra/Trans%20PNG.html

Here's an example of one of the possibilities for framing photos using a soft edge – on the PNG file the black areas are transparent, however I've made them black so you can see them.

With 1 photo on a sheet, I can place the ID plate anywhere on the photo. Is that possible for multiple photos?

No, it's placed in the center of the photo when there are multiple photos per page. You can still rotate it and adjust the size and opacity, but you can't move it around.

I have the Rulers and Grid checked in the Rulers, Grid & Guides panel – why can't I see them?

Make sure you haven't unchecked View menu > Show Guides, as that will hide the lines regardless of your Rulers, Grid and Guides panel settings.

How can I save my print settings for later?

If you want to save your settings for use on a variety of different photos, save them as a Template. Having arranged the Print settings to suit, use the + button on the Template Browser panel, just as you would with Develop presets.

Name your template, and place it in the User Templates folder or another of your choice.

That template will then appear in the Template Browser panel for use on any photos in the future.

As with all presets, you can update your User Templates at any time by changing your settings and then right-clicking on the template and choosing Update with Current Settings.

The printer settings from the Page Setup and Print Settings dialogs are also saved as part of the template, so the paper orientation and suchlike are part of the template too.

If you want to save the Print settings for specific photos, place those photos in a collection and the settings will be saved. It only saves one set of Print settings per collection, so you'll need separate collections for different settings.

Printing

Why do Page Setup, Print Settings and Print buttons show the same dialog?

Some driver/operating system combinations show the same dialog for Page Setup, Print Settings and/or Print, while other combinations show different dialogs.

Where different dialogs are shown for the different buttons, generally Page Setup allows you to set paper size, orientation and margins, whereas Print Settings sets up paper type, quality, color management and other printer-specific settings.

Both can be set up and saved as part of a template without actually queuing up a print job.

Which Print Sharpening option do I choose?

Select the correct paper type and Lightroom will work out the sharpening automatically, based on the resolution and paper type.

 See 'Why does the Export Sharpening only have a few options? How can I control it?' on page 320 and 'Which Export Sharpening setting applies more sharpening – screen, matte or glossy?' on page 320

How do I print to a file such as a JPEG to send to my lab?

Lightroom now offers full Print to JPEG facilities, enabling saving JPEGs of contact sheets, bordered images and a whole host of other ideas.

To print to a JPEG file from the Print module, select JPEG File from the Print Job panel. In that panel you can select a custom file size (currently only available in inches), the file resolution (PPI), JPEG quality, sharpening settings and the ICC profile.

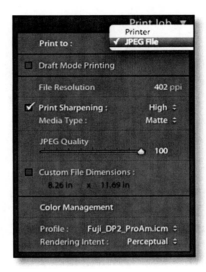

How do I set up my printer to match the preview I see on screen?

Setup for each printer is different, so we'll just run through the basic guidelines... if you need help with your specific printer, it's best to drop by one of the Lightroom forums.

Option 1 – Lightroom manages color

In the Print Job panel in Lightroom, find the Color Management section and select the correct profile from the popup menu.

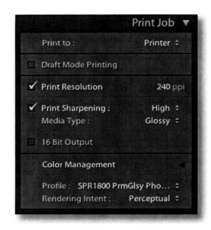

In the Printer dialog, select the correct paper type and quality settings, and set the Color Management section to 'No Color Adjustment'. The Printer dialog will vary depending on the operating system and printer model, so these screenshots are just a guide.

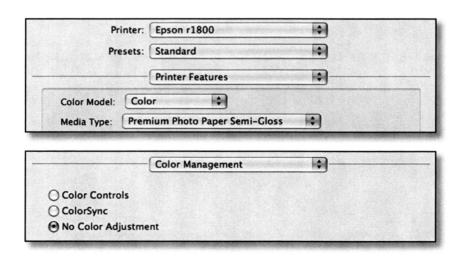

Option 2 – Printer manages color

In the Print Job panel in Lightroom, find the Color Management section and select 'Managed by Printer' from the popup menu.

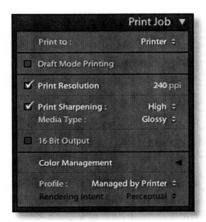

In the Printer dialog, select the correct paper type and quality settings and select the correct ICC profile in the Color Management section. The Printer dialog will vary depending on the operating system and printer model, so these screenshots are just a guide.

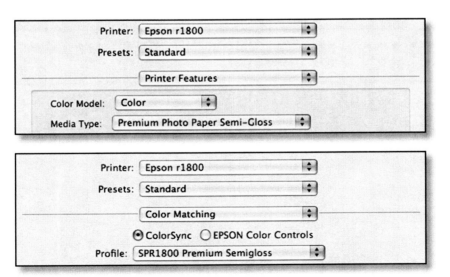

A quick review:

You either want Lightroom to manage the colors or your printer to do so – not both.

Make sure you have the correct ICC profile for your printer/ink/paper combination – printer profiles are not one-size-fits-all.

Calibrate your monitor using a hardware calibration tool, otherwise you have no way of telling whether you are seeing an accurate preview on screen.

Why are Lightroom's prints too dark?

Most monitors are too bright straight out of the box – they're set up to be bright and punchy, but that doesn't match printed output. Ideally you want to calibrate your monitor using a hardware calibration tool and adjust the luminance to about 110–120 cd/m2. This may be under the 'advanced' section of your calibration software.

You may also want to check your print settings, and ensure you have the correct ICC profile for your printer/ink/paper combination.

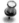 See 'How do I set up my printer to match the preview I see on screen?' on page 355

How do I get Lightroom to see my custom print profile?

To add custom printer profiles, you first need to install them, and then restart Lightroom.

Windows XP/Vista:
Place the profile in [systemdrive]\Windows\system32\spool\drivers\color. This may be a hidden folder.

 See 'How do I show hidden files?' on page 398

Mac:
Place the profile in [systemdrive]/Users/[your username]/Library/ColorSync/Profiles, or the global ColorSync folder if multiple users will need access to it.

Why does my custom ICC printer profile not show in Lightroom's list of profiles?

It may be a CMYK profile, and Lightroom is not designed to work with CMYK. If you have a Mac you can open the profile in ColorSync Utility to check – the color space is recorded in the profile info.

Web Module

Styles & Settings

How do I install new web galleries?

Unzip and copy the folder to the Web Galleries folder (not Web Templates... there is a difference).

 See 'The default location of the Presets is...' on page 396

If the Web Galleries folder doesn't already exist, you may need to create it.

The default flash gallery appears to be capped at 500 photos, but I need to include more – how can I change the default?

It is possible to change, but involves digging in the program files to duplicate the gallery, so take care! Duplicating the gallery also means that you won't have to repeat the process every time you install a dot release update (i.e. 2.1). We're just going looking for this little line...

```
        <ag:galleryOptions supportsChunkedGroupXML='yes' s
supportsOnDemandImages='yes' />
        <ag:maximumGallerySize>500</ag:maximumGallerySize>
        </galleryInfo>
```

Windows:

1. Find the following folder: [systemdrive]\Program Files\Adobe\Adobe Photoshop Lightroom 2.0\shared\webengines\default_flash.lrwebengine\galleryMaker.xml

2. Copy the default_flash.lrwebengine to your own web galleries folder – you may have to create the Web Galleries folder:

3. Windows XP – [systemdrive]\Documents and Settings\[your username]\Application Data\Adobe\Lightroom\Presets\Web Galleries\

4. Windows Vista – [systemdrive]\Users\[your username]\AppData\Roaming\Adobe\Lightroom\Presets\Web Galleries\

5. Ensure that you have read/write access to the folder and files.

6. Open the galleryMaker.xml file in a basic text editor.

7. Find the like that says <ag:maximumGallerySize>500</ag:maximumGallerySize> and change the value.

8. Restart Lightroom and check that your gallery will now allow larger numbers of photos.

Mac:

1. Go to Applications folder

2. Right-click on Adobe Lightroom 2 and select 'Show Package Contents'

3. Navigate to Contents > PlugIns > Web.agmodule

4. Right-click on Web.agmodule and select 'Show Package Contents'

5. Navigate to Contents > Resources > galleries

6. Copy the default_flash.lrwebengine to your own web galleries folder at: [systemdrive]/Users/[your username]/Library/Application Support/Adobe/Lightroom/Presets/Web Galleries/

7. Ensure that you have read/write access to the folder and files.

8. Open the galleryMaker.xml file in a basic text editor.

9. Find the like that says <ag:maximumGallerySize>500</ag:maximumGallerySize> and change the value.

10. Restart Lightroom and check that your gallery will now allow larger numbers of photos.

Is it possible to add music to the galleries?

Some third party galleries allow you to add music, although it does usually involve minor editing to the resulting gallery as Lightroom doesn't currently have an interface for adding music to a web gallery.

How can I change a web gallery I've already created?

Make a collection when you make a web gallery. Your web gallery settings are stored with that collection – it remembers your gallery choice and settings – so you can always add or remove photos, change the sort order, update the photos, and then re-export or re-upload the gallery.

How can I save certain settings to a default gallery template, such as identity plates and color settings?

Drag the template that you're using down to the User Templates folder. That will create a duplicate. Change the settings in the right hand panels and then right-click on the new template you've just created. Select 'Update with Current Settings' to update it.

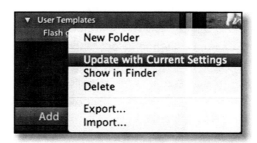

Now whenever you start a new gallery, click on that template and your settings will all be there ready.

Uploading

How do I upload my gallery?

Set up your gallery and then go to the Upload Settings panel.

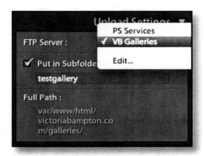

Select your FTP Server from the popup menu if you've already set it up, or select Edit... to show the Configure FTP File Transfer dialog.

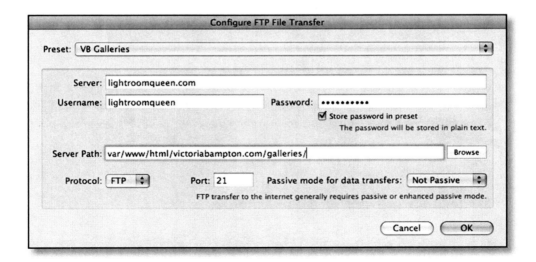

Enter the details for your website FTP – check with your host for the details.

Save the details as a preset for next time, and press OK to return to the Lightroom interface.

Back in the Upload Settings panel, give your gallery a subfolder name, otherwise any further galleries that you upload will overwrite your existing galleries. Be careful – if you don't select a subfolder, you could overwrite your home page.

Press Upload and wait... you can check the progress in the Activity Monitor in the top left hand corner of the screen.

Alternatively, you could use the Export button to export to your hard drive, and upload using your normal FTP software.

Why doesn't the FTP upload work – it says "Remote Disc Error"?

Lightroom's FTP facility is there for convenience, but it's not quite as robust as dedicated FTP software. Try exporting directly to your hard drive using the Export button rather than the Upload button, and then use standard FTP software to upload instead.

Can I have multiple galleries on my website?

Yes, just put them in folders on your web server, and add an index page. See below for some galleries which will automatically create index pages for you.

Additional Galleries

Where can I download additional web galleries?

The most popular galleries can be found at:

- http://www.theturninggate.net/

- http://www.lightroomgalleries.com/

- http://www.slideshowpro.net/

- http://lightroom-blog.com/labels/LRB%20Gallery.html

and the Lightroom Exchange is a great place to find all sorts of new plug-ins, presets and other goodies: http://www.adobe.com/cfusion/exchange/index. cfm?event=productHome&exc=25

General Troubleshooting

Troubleshooting Steps

I have a problem with Lightroom – are there any troubleshooting steps I can try?

Make sure you have backups before going any further!

1. Restart Lightroom.

2. Restart the Computer.

3. Make sure you're running the latest release.

4. Delete the Preferences file...
 Close Lightroom and find the Preferences file. The Preferences may be in a hidden folder on some systems, which you may need to show. You can move or rename that Preferences file, rather than deleting, if you think you may wish to put it back.

 See 'The default location of the Preferences is...' on page 395, 'How do I show hidden files?' on page 398 and 'What is deleted when I delete my Preferences file?' on page 368

5. Optimize the Catalog..

 Go to File menu > Catalog Settings > General panel and press the 'Relaunch and Optimize' button.

Wait for it to tell you it's completed before moving on.

6. If your catalog won't open, check for a *.lock file alongside your catalog file, and delete it, and then try to restart. The lock file can get left behind if Lightroom crashes, preventing you from opening the catalog.

7. Create a new catalog to rule out catalog corruption...
 Restart Lightroom while holding down Ctrl (Windows) / Opt (Mac).
 Select Create New Catalog.
 Import some photos into that new catalog to check everything is working as expected. If this works, the problem is with the catalog, possibly corruption.

 See 'How do I create a new catalog and then switch between catalogs?' on page 58 and 'My catalog appears to be corrupted – how do I rescue it?' on page 385

8. Move all user presets to another location in case a corrupted preset is causing the problem.

 See 'The default location of the Presets is...' on page 396

9. Update drivers on your machine, particularly the graphics card drivers. If you have a nVidia Graphics card, turn off the nView software as it's known to cause conflicts.

 See 'I've heard of incompatibilities with nVidia graphics cards and software – is there anything I can do, other than using a different graphics card?' on page 392

10. Damaged RAM can also cause some odd problems – Lightroom will find dodgy memory quicker than almost any other program.

What is deleted when I delete my Preferences file?

The obvious settings are those in the Preferences dialog, but it also includes other details such as your View Options settings, last used catalogs, last export settings, etc.

Your original photos, Develop settings, collections and suchlike are not affected by deleting the Preferences file.

You may choose to set up your Preferences and then duplicate the Preferences file, so that, should you ever have to delete a corrupted Preferences file, you can easily replace it with another clean copy and continue as normal. If you simply delete the Preferences file, another one will be created.

Interface & Toolbar

My toolbar's disappeared – where's it gone?

Press T – you've hidden it!

How do I change the tools that are shown in the toolbar?

The little arrow at the right hand end of each toolbar allows you to choose which icons to show.

Where's the Close Window button gone?

If you can't see the standard Close Window button, you're in Full Screen mode. Press F once or twice to get back to normal window mode.

It's all gone black! How do I change the view back to normal?

You're in Lights Out mode – press 'L' key once or twice until it reverts to normal view.

Where have my panels gone?

Press Tab to hide the side panels, Shift-Tab to hide all of the panels, and repeat to bring them back. Alternatively, clicking on the outside edge (black edge strip) of each panel controls the individual panel groups.

Can I change the panel auto hide options?

Right-click on the outside edge (black edge strip) of each panel and you'll have a choice of auto hide behavior.

Identity Plates

How do I create identity plates?

Go to Identity Plate Setup under the Edit menu (Windows) / Lightroom menu (Mac).

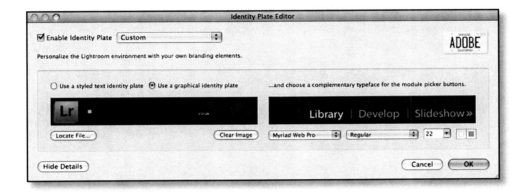

Click 'Enable Identity Plate' and select 'Use a graphical identity plate'.

Drag a photo into the space available, or use the Locate File... button to find a suitable file. Standard image formats are fine – PNG format will also allow for transparency.

You can also 'Use a styled text identity plate' and type the text of your choice.

These identity plates can be used in the Slideshow, Print and Web modules, so you'll want to save them using the popup menu to easily switch between different identity plates.

 See 'How can I overlay a graphic such as a border onto my print?' on page 350

Where has my Identity Plate gone?

Identity plates are stored within each catalog, not a global location.

If you want to be able to use the same identity plate on multiple catalogs, it's easiest to create a blank catalog, set all of your catalog settings and identity plates, and save that as a blank catalog with no photos.

In future, whenever you need to start a new catalog, you can duplicate that catalog and all of your catalog-specific settings will be ready for you.

Previews & Speed

What is the difference between Minimal previews, Standard previews and 1:1 previews?

There are a number of options to choose from when importing your photos, and which you choose will depend on your own browsing habits.

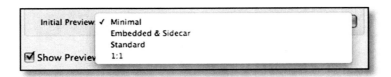

Minimal shows the thumbnail preview embedded in the file. It's the quickest option initially, but it's a very small low quality preview (i.e. usually with a black edging and about 160 px along the long edge) so you then have to wait to render previews as you browse. Minimal previews are not color managed.

Embedded & Sidecar checks the files and their sidecar files for larger previews (approx. 1024 px or larger), giving you the largest ready-built preview it can. It's still just a temporary option – Lightroom will build its own previews as soon as it can.

Standard builds a standard-sized preview used for browsing through the photos. You set the size and quality of these previews in Catalog Settings. Standard-sized previews are highly recommended – it will greatly speed up browsing performance if Lightroom isn't having to render previews on the fly.

1:1 previews are full resolution so they take up more space, but if you wish to zoom in on your photos in Library module, it will save Lightroom having to render 1:1 previews on the fly, which would slow your browsing experience. If you're concerned about the disc space that they take up, you can set them to delete after a fixed time (in Catalog Settings), or you can discard 1:1 previews on demand by selecting the photos and choosing Library menu > Previews > Discard 1:1 Previews.

You can either choose to render either Standard-Sized or 1:1 previews in the Import dialog or if you wish to render the previews later, select all (or none) of the photos in Grid view and choose Library menu > Previews > Render Standard-Sized Previews or 1:1 Previews.

In early version 1 releases, rendering previews at the same time as importing was much quicker than rendering them later, but this difference is no longer noticeable.

What size and quality should I set for Standard-Sized Previews?

In Catalog Settings > File Handling panel you can set the preview size and quality. This is a per-catalog setting, so if you use multiple catalogs, you'll want to check each catalog.

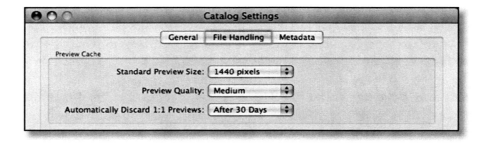

The settings you use will depend on your general browsing habits and on your screen resolution.

As a guide, choosing a size about the width of your screen is a good starting point.

Alternatively, you could try a few tests. Set to the smallest size preview and import some new photos as choosing a smaller preview size will not shrink existing previews. Browse through those photos as you usually would. If the bezel says 'Rendering: Larger Preview...' on all or most photos, you probably want to move your previews up a size.

Having increased the preview size, select all in Grid view and choose Library menu > Previews > Render Standard–Sized Previews to increase the preview size to your new setting, and browse through the photos again. Keep repeating these steps until it no longer says 'Rendering: Larger Preview...".

The quality setting, as with most things, is a tradeoff. Low and Medium quality are stored as Adobe RGB whereas High quality previews are stored as ProPhoto RGB – all of the conversions take place behind the scenes so don't be too concerned about that. Smaller previews will be quicker to load and High quality take up more space on disc as they are less compressed, but higher quality previews look better.

When I choose Render 1:1 Previews from the Library menu, does it apply to the entire catalog or just the selected photos?

If you have no photos selected, it applies to all photos in the current view, whether that is a collection, a folder, a filtered view, etc.

If you have more than 1 photo selected in Grid mode, it assumes you just want to apply to the selected photos.

If you have just 1 photo selected, version 2 now asks whether you wish to render just that one preview, or previews for all photos in the current view.

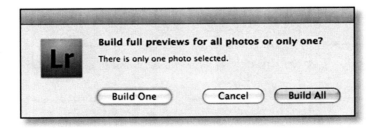

Is there any way to make Lightroom render thumbnails quicker when I'm scrolling through Grid view?

Make sure that you've rendered standard-sized previews in advance - it'll speed up Grid browsing as well as browsing in other views. Thumbnails are rendered on-the-fly due to the variety of different thumbnail sizes available.

Lightroom's slow in moving from one photo to the next in Library module - is there anything I can do to speed it up?

You can check the bezel to see what's taking the time.

'Loading from Previews...'
It's loading a cached preview from disc, so long delays could suggest slow disc read or very large preview file size. Try to keep your catalog and previews on a fast internal drive whenever possible. Having the catalog and previews on a different drive from the originals can help a little too.

'Rendering: Larger Previews...' or 'Rendering: Higher Quality'
The existing preview isn't big enough for the current zoom/screen size. Consider increasing your Standard Previews size, or render 1:1 Previews.

'Rendering: Settings Changed...'
You've made Develop changes to the photo, so it's re-rendering the preview. If you apply a preset or otherwise changed a batch of photos, consider setting it updating the previews (select the files and choose Library menu > Previews > Render Standard-Sized or 1:1 Previews) while you go and do something else. It saves the extra time updating the previews while you're looking at them, and it may only be a second per image, but that adds up!

 See 'How do I turn off the overlay which says Loading... or Rendering...?' on page 118

Lightroom's slow in moving from one photo to the next in Develop module – is there anything I can do to speed it up?

When you're in Develop module, it initially reads the existing preview, so rendering standard previews in advance is worthwhile. Next it does a quick read of the original file, frees up the sliders for you to start working, then does a full read of the original file, on the basis that you will want a much more accurate view of the photo while processing.

You can help this along by rendering Standard-Sized previews while importing or before you start processing. Then the photo snaps into view quickly and you can start evaluating changes while it continues loading the full original file.

Only once the full read has completed does the 'Loading...' bezel disappear, however you can start working on the file as soon as the sliders become available.

Disc read speed is the biggest issue on most systems, so keep the files on a fast internal drive where possible.

The previews file is huge – can I delete it?

You can, but Lightroom will have to rebuild the previews as you next view the files, and if the files are offline, it will just show grey boxes until the files are next online and the previews can be rebuilt.

Can I move the previews onto another drive?

Officially the answer's no, although it's possible to do on Mac OS using a Symbolic Link (not a standard alias). Sean McCormack wrote instructions at http://lightroom-blog.com/2007/09/moving-preview-folder-mac-osx.html

If you do put the previews on another drive, make sure it's a fast drive, as you'll need good read speeds. Disk read speed makes a big difference when switching from one

photo to the next, so avoid keeping files on a network drive, and if they'll fit on an internal drive rather than an external hard drive, that'll help a bit too.

If I delete the file, is the preview deleted too?

If you delete the photo from within Lightroom, the preview will be deleted too. There is a slight delay in deleting the preview, just in case you undo.

If you delete the file using Explorer, Finder or other software, and yet it remains within Lightroom's catalog, the preview will remain until you remove the photo from the catalog.

Why do I have to create previews? Why can't I just look at the files?

Raw files are not photos until they are converted, so there's no image to see! All raw converters create previews for you to be able to view.

Lightroom offers non-destructive editing on other file types too, such as JPEGs, TIFFs and PSDs, therefore in order to show you how your Develop settings will look without applying directly to the original, it creates a preview file.

The preview in Library module is slightly different from the preview in Develop module - why is that?

The previews you see are rendered differently between Library and Develop. Library uses a pre-rendered Adobe RGB or ProPhoto RGB compressed JPEG for speed so there will be slight losses compared to Develop which renders a preview from the original file then applies the edits you have made. Develop will always display the more accurate preview.

Lightroom appears to be creating Cache*.dat files in ACR's cache as well as its own previews – why?

Whether or not you have Photoshop installed, Lightroom uses the shared ACR cache and creates Cache*.dat preview files in that folder.

This makes it quicker to load previews in the Develop module, particularly when returning to a photo that you've just viewed. Remember the Develop module doesn't use Lightroom's previews, but builds previews directly from the original file.

Benefits aren't as noticeable at low cache sizes, so you may wish to increase the cache size, or move it to another drive.

In Lightroom's Preferences > File Handling panel, you can now change the cache size and location.

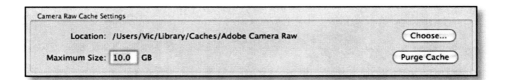

You can also change it in ACR's Preferences dialog by opening any file in ACR and select the Preferences icon (9th icon from the left).

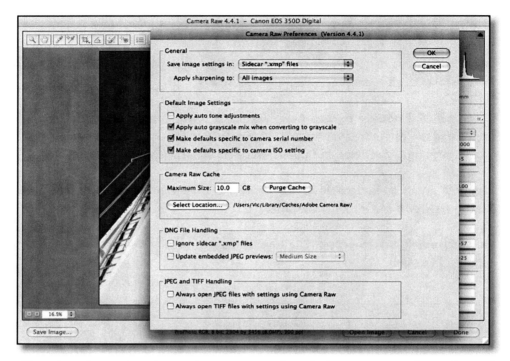

Changing the cache size or location in either dialog automatically updates the other.

Some have asked how to turn the cache off. While it's not recommended, it is possible to disable the ACR cache by making the index.dat file in the cache folder read-only.

 See 'The default location of all of the Camera Raw Cache is...' on page 396

Error Messages

I uninstalled the program, but now I want to reinstall and it won't let me as it says "A newer version already exists". How do I uninstall cleanly to be able to reinstall?

On a Mac, the key to being able to reinstall is usually to simply delete the receipt package from [systemdrive]/Library/Receipts/Adobe/Adobe Photoshop Lightroom 2.pkg

On Windows, a full uninstall should allow you to reinstall without issue.

If you continue to have problems, there is an official TechNote at: http://www.adobe.com/go/kb401119

I installed Lightroom, but it says "An error occurred while attempting to change modules". How do I fix it?

Standard troubleshooting steps apply – corrupted catalogs, corrupted preferences and presets have been known to cause similar problems.

 See 'I have a problem with Lightroom – are there any troubleshooting steps I can try?' on page 366

If that doesn't work, reinstall the latest Lightroom release – there have been some cases of the installation not copying across all of the necessary program files, or certain software removing those files.

There's a question mark in the corner of my thumbnail cell, and when I try to open the photo in Develop module it says "The file cannot be opened". Why not?

The file is missing or offline.

 See 'Lightroom thinks my photos are missing – how do I fix it?' on page 129

"Lightroom encountered an error and needs to quit"

It's most likely corrupted preferences, or perhaps a problem with the catalog, so standard troubleshooting steps apply.

 See 'I have a problem with Lightroom – are there any troubleshooting steps I can try?' on page 366 and 'My catalog appears to be corrupted – how do I rescue it?' on page 385

I tried to open my catalog but it says "The Lightroom Catalog at * cannot be used because the folder does not allow files to be created within it." How do I open my catalog?**

Check your folder and file permissions – it's likely set to read-only. Your catalog can't be on read-only media such as a DVD.

It says "There was an error working with the photo" or an exclamation mark in the corner of the thumbnail and a small fuzzy preview. What's wrong?

Unfortunately this is a corrupted file, usually caused by a damaged memory card or card reader. They don't usually even pass the import stage.

 See 'It says "Some import operations were not performed. The files appear to be unsupported or damaged."' on page 109

When you try to open the file in Develop module, it will warn you that this file cannot be opened.

The file appears to be unsupported or damaged.

If you can see a preview, but it has a black line around it, that's the camera's embedded preview. If there's a little more data available, Lightroom may try to read the full file, in which case you get a colorful pattern instead.

Either way, the data is unfortunately not readable, so try re-downloading the file from the memory card or replacing with a backup.

When I use the Browse dialog to locate a folder, the Windows Live Login dialog pops up. If I don't log in, Lightroom stops responding and I have to restart. How can I stop this?

There have been a few reports of similar problems, and a solution which works for most people. I haven't seen this issue personally to be able to test it, so I will simply repeat the information from those who have seen it.

The problem appears to be a virtual folder called "My Web Sites on MSN" – deleting that folder solved the problem in all reported cases.

You should find that folder in:

Windows XP – [systemdrive]\Documents and Settings\[your username]\Nethood\

Windows Vista – [systemdrive]\Users\[your username]\AppData\Roaming\Microsoft\Windows\Network Shortcuts\

Catalog Problems

My catalog appears to be corrupted – how do I rescue it?

If your catalog is causing issues, you can try a few rescue options:

1. Optimize the Catalog.

 See 'I have a problem with Lightroom – are there any troubleshooting steps I can try?' on page 366

2. Import the data into a new catalog – the data sometimes transfers correctly into a new catalog, leaving behind any corruption, so it's worth a try. It is likely to help narrow down the exact folder holding down the corruption, which means that most of the data, if not all, can be rescued. To do so: Start a new catalog and select File menu > Import from Catalog. Point to the corrupted catalog and import all images into the new catalog with it set to 'Add photos to catalog without moving' so that it doesn't move your original photos. It's best to do a few folders at a time if you can, as you may be able to narrow down where the corruption has occurred. A single corrupted image that has slipped past the import checks can cause repeated crashes. Once you're sure everything has moved correctly, you can delete the old catalog and carry on working on the new one you've created.

 See 'How do I create a new catalog and then switch between catalogs?' on page 58 and 'How does Import from Catalog work?' on page 60

3. Duplicate your last backup catalog and try opening that (that's why it's important to let the backup run...)

I've renamed the files outside of Lightroom and now Lightroom thinks they're missing. I've lost all of my changes! Is it possible to recover them?

As always, back up your catalog before you try any troubleshooting tips...

Did you write the settings to XMP, or have 'Automatically write changes into XMP' turned on? And is the program you used to rename XMP-aware (i.e. did it rename the XMP files at the same time?) If so, you could just reimport the renamed files into Lightroom. You'll lose anything that isn't stored in XMP, but you'll be back in business.

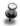 See 'Which data is not stored in XMP?' on page 282

Do you have a copy of the files before they were renamed, maybe on a DVD? If so, move the renamed files, and put the originals back where Lightroom is expecting to find them. Lightroom can then find the original files - and you can rename again using Lightroom's rename facility.

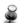 See 'Renaming' section starting on page 139

I renamed my photos inside of Lightroom, but I've accidentally deleted those renamed files from the hard drive. I do have copies of the files on DVD, but they have the original filenames, so Lightroom won't recognize them. Is it possible re-link them?

As always, back up your catalog before you try any troubleshooting tips...

You can go through and click on each question mark and link it with the correct file, but that's quite time consuming and there may be a quicker way.

1. Check in the Metadata panel and see if Lightroom still has the 'Original Filename'. If it does, and that matches the names of your backup files, you can use dummy photos to reset Lightroom back to your original names.

2. Borrow some duplicate photos – you're going to delete them once we're done, so any files of the same format will do – and name them to the same names that Lightroom's expecting to see. Obviously this is only quicker if you've used an easy naming format which can be batch renamed.

3. Put those photos in the folder that should hold the missing photos.

4. Restart Lightroom or click the question mark to link one of the missing files with the 'dummy' image.

5. Select all and choose Rename and set it to 'Original Filename'.

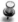 See 'Is it possible to revert to the original filename?' on page 143

6. All of the files should now be back to their original filenames, which should match your original filenames on your DVD.

7. Close Lightroom.

8. Delete the dummy photos

9. Replace with the original photos from the DVD.

10. Reopen Lightroom. Hopefully you'll be back to normal, and can rename the photos to your choice of filename.

Preview Problems

Everything in Lightroom is a funny color, but the original photos look perfect in other programs, and the exported photos don't look like they do in Lightroom either. What could be wrong?

Usually this is down to a corrupted monitor profile – Lightroom uses the profile differently to other programs (perceptual rendering rather than relative colorimetric), so corruption in that part of the profile shows up even though it is not noticeable in other programs. It often happens with the canned profiles that come with many monitors.

The easiest way to tell that Lightroom's displaying incorrectly is to check the Histogram on a grayscale image. It should be neutral, like the screenshot on the left, but corrupted profiles can create some weird color casts which also show on the Histogram, giving it the neutral display a cast (which obviously you can't see in the B&W print version of this book!)

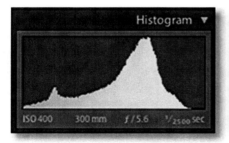 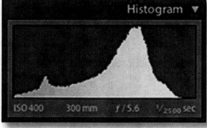

Ideally you should recalibrate your monitor using a hardware calibration tool. If you don't have such a tool, put it on your shopping list, and in the meantime, remove the corrupted monitor profile to confirm that is the problem.

 See 'How do I change my monitor profile to check whether it's corrupted?' on page 389

How do I change my monitor profile to check whether it's corrupted?

Windows XP

1. Exit Photoshop Lightroom.
2. Choose Start > Control Panel > Display.
3. Click the Settings tab.
4. Click the Advanced button.
5. Click the Color Management tab.
6. Click the "ADD..." button.
7. Choose a standard RGB color profile, such as sRGB IEC61966 – 2.1.
8. In the "Color profiles currently associated with this device" field, select the new profile you just picked.
9. Click the "Set As Default" button.
10. (Optional) Select the old profile.
11. Click the Remove button.
12. Click the "OK" button.

Windows Vista

1. Exit Photoshop Lightroom.
2. Choose Start > Control Panel > Color Management.
3. In the "Profiles associated with this device" field, select the default monitor profile.
4. Click the Advanced tab.
5. Click the Remove button. or Change the Device Profile to a standard RGB color profile, such as sRGB IEC61966 – 2.1.

Mac OS X

1. Go to System Preferences > Display
2. Select the Color tab
3. Press the Calibrate... button and follow the instructions. Turn on the Expert Options and calibrate to gamma 2.2.

Lightroom doesn't show me a preview of my PSD file in Grid view – why not?

PSD files must be saved with composite preview checked.

 See 'It says "Some import operations were not performed. The files could not be read. Please reopen the file and save with 'Maximize Compatibility' preference enabled."' on page 113

Other Problems

I have a huge problem! I accidentally deleted my photos from my hard drive and I don't have backups! There are 1:1 previews in Lightroom's catalog – is there any way of creating JPEGs from the previews?

Before you do ANYTHING else, duplicate the catalog and previews.

It's possible to retrieve the previews using Marc Rochkind's Lightroom Viewer http://basepath.com/PhotoIngester/LightroomViewer-info.php

Lightroom has slowed to a crawl – how can I speed it up?

Try the general troubleshooting steps – steps such as restarting or optimizing the catalog can make massive improvements.

 See 'I have a problem with Lightroom – are there any troubleshooting steps I can try?' on page 366

If your catalog has become too large for your existing machine specs, it may be best to split the catalog.

 See 'How does Export from Catalog work?' on page 61

For performance, it's best to stop your virus protection scanning certain files – particularly the Camera Raw cache, Lightroom's catalog and previews, and perhaps the image files too.

How do I change Lightroom's memory management?

You can't change Lightroom's memory settings as you can in Photoshop, however you don't need to, as the technology is much newer. It doesn't have a virtual memory manager – it uses the operating system instead.

You can also increase the Windows page file and restart the computer to minimize memory fragmentation – if Lightroom is giving 'Out of Memory' errors, it's running out of contiguous memory.

Does Lightroom use multiple cores?

Most operations only require a single core processor, however processor intensive functions such as Export or creating previews will use all available cores.

I've heard of incompatibilities with nVidia graphics cards and software – is there anything I can do, other than using a different graphics card?

There have been many reports of Lightroom being incompatible with the nVidia nView software, which is therefore best uninstalled or at least disabled.

Some have also found that adjusting a setting in the driver helps with sluggish behavior. If you wish to try it yourself, then find 3D Settings > Manage 3D Settings > Global Settings > Multi-display/mixed GPU Acceleration. By default it should be multiple display performance mode, however try changing this to a single display performance mode – many report that Lightroom's performance is improved as a result of this tweak.

Leopard Finder crashes when I try to view previews of photos which have Develop settings embedded. How do I fix it?

If you have done any Develop module changes settings in Lightroom on JPEGs or TIFFs or PSDs, and you have Lightroom's preferences set to "Include Develop settings in metadata inside JPEG TIFF and PSD files", then the Leopard Finder will crash if you do a "Get Info" or try and see it with preview in column view and a few other things. The same bug applies to other Apple programs.

The bug was fixed in 10.5.2, so run Software Update if you haven't already updated.

Useful Information

Preferences & Settings

Lightroom Preferences are...

Windows – under the Edit menu
Mac – under the Lightroom menu

Lightroom Catalog Settings are...

Windows – under the Edit menu
Mac – under the Lightroom menu

Photoshop Preferences are...

Windows – under the Edit menu
Mac – under the Photoshop menu

Photoshop Color Settings are...

Windows – under the Edit menu
Mac – under the Edit menu

Default File Locations

The default location of the Lightroom catalog is...

Windows XP – [systemdrive]\Documents and Settings\[your username]\My Documents\My Photos\Lightroom\Lightroom Catalog.lrcat

Windows Vista – [systemdrive]\Users\[your username]\Photos\Lightroom\Lightroom Catalog.lrcat

Mac – [systemdrive]/Users/[your username]/Photos/Lightroom/ Lightroom Catalog. lrcat

The catalogs are now fully cross platform, and the catalog file extensions are:
*.lrcat is version 1.1 onwards.
*.lrdb was version 1.0.
*.aglib was the early beta.

The default location of the Preferences is...

Windows XP – [systemdrive]\Documents and Settings\[your username]\Application Data\Adobe\Lightroom\Preferences\Lightroom 2 Preferences.agprefs

Windows Vista – [systemdrive]\Users\[your username]\AppData\Roaming\Adobe\ Lightroom\Lightroom 2 Preferences.agprefs

Mac – [systemdrive]/Users/[your username]/Library/Preferences/com.adobe. Lightroom2.plist

Preference files are not cross-platform.

The default location of the Presets is...

Windows XP – [systemdrive]\Documents and Settings\[your username]\Application Data\Adobe\Lightroom\Presets\

Windows Vista – [systemdrive]\Users\[your username]\AppData\Roaming\Adobe\Lightroom\Presets\

Mac – [systemdrive]/Users/[your username]/Library/Application Support/Adobe/Lightroom/Presets/

Presets are cross-platform and are saved in a Lightroom only format (.lrtemplate)

To find them easily, go to Preferences > Presets panel and press 'Show Lightroom Presets Folder..'

The default location of all of the Camera Raw Cache is...

Windows XP – [systemdrive]\Documents and Settings\[your username]\Application Data\Adobe\CameraRaw\Cache\

Windows Vista – [systemdrive]\Users\[your username]\AppData\Local\Adobe\CameraRaw\Cache\

Mac – [systemdrive]/Users/[your username]/Library/Caches/Adobe Camera Raw/

The default location of the Adobe Camera Raw Profiles is...

Windows XP – [systemdrive]\Documents and Settings\All Users\Local Settings\ Application Data\Adobe\CameraRaw\Cache\

Windows Vista – [systemdrive]\Users\[your username]\AppData\Roaming\Adobe\ CameraRaw\CameraProfiles\

Mac – [systemdrive]/Library/Application Support/Adobe/CameraRaw/ CameraProfiles/

Your custom Camera Raw Profiles can also be installed to the User folders...

Windows XP – [systemdrive]\Documents and Settings\[your username]\Application Data\Adobe\CameraRaw\CameraProfiles\

Windows Vista – [systemdrive]\Users\[your username]\AppData\Local\Adobe\ CameraRaw\CameraProfiles\

Mac – [systemdrive]/Users/[your username]/Library/Application Support/Adobe/ CameraRaw/CameraProfiles/

Hidden Files

How do I show hidden files?

Windows XP or Vista:

1. Go to Start menu and go to Control Panel.
2. Select Folder Options (under Appearance and Personalization if in Category view).
3. Click the View panel.
4. Under Advanced settings, click Show hidden files and folders.
5. Click OK.

64-bit

I've heard Lightroom 2.0 is now 64-bit. How is that beneficial?

For many functions, such as building previews or doing large exports, it won't make a big difference as those are mainly tied to disc I/O speeds. It may be faster for general processing speed though, and Vista 64-bit operating system running the 64-bit version shouldn't particularly see 'Out of Memory' errors.

 See 'How do I change Lightroom's memory management?' on page 392

How do I install the 64-bit version?

For Windows, the installation package will automatically install the 32-bit version unless you are running Windows Vista 64-bit. Windows XP 64-bit is not officially supported, however should you wish to attempt it, both installers are available in the same download.

For the Mac OS, find the Adobe Lightroom 2 application in the Applications folder, select it, and choose Get Info from the right-click menu. Uncheck the 'Open in 32 Bit Mode' checkbox to convert the application to 64-bit.

My Mac version doesn't have an 'Open as 32-bit' checkbox. Why not?

A 64-bit processor is required, and PowerPC's and the earliest Intel Macs didn't have 64-bit processors. If your Mac doesn't have a 64-bit processor, the checkbox won't appear in the Info dialog.

If you do have a recent Intel Mac, make sure you're checking Info from Finder and not a Finder-alternative – some such as Path Finder don't show the checkbox even on machines where 64-bit is available.

Licensing Information

I'm switching from PC to Mac – how do I switch my Lightroom license?

The license is cross platform, and the same license key and program CD work on both Windows and Mac.

How many machines can I install Lightroom on?

You can install it on up to 2 machines, and they can either both be Windows, both be Mac, or one of each. You're not allowed to use Lightroom on both machines simultaneously.

How do I deactivate Lightroom to move it to another machine?

There is currently no activation on Lightroom.

Trials & Downloads

Is the download on Adobe's website the full program or just an update?

The trial download and updates are all the full program, and there's no need to install a previous version first if you have to reinstall – you can jump straight to the latest download.

I'm having problems accessing the Adobe website to download the update – can I download it elsewhere?

The direct Adobe FTP server links are:

Windows: ftp://ftp.adobe.com/pub/adobe/lightroom/win/
Mac: ftp://ftp.adobe.com/pub/adobe/lightroom/mac/

I'm Still Stuck!

Where else can I go to find solutions to my problems that aren't covered here?

Adobe Wiki for Lightroom:
>http://learn.adobe.com/wiki/display/Lightroom/Home/

Lightroom Forums:
>http://www.lightroomforums.net

Adobe User to User forums:
>http://www.adobeforums.com/cgi-bin/webx/.3bc2cf0a/

Keyboard Shortcuts

Shortcuts

On the following pages are all of the known keyboard shortcuts for Adobe Lightroom, both the Windows and Mac versions.

The shortcuts are also available in printable format from the Lightroom Queen website: http://www.lightroomqueen.com/lrqshortcuts.php

As new shortcuts are discovered, the updated list will be available for free download from that same page.

If you find a new keyboard shortcut, or a change in the following lists, please feel free to report it via email to victoria@lightroomqueen.com. Thank you!

Windows Keyboard Shortcuts

Catalog Facilities	Library	Develop	Slideshow	Print	Web
Open Catalog	Ctrl–O	Ctrl–O	Ctrl–O	Ctrl–O	Ctrl–O
Save Metadata to File (XMP)	Ctrl–S	Ctrl–S	Ctrl–S	Ctrl–S	Ctrl–S
Module Navigation	Library	Develop	Slideshow	Print	Web
Go to Library Compare Mode	C	C	C	C	C
Go to Library Loupe Mode	E or Enter	E	E	E	E
Go to Library Grid Mode	G	G	G	G	G
Go to Library Survey Mode	N	–	–	–	–
Return to Grid View from another Library Mode	Esc	–	–	–	–
Go to Library Module	Ctrl–Alt–1	Ctrl–Alt–1	Ctrl–Alt–1	Ctrl–Alt–1	Ctrl–Alt–1
Go to Develop Module	D or Ctrl–Alt–2	Ctrl–Alt–2	D or Ctrl–Alt–2	D or Ctrl–Alt–2	D or Ctrl–Alt–2
Go to Slideshow Module	Ctrl–Alt–3	Ctrl–Alt–3	Ctrl–Alt–3	Ctrl–Alt–3	Ctrl–Alt–3
Go to Print Module	Ctrl–Alt–4	Ctrl–Alt–4	Ctrl–Alt–4	Ctrl–Alt–4	Ctrl–Alt–4
Go to Web Module	Ctrl–Alt–5	Ctrl–Alt–5	Ctrl–Alt–5	Ctrl–Alt–5	Ctrl–Alt–5
Return to Previous Module	Ctrl–Alt–Up Arrow	Ctrl–Alt–Up Arrow	Ctrl–Alt–Up Arrow	Ctrl–Alt–Up Arrow	Ctrl–Alt–Up Arrow
Show/Hide Panels	Library	Develop	Slideshow	Print	Web
Show/Hide Toolbar	T	T	T	T	T
Show/Hide Side Panels	Tab	Tab	Tab	Tab	Tab
Show/Hide All Panels (excl. toolbar)	Shft–Tab	Shft–Tab	Shft–Tab	Shft–Tab	Shft–Tab

Show Module Picker	F5	–	–	–	–
Show Filmstrip	F6				
Show/Hide Left Panel	F7				
Show/Hide Right Panel	F8				
Cycle through Screen Modes	F	F	F	F	F
Full Screen & Hide All Panels	Ctrl-Shft-F	Ctrl-Shft-F	Ctrl-Shft-F	Ctrl-Shft-F	Ctrl-Shft-F
Normal Screen Mode	Ctrl-Alt-F	Ctrl-Alt-F	Ctrl-Alt-F	Ctrl-Alt-F	Ctrl-Alt-F
Cycle the Lights Out Modes	L	L	L	L	L
Go to Lights Dim Mode	Ctrl-Shft-L	Ctrl-Shft-L	Ctrl-Shft-L	Ctrl-Shft-L	Ctrl-Shft-L
Left Panel:					
Open/Close Navigator/Preview Palette	Ctrl-Shft-0	Ctrl-Shft-0	Ctrl-Shft-0	Ctrl-Shft-0	Ctrl-Shft-0
Open/Close 1st Left Palette	Ctrl-Shft-1 (Catalog)	Ctrl-Shft-1 (Presets)	Ctrl-Shft-1 (Template Browser)	Ctrl-Shft-1 (Template Browser)	Ctrl-Shft-1 (Template Browser)
Open/Close 2nd Left Palette	Ctrl-Shft-2 (Folders)	Ctrl-Shft-2 (Snapshots)	Ctrl-Shft-2 (Collections)	Ctrl-Shft-2 (Collections)	Ctrl-Shft-2 (Collections)
Open/Close 3rd Left Palette	Ctrl-Shft-3 (Collections)	Ctrl-Shft-3 (History)	Ctrl-Shft-3 (Content)	Ctrl-Shft-3 (Content)	Ctrl-Shft-3 (Content)
Open/Close 4th Left Palette	–	–	–	–	–
Open/Close 5th Left Palette	–	–	–	–	–
Open/Close 6th Left Palette	–	–	–	–	–
Right Panel:					
Open/Close Histogram Palette	Ctrl-0 (Histogram)	Ctrl-0 (Histogram)	–	–	–

Open/Close 1st Right Palette	Ctrl–1 (Quick Develop)	Ctrl–1 (Basic)	Ctrl–1 (Options)	Ctrl–1 (Image Settings)	Ctrl–1 (Gallery)
Open/Close 2nd Right Palette	Ctrl–2 (Keywording)	Ctrl–2 (Tone Curve)	Ctrl–2 (Layout)	Ctrl–2 (Layout Engine)	Ctrl–2 (Site Info)
Open/Close 3rd Right Palette	Ctrl–3 (Keyword List)	Ctrl–3 (HSL/ Color/ Grayscale)	Ctrl–3 (Overlays)	Ctrl–3 (Layout)	Ctrl–3 (Color Palette)
Open/Close 4th Right Palette	Ctrl–4 (Metadata)	Ctrl–4 (Split Toning)	Ctrl–4 (Backdrop)	Ctrl–4 (Overlays)	Ctrl–4 (Appearance)
Open/Close 5th Right Palette	–	Ctrl–5 (Detail)	Ctrl–5 (Playback)	Ctrl–5 (Print Job)	Ctrl–5 (Image Info)
Open/Close 6th Right Palette	–	Ctrl–6 (Vignettes)	–	–	Ctrl–6 (Output Settings)
Open/Close 7th Right Palette	–	Ctrl–7 (Camera Calibration)	–	–	Ctrl–7 (Upload Settings)
Open/Close 8th Right Palette	–	Ctrl–8 (Retouch)	–	–	–
Expand/Collapse All Palettes	Ctrl-Click on panel name	Ctrl-Click on panel name	Ctrl-Click on panel name	Ctrl-Click on panel name	Ctrl-Click on panel name
Solo Mode On/Off	Alt-Click on panel name	Alt-Click on panel name	Alt-Click on panel name	Alt-Click on panel name	Alt-Click on panel name
Open additional panel without closing previous	Shft-Click on panel name	Shft-Click on panel name	Shft-Click on panel name	Shft-Click on panel name	Shft-Click on panel name
View Extras	**Library**	**Develop**	**Slideshow**	**Print**	**Web**
Cycle through Grid Modes	J	–	–	–	–
Show Cell Extras	Ctrl-Shft-H	–	–	–	–
Show Badges	Ctrl-Alt-Shft-H	–	–	–	–
Show/Hide Guides	–	–	Ctrl-Shft-H	Ctrl-Shft-H	–
Show Margins & Guides	–	–	–	Ctrl-Shft-M	–
Show Rulers	–	–	–	Ctrl-R	–

Show Image Cells	–	–	–	Ctrl–Alt–T	–
Show Character Palette	Ctrl–Alt–T	Ctrl–Alt–T	Ctrl–Alt–T	Ctrl–Alt–T	Ctrl–Alt–T
Show Page Bleed	–	–	–	Ctrl–Shft–Y	–
Cycle Info Display	I	I	–	–	–
Show Info Display	Ctrl–I	Ctrl–I	–	–	–
View Options dialog	Ctrl–J	Ctrl–J	–	–	–
Zoom	**Library**	**Develop**	**Slideshow**	**Print**	**Web**
Toggle Zoom View (last 2 settings used)	Z or Space	Z	–	–	–
Zoom In (4 major zoom increments)	Ctrl–+	–	–	–	–
Zoom Out (4 major zoom increments)	Ctrl–– (minus key)	–	–	–	–
Zoom In (minor increments)	Ctrl–Alt–+	–	–	–	–
Zoom Out (minor increments)	Ctrl–Alt–– (minus key)	–	–	–	–
Enter Loupe or 1:1 View	Return	–	–	–	–
Scroll Down Image	Page Down (1:1 view +)	Page Down (1:1 view +)	–	–	–
Scroll Up Image	Page Up (1:1 view +)	Page Up (1:1 view +)	–	–	–
Dual Displays	**Library**	**Develop**	**Slideshow**	**Print**	**Web**
Show Second Display	F11	F11	F11	F11	F11
Second Display Full Screen	Shft–F11	Shft–F11	Shft–F11	Shft–F11	Shft–F11

Grid on Second Display	Shft–G	Shft–G	Shft–G	Shft–G	Shft–G
Loupe on Second Display	Shft–E	Shft–E	Shft–E	Shft–E	Shft–E
Locked Loupe on Second Display	Ctrl–Shft–Enter	Ctrl–Shft–Enter	Ctrl–Shft–Enter	Ctrl–Shft–Enter	Ctrl–Shft–Enter
Compare on Second Display	Shft–C	Shft–C	Shft–C	Shft–C	Shft–C
Survey on Second Display	Shft–N	Shft–N	Shft–N	Shft–N	Shft–N
Show Filter Bar on Second Display	Shft–\	Shft–\	Shft–\	Shft–\	Shft–\
Lock selected photo to Second Display	Cmd–Shft–Enter	–	–	–	–
Zoom In on Second Display (4 major zoom increments)	Ctrl–Shft–=	Ctrl–Shft–=	Ctrl–Shft–=	Ctrl–Shft–=	Ctrl–Shft–=
Zoom Out on Second Display (4 major zoom increments)	Ctrl–Shft–– (minus key)	Ctrl–Shft–– (minus key)	Ctrl–Shft–– (minus key)	Ctrl–Shft–– (minus key)	Ctrl–Shft–– (minus key)
Zoom In on Second Display (minor increments)	Ctrl–Alt–Shft–=	Ctrl–Alt–Shft–=	Ctrl–Alt–Shft–=	Ctrl–Alt–Shft–=	Ctrl–Alt–Shft–=
Zoom Out on Second Display (minor increments)	Ctrl–Alt–Shft–– (minus key)	Ctrl–Alt–Shft–– (minus key)	Ctrl–Alt–Shft–– (minus key)	Ctrl–Alt–Shft–– (minus key)	Ctrl–Alt–Shft–– (minus key)
Increase Thumbnail Size on Second Display	=	=	=	=	=
Decrease Thumbnail Size on Second Display	– (minus key)	– (minus key)	– (minus key)	– (minus key)	– (minus key)
Importing and Exporting	**Library**	**Develop**	**Slideshow**	**Print**	**Web**
Import Photos from Disk	Ctrl–Shft–I	Ctrl–Shft–I	Ctrl–Shft–I	Ctrl–Shft–I	Ctrl–Shft–I
Export Photos	Ctrl–Shft–E	Ctrl–Shft–E	Ctrl–Shft–E	Ctrl–Shft–E	Ctrl–Shft–E
Export Photos as Previous	Ctrl–Alt–Shft–E	Ctrl–Alt–Shft–E	Ctrl–Alt–Shft–E	Ctrl–Alt–Shft–E	Ctrl–Alt–Shft–E
Edit in Photoshop	Ctrl–E	Ctrl–E	–	–	–
Edit in Other Application	Ctrl–Alt–E	Ctrl–Alt–E	–	–	–

New Collection	Ctrl-N	-	-	-	-
New Folder	Ctrl-Shft-N	-	-	-	-
Reveal in Finder	Ctrl-R	-	-	-	-
Plugin Manager	Ctrl-Alt-Shft-,	Ctrl-Alt-Shft-,	Ctrl-Alt-Shft-,	Ctrl-Alt-Shft-,	Ctrl-Alt-Shft-,
Viewing / Sorting Photos	**Library**	**Develop**	**Slideshow**	**Print**	**Web**
Select All	Ctrl-A	Ctrl-A	Ctrl-A	Ctrl-A	Ctrl-A
Select All Flagged Photos	Ctrl-Alt-A	-	-	-	-
Select None	Ctrl-D	Ctrl-D	Ctrl-D	Ctrl-D	Ctrl-D
Select Only Active Photo	Ctrl-Shft-D	-	-	-	-
Deselect Active Photo	/				
Deselect Unflagged Photos	Ctrl-Alt-Shft-D	-	-	-	-
Go to Previous Photo	Left Arrow	-	-	-	-
Go to Next Photo	Right Arrow	-	-	-	-
Add Previous Photo to Selection	Shft-Left Arrow	-	-	-	-
Add Next Photo to Selection	Shft-Right Arrow	-	-	-	-
Go to Previous Selected Photo	Ctrl-Left Arrow	Ctrl-Left Arrow	-	-	-
Go to Next Selected Photo	Ctrl-Right Arrow	Ctrl-Right Arrow	-	-	-
Scroll Down Screen	Page Down (Grid view)	-	-	-	-

Scroll Up Screen	Page Up (Grid view)	–	–	–	–
Rename Photos	F2	–	–	–	–
Rotate Left	Ctrl–[Ctrl–[Ctrl–[–	–
Rotate Right	Ctrl–]	Ctrl–]	Ctrl–]	–	–
Flag / Pick	P	P	P	P	P
Flag / Pick and Move to Next Photo	Shft–P or Caps Lock On + P	Shft–P or Caps Lock On + P	Shft–P or Caps Lock On + P	Shft–P or Caps Lock On + P	Shft–P or Caps Lock On + P
Unflagged	U	U	U	U	U
Unflagged and Move to Next Photo	Shft–U or Caps Lock On + U	Shft–U or Caps Lock On + U	Shft–U or Caps Lock On + U	Shft–U or Caps Lock On + U	Shft–U or Caps Lock On + U
Rejected	X	X	X	X	X
Rejected and Move to Next Photo	Shft–X or Caps Lock On + X	Shft–X or Caps Lock On + X	Shft–X or Caps Lock On + X	Shft–X or Caps Lock On + X	Shft–X or Caps Lock On + X
Toggle Flag	'	'	'	'	'
Increase Flag Status	Ctrl–Up Arrow	Ctrl–Up Arrow	Ctrl–Up Arrow	Ctrl–Up Arrow	Ctrl–Up Arrow
Decrease Flag Status	Ctrl–Down Arrow	Ctrl–Down Arrow	Ctrl–Down Arrow	Ctrl–Down Arrow	Ctrl–Down Arrow
Delete Photo / Remove from Library dialog	Bksp	Bksp	Bksp	Bksp	Bksp
Remove from Catalog	Alt–Bksp	Alt–Bksp	Alt–Bksp	Alt–Bksp	Alt–Bksp
Delete Rejected Photos	Ctrl–Bksp	Ctrl–Bksp	Ctrl–Bksp	Ctrl–Bksp	Ctrl–Bksp
Remove & Send to Recycle Bin	Ctrl–Alt–Shft–Bksp	Ctrl–Alt–Shft–Bksp	Ctrl–Alt–Shft–Bksp	Ctrl–Alt–Shft–Bksp	Ctrl–Alt–Shft–Bksp

Set Rating to 0 / Remove Rating	0	0	0	0	0
Set Rating to 1-5	1-5	1-5	1-5	1-5	1-5
Set Rating to 1-5 and Move to Next Photo	Shft-(1-5)	Shft-(1-5)	Shft-(1-5)	Shft-(1-5)	Shft-(1-5)
Decrease the Rating	[[[[[
Increase the Rating]]]]]
Set Label to Red, Yellow, Green, Blue	6-9	6-9	6-9	6-9	6-9
Set Label to RYGB and Move to Next Photo	Shft-(6-9) or Caps Lock On + (6-9)	Shft-(6-9) or Caps Lock On + (6-9)	Shft-(6-9) or Caps Lock On + (6-9)	Shft-(6-9) or Caps Lock On + (6-9)	Shft-(6-9) or Caps Lock On + (6-9)
Add Keywords to selected photo	Ctrl-K	-	-	-	-
Change Keywords for selected photo	Ctrl-Shft-K	-	-	-	-
Add Shortcut Keyword	Alt-K	-	-	-	-
Change Shortcut Keywords	Ctrl-K	-	-	-	-
Set Keyword Shortcut	Ctrl-Alt-Shft-K	-	-	-	-
Enable/Disable Painting (Tagging)	Ctrl-Alt-K	-	-	-	-
Set Keyword Number 1-9 (see menu)	Alt-(1-9)	Alt-(1-9)	-	-	-
Next Keyword Set	Alt-0	-	-	-	-
Show Filter Bar	\	-	-	-	-
Find...	Ctrl-F	-	-	-	-
Enable Filter	Ctrl-L	Ctrl-L	Ctrl-L	Ctrl-L	Ctrl-L

Select Multiple Folders / Collections / Keywords / Metadata Fields	Ctrl-Click on name	–	–	–	–
Select Filters – Text & Refine & Metadata	Shft-Click on Text & Refine & Metadata	–	–	–	–
Stack Photos	Ctrl-G	–	–	–	–
Unstack Photos	Ctrl-Shft-G	–	–	–	–
Toggle Stack	S	–	–	–	–
Move to Top of Stack	Shft-S	–	–	–	–
Move Up in Stack	Shft-[–	–	–	–
Move Down in Stack	Shft-]	–	–	–	–
Compare Mode – swap images	Down Arrow	–	–	–	–
Compare Mode – make select	Up Arrow	–	–	–	–
Create Virtual Copy	Ctrl -'	Ctrl -'	–	–	–
Metadata	**Library**	**Develop**	**Slideshow**	**Print**	**Web**
Cut (standard cut text, not images)	Ctrl-X	Ctrl-X	Ctrl-X	Ctrl-X	Ctrl-X
Copy (standard copy text, not images)	Ctrl-C	Ctrl-C	Ctrl-C	Ctrl-C	Ctrl-C
Copy Metadata	Ctrl-Alt-Shft-C	–	–	–	–
Paste (standard paste text, not images)	Ctrl-V	Ctrl-V	Ctrl-V	Ctrl-V	Ctrl-V
Paste / Sync Metadata	Ctrl-Alt-Shft-V	–	–	–	–

Quick Collection	Library	Develop	Slideshow	Print	Web
Add to Quick Collection	B	B	B	B	B
Show the Quick Collection	Ctrl-B	Ctrl-B	Ctrl-B	Ctrl-B	Ctrl-B
Save the Quick Collection	Ctrl-Alt-B	Ctrl-Alt-B	Ctrl-Alt-B	Ctrl-Alt-B	Ctrl-Alt-B
Clear the Quick Collection	Ctrl-Shft-B	Ctrl-Shft-B	Ctrl-Shft-B	Ctrl-Shft-B	Ctrl-Shft-B
Set as Target Collection	Ctrl-Shft-Alt-B	-	-	-	
Quick Slideshow	**Library**	**Develop**	**Slideshow**	**Print**	**Web**
Show Selected Photos in Quick Slideshow	Ctrl-Return	-	-	-	-
Developing	**Library**	**Develop**	**Slideshow**	**Print**	**Web**
Sync Settings	Ctrl-Shft-S	Ctrl-Shft-S	-	-	-
Sync Settings bypassing Dialog	-	Ctrl-Alt-S	-	-	-
Auto Sync	-	Ctrl-Click on Sync button	-	-	-
Copy Develop Settings	Ctrl-Shft-C	Ctrl-Shft-C	-	-	-
Paste Develop Settings	Ctrl-Shft-V	Ctrl-Shft-V	-	-	-
Paste Develop Settings from Previous	Ctrl-Alt-V	Ctrl-Alt-V	-	-	-
Copy After's Settings to Before	-	Ctrl-Alt-Shft-Left Arrow	-	-	-
Copy Before's Settings to After	-	Ctrl-Alt-Shft-Right Arrow	-	-	-
Swap Before/After's Settings	-	Ctrl-Alt-Shft-Up Arrow	-	-	-
Reset All Develop Settings	Ctrl-Shft-R	Ctrl-Shft-R	-	-	-

Reset Single Section	–	Hold Alt and Reset buttons appear	–	–	–
Reset Single Slider	–	Double click on slider label or slider	–	–	–
Undo Last Action	Ctrl-Z	Ctrl-Z	Ctrl-Z	Ctrl-Z	Ctrl-Z
Redo Last Action	Ctrl-Y	Ctrl-Y	Ctrl-Y	Ctrl-Y	Ctrl-Y
Auto Tone	Ctrl-U	Ctrl-U	–	–	–
Auto White Balance	Ctrl-Shft-U	Ctrl-Shft-U	–	–	–
Convert to Grayscale	V	V	–	–	–
Go to White Balance in Develop Mode	W	W	–	–	–
Increase Selected Slider (default Exposure)	–	+	–	–	–
Decrease Selected Slider (default Exposure)	–	– (minus key)	–	–	–
Increase Selected Slider (larger increments)	–	Shft-+	–	–	–
Decrease Selected Slider (larger increments)	–	Shft-- (minus key)	–	–	–
Move forwards through sliders	–	.	–	–	–
Move backwards through sliders	–	,	–	–	–
	–	;	–	–	–
Show Clipping	–	J	–	–	–
Temporary Show Clipping		Hold down Alt while move slider			

Cycle Grid Overlay	–	O	–	–	–
Go to Crop in Develop Mode	R	R	R	R	R
Crop – Toggle Constrain Aspect Ratio	–	A	–	–	–
Crop to Same Aspect Ratio	–	S	–	–	–
Reset Crop	–	Ctrl-Alt-R	–	–	–
Crop grows from Center	–	Alt while drag corner	–	–	–
Cycle the Crop Overlay on and off	–	H	–	–	–
Cycle the Crop Overlay Style	–	O	–	–	–
Cycle the Overlay Orientation	–	Shft-O	–	–	–
No Target Adjustment Tool	–	Ctrl-Alt-Shft-N	–	–	–
Target Adjustment Tool – Grayscale Mix	–	Ctrl-Alt-Shft-G	–	–	–
Target Adjustment Tool – Hue	–	Ctrl-Alt-Shft-H	–	–	–
Target Adjustment Tool – Saturation	–	Ctrl-Alt-Shft-S	–	–	–
Target Adjustment Tool – Luminance	–	Ctrl-Alt-Shft-L	–	–	–
Target Adjustment Tool – Tone Curve	–	Ctrl-Alt-Shft-T	–	–	–
Enter Spot Healing Mode	–	N	–	–	–
Increase Brush Size	–]	–	–	–
Decrease Brush Size	–	[
Change Size of Existing Spot	–	Drag edge of spot	–	–	–
Delete Spot	–	Select spot, Delete	–	–	–

Hide Spot	–	H	–	–	–
Hand Tool in Spot Mode	–	Space	–	–	–
Go to Adjustment Brush in Develop Mode	K	K	K	K	K
Graduated Filter Tool	–	M	–	–	–
Increase Brush Size	–]	–	–	–
Decrease Brush Size	–	[–	–	–
Increase Brush Feathering	–	Shft-]	–	–	–
Decrease Brush Feathering	–	Shft=[–	–	–
Commit Changes	–	Enter Loupe or 1:1 View	–	–	–
Delete Currently Selected Mask	–	Delete	–	–	–
Change Brush to Eraser	–	Hold Alt while brushing	–	–	–
Switch A/B Brushes	–	/	–	–	–
Draw a horizontal or vertical line	–	Hold Shft while brushing	–	–	–
Increase/Decrease Amount Slider	–	Drag mask pin left/ right	–	–	–
Show Mask Overlay	–	0	–	–	–
Cycle through Mask Overlay colors	–	Shft-O	–	–	–
Show/Hide Mask Pins	–	H	–	–	–
New Snapshot	–	Ctrl-N	–	–	–
New Preset	–	Ctrl-Shft-N	--	–	–
New Preset Folder	–	Ctrl-Alt-N	--	–	–

View Before Only	-	\	-	-	-
View Before/After Left/Right	-	Y	-	-	-
View Before/After Up/Down	-	Alt-Y	-	-	-
View Before/After Split Screen	-	Shft-Y	-	-	-
Slideshow / Print / Web Gallery	Library	Develop	Slideshow	Print	Web
New Template	-	-	Ctrl-N	Ctrl-N	-
New Template Folder / Preset Folder	-	-	Ctrl-Shft-N	Ctrl-Shft-N	Ctrl-Shft-N
Save Settings	-	-	Ctrl-S	Ctrl-S	Ctrl-S
Add Text Overlay	-	-	Ctrl-T	-	-
Show/Hide Guides	-	-	Ctrl-Shft-T	Ctrl-Shft-T	-
Guides - Page Bleed	-	-	-	Ctrl-Shft-Y	-
Guides - Margins & Gutter	-	-	-	Ctrl-Shft-M	-
Guides - Image Cells	-	-	-	Ctrl-Shft-T	-
Guides - Dimensions	-	-	-	Ctrl-Shft-U	-
Play Slideshow	-	-	Return	-	-
Preview Slideshow	-	-	Alt-Return	-	-
Pause Slideshow	-	-	Space	-	-
End Slideshow	-	-	Esc	-	-
Go to Next Slide	-	-	Ctrl-Left Arrow	-	-
Go to Previous Slide	-	-	Ctrl-Right Arrow	-	-

Go to Previous Page	-	-	-	Ctrl–Left Arrow	-
Go to Next Page	-	-	-	Ctrl–Right Arrow	-
Go to First Page	-	-	-	Ctrl–Shft–Left Arrow	-
Go to Last Page	-	-	-	Ctrl–Shft–Right Arrow	-
Print	Ctrl–P	Ctrl–P	Ctrl–P	Ctrl–P	Ctrl–P
Print One Copy	-	-	-	Ctrl–Alt–P	-
Page Setup	Ctrl–Shft–P	Ctrl–Shft–P	Ctrl–Shft–P	Ctrl–Shft–P	Ctrl–Shft–P
Print Settings	-	-	-	Ctrl–Shft–Alt–P	-
Reload Web Gallery	-	-	-	-	Ctrl–R
Preview Web Gallery in Browser	-	-	-	-	Ctrl–Alt–P
Export Slideshow	-	-	Ctrl–J	-	-
Export Web Gallery	-	-	-	-	Ctrl–J
Standard Shortcuts	Library	Develop	Slideshow	Print	Web
Help	F1	Ctrl–?	Ctrl–?	Ctrl–?	Ctrl–?
Preferences	Ctrl–,	Ctrl–,	Ctrl–,	Ctrl–,	Ctrl–,
Catalog Settings	Ctrl–Alt–,	Ctrl–Alt–,	Ctrl–Alt–,	Ctrl–Alt–,	Ctrl–Alt–,
Close Window	Ctrl–W	Ctrl–W	Ctrl–W	Ctrl–W	Ctrl–W

Mac Keyboard Shortcuts

Catalog Facilities	Library	Develop	Slideshow	Print	Web
Open Catalog	Cmd-O	Cmd-O	Cmd-O	Cmd-O	Cmd-O
Save Metadata to File (XMP)	Cmd-S	Cmd-S	Cmd-S	Cmd-S	Cmd-S
Module Navigation	Library	Develop	Slideshow	Print	Web
Go to Library Compare Mode	C	C	C	C	C
Go to Library Loupe Mode	E or Enter	E	E	E	E
Go to Library Grid Mode	G	G	G	G	G
Go to Library Survey Mode	N	-	-	-	-
Return to Grid View from another Library Mode	Esc	-	-	-	-
Go to Library Module	Cmd-Opt-1	Cmd-Opt-1	Cmd-Opt-1	Cmd-Opt-1	Cmd-Opt-1
Go to Develop Module	D or Cmd-Opt-2	Cmd-Opt-2	D or Cmd-Opt-2	D or Cmd-Opt-2	D or Cmd-Opt-2
Go to Slideshow Module	Cmd-Opt-3	Cmd-Opt-3	Cmd-Opt-3	Cmd-Opt-3	Cmd-Opt-3
Go to Print Module	Cmd-Opt-4	Cmd-Opt-4	Cmd-Opt-4	Cmd-Opt-4	Cmd-Opt-4
Go to Web Module	Cmd-Opt-5	Cmd-Opt-5	Cmd-Opt-5	Cmd-Opt-5	Cmd-Opt-5
Return to Previous Module	Cmd-Opt-Up Arrow	Cmd-Opt-Up Arrow	Cmd-Opt-Up Arrow	Cmd-Opt-Up Arrow	Cmd-Opt-Up Arrow
Show/Hide Panels	Library	Develop	Slideshow	Print	Web
Show/Hide Toolbar	T	T	T	T	T
Show/Hide Side Panels	Tab	Tab	Tab	Tab	Tab
Show/Hide All Panels (excl. toolbar)	Shft-Tab	Shft-Tab	Shft-Tab	Shft-Tab	Shft-Tab

Show Module Picker	F5	–	–	–	–
Show Filmstrip	F6				
Show/Hide Left Panel	F7				
Show/Hide Right Panel	F8				
Cycle through Screen Modes	F	F	F	F	F
Full Screen & Hide All Panels	Cmd–Shft–F	Cmd–Shft–F	Cmd–Shft–F	Cmd–Shft–F	Cmd–Shft–F
Normal Screen Mode	Cmd–Opt–F	Cmd–Opt–F	Cmd–Opt–F	Cmd–Opt–F	Cmd–Opt–F
Cycle the Lights Out Modes	L	L	L	L	L
Go to Lights Dim Mode	Cmd–Shft–L	Cmd–Shft–L	Cmd–Shft–L	Cmd–Shft–L	Cmd–Shft–L
Left Panel:					
Open/Close Navigator/Pre-view Palette	Cmd–Ctrl–0	Cmd–Ctrl–0	Cmd–Ctrl–0	Cmd–Ctrl–0	Cmd–Ctrl–0
Open/Close 1st Left Palette	Cmd–Ctrl–1 (Catalog)	Cmd–Ctrl–1 (Presets)	Cmd–Ctrl–1 (Template Browser)	Cmd–Ctrl–1 (Template Browser)	Cmd–Ctrl–1 (Template Browser)
Open/Close 2nd Left Palette	Cmd–Ctrl–2 (Folders)	Cmd–Ctrl–2 (Snapshots)	Cmd–Ctrl–2 (Collections)	Cmd–Ctrl–2 (Collections)	Cmd–Ctrl–2 (Collections)
Open/Close 3rd Left Palette	Cmd–Ctrl–3 (Collections)	Cmd–Ctrl–3 (History)	Cmd–Ctrl–3 (Content)	Cmd–Ctrl–3 (Content)	Cmd–Ctrl–3 (Content)
Open/Close 4th Left Palette	–	–	–	–	–
Open/Close 5th Left Palette	–	–	–	–	–
Open/Close 6th Left Palette	–	–	–	–	–
Right Panel:					
Open/Close Histogram Palette	Cmd–0 (Histogram)	Cmd–0 (Histogram)	–	–	–

Open/Close 1st Right Palette	Cmd-1 (Quick Develop)	Cmd-1 (Basic)	Cmd-1 (Options)	Cmd-1 (Image Settings)	Cmd-1 (Gallery)
Open/Close 2nd Right Palette	Cmd-2 (Keywording)	Cmd-2 (Tone Curve)	Cmd-2 (Layout)	Cmd-2 (Layout Engine)	Cmd-2 (Site Info)
Open/Close 3rd Right Palette	Cmd-3 (Keyword List)	Cmd-3 (HSL/Color/ Grayscale)	Cmd-3 (Overlays)	Cmd-3 (Layout)	Cmd-3 (Color Palette)
Open/Close 4th Right Palette	Cmd-4 (Metadata)	Cmd-4 (Split Toning)	Cmd-4 (Backdrop)	Cmd-4 (Overlays)	Cmd-4 (Appearance)
Open/Close 5th Right Palette	–	Cmd-5 (Detail)	Cmd-5 (Playback)	Cmd-5 (Print Job)	Cmd-5 (Image Info)
Open/Close 6th Right Palette	–	Cmd-6 (Vignettes)	–	–	Cmd-6 (Output Settings)
Open/Close 7th Right Palette	–	Cmd-7 (Camera Calibration)	–	–	Cmd-7 (Upload Settings)
Open/Close 8th Right Palette	–	Cmd-8 (Retouch)	–	–	–
Expand/Collapse All Palettes	Cmd-Click on panel name	Cmd-Click on panel name	Cmd-Click on panel name	Cmd-Click on panel name	Cmd-Click on panel name
Solo Mode On/Off	Opt-Click on panel name	Opt-Click on panel name	Opt-Click on panel name	Opt-Click on panel name	Opt-Click on panel name
Open additional panel without closing previous	Shft-Click on panel name	Shft-Click on panel name	Shft-Click on panel name	Shft-Click on panel name	Shft-Click on panel name
View Extras	**Library**	**Develop**	**Slideshow**	**Print**	**Web**
Cycle through Grid Modes	J	–	–	–	–
Show Cell Extras	Cmd-Shft-H	–	–	–	–
Show Badges	Cmd-Opt-Shft-H	–	–	–	–
Show/Hide Guides	–	–	Cmd-Shft-H	Cmd-Shft-H	–
Show Margins & Guides	–	–	–	Cmd-Shft-M	–

Show Rulers	–	–	–	Cmd–R	–
Show Image Cells	–	–	–	Cmd–Opt–T	–
Show Character Palette	Cmd–Opt–T	Cmd–Opt–T	Cmd–Opt–T	Cmd–Opt–T	Cmd–Opt–T
Show Page Bleed	–	–	–	Cmd–Shft–Y	–
Cycle Info Display	I	I	–	–	–
Show Info Display	Cmd–I	Cmd–I	–	–	–
View Options dialog	Cmd–J	Cmd–J	–	–	–
Zoom	**Library**	**Develop**	**Slideshow**	**Print**	**Web**
Toggle Zoom View (last 2 settings used)	Z or Space	Z	–	–	–
Zoom In (4 major zoom increments)	Cmd–+	–	–	–	–
Zoom Out (4 major zoom increments)	Cmd–– (minus key)	–	–	–	–
Zoom In (minor increments)	Cmd–Opt–+	–	–	–	–
Zoom Out (minor increments)	Cmd–Opt–– (minus key)	–	–	–	–
Enter Loupe or 1:1 View	Return	–	–	–	–
Scroll Down Image	Page Down (1:1 view +)	Page Down (1:1 view +)	–	–	–
Scroll Up Image	Page Up (1:1 view +)	Page Up (1:1 view +)	–	–	–
Dual Displays	**Library**	**Develop**	**Slideshow**	**Print**	**Web**
Show Second Display	Cmd–F11	Cmd–F11	Cmd–F11	Cmd–F11	Cmd–F11
Second Display Full Screen	Cmd–Shft–F11	Cmd–Shft–F11	Cmd–Shft–F11	Cmd–Shft–F11	Cmd–Shft–F11

Grid on Second Display	Shft-G	Shft-G	Shft-G	Shft-G	Shft-G
Loupe on Second Display	Shft-E	Shft-E	Shft-E	Shft-E	Shft-E
Locked Loupe on Second Display	Opt-Return	Opt-Return	Opt-Return	Opt-Return	Opt-Return
Compare on Second Display	Shft-C	Shft-C	Shft-C	Shft-C	Shft-C
Survey on Second Display	Shft-N	Shft-N	Shft-N	Shft-N	Shft-N
Show Filter Bar on Second Display	Shft-\	Shft-\	Shft-\	Shft-\	Shft-\
Lock selected photo to Second Display	Cmd-Shft-Enter	-	-	-	-
Zoom In on Second Display (4 major zoom increments)	Cmd-Shft-=	Cmd-Shft-=	Cmd-Shft-=	Cmd-Shft-=	Cmd-Shft-=
Zoom Out on Second Display (4 major zoom increments)	Cmd-Shft-- (minus key)	Cmd-Shft-- (minus key)	Cmd-Shft-- (minus key)	Cmd-Shft-- (minus key)	Cmd-Shft-- (minus key)
Zoom In on Second Display (minor increments)	Cmd-Opt-Shft-=	Cmd-Opt-Shft-=	Cmd-Opt-Shft-=	Cmd-Opt-Shft-=	Cmd-Opt-Shft-=
Zoom Out on Second Display (minor increments)	Cmd-Opt-Shft-- (minus key)	Cmd-Opt-Shft-- (minus key)	Cmd-Opt-Shft-- (minus key)	Cmd-Opt-Shft-- (minus key)	Cmd-Opt-Shft-- (minus key)
Increase Thumbnail Size on Second Display	=	=	=	=	=
Decrease Thumbnail Size on Second Display	- (minus key)	- (minus key)	- (minus key)	- (minus key)	- (minus key)
Importing and Exporting	**Library**	**Develop**	**Slideshow**	**Print**	**Web**
Import Photos from Disk	Cmd-Shft-I	Cmd-Shft-I	Cmd-Shft-I	Cmd-Shft-I	Cmd-Shft-I
Export Photos	Cmd-Shft-E	Cmd-Shft-E	Cmd-Shft-E	Cmd-Shft-E	Cmd-Shft-E
Export Photos as Previous	Cmd-Opt-Shft-E	Cmd-Opt-Shft-E	Cmd-Opt-Shft-E	Cmd-Opt-Shft-E	Cmd-Opt-Shft-E
Edit in Photoshop	Cmd-E	Cmd-E	-	-	-
Edit in Other Application	Cmd-Opt-E	Cmd-Opt-E	-	-	-

New Collection	Cmd–N	–	–	–	–
New Folder	Cmd–Shft–N	–	–	–	–
Reveal in Finder	Cmd–R	–	–	–	–
Plugin Manager	Cmd–Opt–Shft–,	Cmd–Opt–Shft–,	Cmd–Opt–Shft–,	Cmd–Opt–Shft–,	Cmd–Opt–Shft–,
Viewing / Sorting Photos	**Library**	**Develop**	**Slideshow**	**Print**	**Web**
Select All	Cmd–A	Cmd–A	Cmd–A	Cmd–A	Cmd–A
Select All Flagged Photos	Cmd–Opt–A	–	–	–	–
Select None	Cmd–D	Cmd–D	Cmd–D	Cmd–D	Cmd–D
Select Only Active Photo	Cmd–Shft–D	–	–	–	–
Deselect Active Photo	/				
Deselect Unflagged Photos	Cmd–Opt–Shft–D	–	–	–	–
Go to Previous Photo	Left Arrow				
Go to Next Photo	Right Arrow				
Add Previous Photo to Selection	Shft–Left Arrow	–	–	–	–
Add Next Photo to Selection	Shft–Right Arrow	–	–	–	–
Go to Previous Selected Photo	Cmd–Left Arrow	Cmd–Left Arrow	–	–	–
Go to Next Selected Photo	Cmd–Right Arrow	Cmd–Right Arrow	–	–	–
Scroll Down Screen	Page Down (Grid view)	–	–	–	–

Scroll Up Screen	Page Up (Grid view)	–	–	–	–
Rename Photos	F2	–	–	–	–
Rotate Left	Cmd-[Cmd-[Cmd-[–	–
Rotate Right	Cmd-]	Cmd-]	Cmd-]	–	–
Flag / Pick	P	P	P	P	P
Flag / Pick and Move to Next Photo	Shft–P or Caps Lock On + P	Shft–P or Caps Lock On + P	Shft–P or Caps Lock On + P	Shft–P or Caps Lock On + P	Shft–P or Caps Lock On + P
Unflagged	U	U	U	U	U
Unflagged and Move to Next Photo	Shft–U or Caps Lock On + U	Shft–U or Caps Lock On + U	Shft–U or Caps Lock On + U	Shft–U or Caps Lock On + U	Shft–U or Caps Lock On + U
Rejected	X	X	X	X	X
Rejected and Move to Next Photo	Shft–X or Caps Lock On + X	Shft–X or Caps Lock On + X	Shft–X or Caps Lock On + X	Shft–X or Caps Lock On + X	Shft–X or Caps Lock On + X
Toggle Flag	'	'	'	'	'
Increase Flag Status	Cmd-Up Arrow	Cmd-Up Arrow	Cmd-Up Arrow	Cmd-Up Arrow	Cmd-Up Arrow
Decrease Flag Status	Cmd-Down Arrow	Cmd-Down Arrow	Cmd-Down Arrow	Cmd-Down Arrow	Cmd-Down Arrow
Delete Photo / Remove from Catalog dialog	Del	Del	Del	Del	Del
Remove from Catalog	Opt-Del	Opt-Del	Opt-Del	Opt-Del	Opt-Del
Delete Rejected Photos	Cmd-Del	Cmd-Del	Cmd-Del	Cmd-Del	Cmd-Del
Remove & Trash Photo	Cmd-Opt-Shft-Del	Cmd-Opt-Shft-Del	Cmd-Opt-Shft-Del	Cmd-Opt-Shft-Del	Cmd-Opt-Shft-Del

Set Rating to 0 / Remove Rating	0	0	0	0	0
Set Rating to 1–5	1–5	1–5	1–5	1–5	1–5
Set Rating to 1–5 and Move to Next Photo	Shft–(1–5)	Shft–(1–5)	Shft–(1–5)	Shft–(1–5)	Shft–(1–5)
Decrease the Rating	[[[[[
Increase the Rating]]]]]
Set Label to Red, Yellow, Green, Blue	6–9	6–9	6–9	6–9	6–9
Set Label to RYGB and Move to Next Photo	Shft–(6–9) or Caps Lock On + (6–9)	Shft–(6–9) or Caps Lock On + (6–9)	Shft–(6–9) or Caps Lock On + (6–9)	Shft–(6–9) or Caps Lock On + (6–9)	Shft–(6–9) or Caps Lock On + (6–9)
Add Keywords to selected photo	Cmd–K	–	–	–	–
Change Keywords for selected photo	Cmd–Shft–K	–	–	–	–
Add Shortcut Keyword	Opt–K	–	–	–	–
Change Shortcut Keywords	Cmd–K	–	–	–	–
Set Keyword Shortcut	Cmd–Opt–Shft–K	–	–	–	–
Enable/Disable Painting (Tagging)	Cmd–Opt–K	–	–	–	–
Set Keyword Number 1–9 (see menu)	Opt–(1–9)	Opt–(1–9)	–	–	–
Next Keyword Set	Opt–0	–	–	–	–
Show Filter Bar	\	–	–	–	–
Find...	Cmd–F	–	–	–	–
Enable Filter	Cmd–L	Cmd–L	Cmd–L	Cmd–L	Cmd–L

Select Multiple Folders / Collections / Keywords / Metadata Fields	Cmd-Click on name	–	–	–	–
Select Filters – Text & Refine & Metadata	Shft-Click on Text & Refine & Metadata	–	–	–	–
Stack Photos	Cmd-G	–	–	–	–
Unstack Photos	Cmd-Shft-G	–	–	–	–
Toggle Stack	S	–	–	–	–
Move to Top of Stack	Shft-S	–	–	–	–
Move Up in Stack	Shft-[–	–	–	–
Move Down in Stack	Shft-]	–	–	–	–
Compare Mode – swap images	Down Arrow	–	–	–	–
Compare Mode – make select	Up Arrow	–	–	–	–
Create Virtual Copy	Cmd -'	Cmd -'	–	–	–
Metadata	**Library**	**Develop**	**Slideshow**	**Print**	**Web**
Cut (standard cut text, not images)	Cmd-X	Cmd-X	Cmd-X	Cmd-X	Cmd-X
Copy (standard copy text, not images)	Cmd-C	Cmd-C	Cmd-C	Cmd-C	Cmd-C
Copy Metadata	Cmd-Opt-Shft-C	–	–	–	–
Paste (standard paste text, not images)	Cmd-V	Cmd-V	Cmd-V	Cmd-V	Cmd-V
Paste / Sync Metadata	Cmd-Opt-Shft-V	–	–	–	–

Quick Collection	Library	Develop	Slideshow	Print	Web
Add to Quick Collection	B	B	B	B	B
Show the Quick Collection	Cmd–B	Cmd–B	Cmd–B	Cmd–B	Cmd–B
Save the Quick Collection	Cmd–Opt–B	Cmd–Opt–B	Cmd–Opt–B	Cmd–Opt–B	Cmd–Opt–B
Clear the Quick Collection	Cmd–Shft–B	Cmd–Shft–B	Cmd–Shft–B	Cmd–Shft–B	Cmd–Shft–B
Set as Target Collection	Cmd–Shft–Opt–B	–	–	–	–
Quick Slideshow	Library	Develop	Slideshow	Print	Web
Show Selected Photos in Quick Slideshow	Cmd–Return	–	–	–	–
Developing	Library	Develop	Slideshow	Print	Web
Sync Settings	Cmd–Shft–S	Cmd–Shft–S	–	–	–
Sync Settings bypassing Dialog	–	Cmd–Opt–S	–	–	–
Auto Sync	–	Cmd–Click on Sync button	–	–	–
Copy Develop Settings	Cmd–Shft–C	Cmd–Shft–C	–	–	–
Paste Develop Settings	Cmd–Shft–V	Cmd–Shft–V	–	–	–
Paste Develop Settings from Previous	Cmd–Opt–V	Cmd–Opt–V	–	–	–
Copy After's Settings to Before	–	Cmd–Opt–Shft–Left Arrow	–	–	–
Copy Before's Settings to After	–	Cmd–Opt–Shft–Right Arrow	–	–	–
Swap Before/After's Settings	–	Cmd–Opt–Shft–Up Arrow	–	–	–
Reset All Develop Settings	Cmd–Shft–R	Cmd–Shft–R	–	–	–

Reset Single Section	–	Hold Alt and Reset buttons appear	–	–	–
Reset Single Slider	–	Double click on slider label or slider	–	–	–
Undo Last Action	Cmd-Z	Cmd-Z	Cmd-Z	Cmd-Z	Cmd-Z
Redo Last Action	Cmd-Shft-Z	Cmd-Shft-Z	Cmd-Shft-Z	Cmd-Shft-Z	Cmd-Shft-Z
Auto Tone	Cmd-U	Cmd-U	–	–	–
Auto White Balance	Cmd-Shft-U	Cmd-Shft-U	–	–	–
Convert to Grayscale	V	V	–	–	–
Go to White Balance in Develop Mode	W	W	–	–	–
Increase Selected Slider (default Exposure)	–	+	–	–	–
Decrease Selected Slider (default Exposure)	–	– (minus key)	–	–	–
Increase Selected Slider (larger increments)	–	Shft-+	–	–	–
Decrease Selected Slider (larger increments)	–	Shft-- (minus key)	–	–	–
Move forwards through sliders	–	.	–	–	–
Move backwards through sliders	–	,	–	–	–
Reset Selected Slider	–	;	–	–	–
Show Clipping	–	J	–	–	–
Temporary Show Clipping	–	Hold down Opt while move slider	–	–	–

Cycle Grid Overlay	–	O	–	–	–
Go to Crop in Develop Mode	R	R	R	R	R
Crop – Toggle Constrain Aspect Ratio	–	A	–	–	–
Crop to Same Aspect Ratio	–	S	–	–	–
Reset Crop	–	Cmd-Opt-R	–	–	–
Crop grows from Center	–	Opt while drag corner	–	–	–
Cycle the Crop Overlay on and off	–	H	–	–	–
Cycle the Crop Overlay Style	–	O	–	–	–
Cycle the Overlay Orientation	–	Shft-O	–	–	–
No Target Adjustment Tool	–	Cmd-Opt-Shft-N	–	–	–
Target Adjustment Tool – Grayscale Mix	–	Cmd-Opt-Shft-G	–	–	–
Target Adjustment Tool – Hue	–	Cmd-Opt-Shft-H	–	–	–
Target Adjustment Tool – Saturation	–	Cmd-Opt-Shft-S	–	–	–
Target Adjustment Tool – Luminance	–	Cmd-Opt-Shft-L	–	–	–
Target Adjustment Tool – Tone Curve	–	Cmd-Opt-Shft-T	–	–	–
Enter Spot Healing Mode	–	N	–	–	–
Increase Brush Size	–]	–	–	–
Decrease Brush Size	–	[–	–	–
Change Size of Existing Spot	–	Drag edge of spot	–	–	–
Delete Spot	–	Select spot, Delete	–	–	–

Hide Spot	–	H	–	–	–
Hand Tool in Spot Mode	–	Space	–	–	–
Go to Adjustment Brush in Develop Mode	K	K	K	K	K
Graduated Filter Tool		M			
Increase Brush Size	–]	–	–	–
Decrease Brush Size	–	[–	–	–
Increase Brush Feathering	–	Opt-]	–	–	–
Decrease Brush Feathering	–	Opt-[–	–	–
Commit Changes	–	Enter	–	–	–
Delete Currently Selected Mask	–	Delete	–	–	–
Change Brush to Eraser	–	Hold Opt while brushing	–	–	–
Switch A/B Brushes	–	/	–	–	–
Draw a horizontal or vertical line	–	Hold Shft while brushing	–	–	–
Increase/Decrease Amount Slider	–	Drag mask pin left/ right	–	–	–
Show Mask Overlay	–	O	–	–	–
Cycle through Mask Overlay colors	–	Shft-O	–	–	–
Show/Hide Mask Pins	–	H	–	–	–
New Snapshot	–	Cmd-N	–	–	–
New Preset	–	Cmd-Shft-N	--	–	–
New Preset Folder	–	Cmd-Opt-N	--	–	–

View Before Only	–	\	–	–	–
View Before/After Left/Right	–	Y	–	–	–
View Before/After Up/Down	–	Opt–Y	–	–	–
View Before/After Split Screen	–	Shft–Y	–	–	–
Slideshow / Print / Web Gallery	Library	Develop	Slideshow	Print	Web
New Template	–	–	Cmd–N	Cmd–N	–
New Template Folder / Preset Folder	–	–	Cmd–Shft–N	Cmd–Shft–N	Cmd–Shft–N
Save Settings	–	–	Cmd–S	Cmd–S	Cmd–S
Add Text Overlay	–	–	Cmd–T	–	–
Show/Hide Guides	–	–	Cmd–Shft–T	Cmd–Shft–T	–
Guides – Page Bleed	–	–	–	Cmd–Shft–Y	–
Guides – Margins & Gutter	–	–	–	Cmd–Shft–M	–
Guides – Image Cells	–	–	–	Cmd–Shft–T	–
Guides – Dimensions	–	–	–	Cmd–Shft–U	–
Play Slideshow	–	–	Return	–	–
Preview Slideshow	–	–	Opt–Return	–	–
Pause Slideshow	–	–	Space	–	–
End Slideshow	–	–	Esc	–	–
Go to Next Slide	–	–	Cmd–Left Arrow	–	–

Go to Previous Slide	–	–	Cmd–Right Arrow	–	–
Go to Previous Page	–	–	–	Cmd–Left Arrow	–
Go to Next Page	–	–	–	Cmd–Right Arrow	–
Go to First Page	–	–	–	Cmd–Shft– Left Arrow	–
Go to Last Page	–	–	–	Cmd–Shft– Right Arrow	–
Print	Cmd–P	Cmd–P	Cmd–P	Cmd–P	Cmd–P
Print One Copy	–	–	–	Cmd–Opt–P	–
Page Setup	Cmd–Shft–P	Cmd–Shft–P	Cmd–Shft–P	Cmd–Shft–P	Cmd–Shft–P
Print Settings	–	–	–	Cmd–Shft– Opt–P	–
Reload Web Gallery	–	–	–	–	Cmd–R
Preview Web Gallery in Browser	–	–	–	–	Cmd–Opt–P
Export Slideshow	–	–	Cmd–J	–	–
Export Web Gallery	–	–	–	–	Cmd–J
Standard Shortcuts	**Library**	**Develop**	**Slideshow**	**Print**	**Web**
Help	Cmd–?	Cmd–?	Cmd–?	Cmd–?	Cmd–?
Preferences	Cmd–,	Cmd–,	Cmd–,	Cmd–,	Cmd–,
Catalog Settings	Cmd–Opt–,	Cmd–Opt–,	Cmd–Opt–,	Cmd–Opt–,	Cmd–Opt–,
Minimize Window	Cmd–M	Cmd–M	Cmd–M	Cmd–M	Cmd–M
Zoom Window	Cmd–0	Cmd–0	Cmd–0	Cmd–0	Cmd–0

Close Window	Cmd-W	Cmd-W	Cmd-W	Cmd-W	Cmd-W

Standard modifier key actions for both platforms

Ctrl (Windows) / Cmd (Mac) – Select or deselect multiple items, not necessarily consecutive. (Library, select multiple images, select multiple folders, select multiple keywords, etc)

Shft – Select or deselect multiple consecutive items. (Library, select multiple images, select multiple folders, select multiple keywords etc)

Alt (Windows) / Opt (Mac) – Changes the use of some controls to alternative uses. (Quick Develop, swaps Clarity and Vibrance for Sharpening and Saturation. Other panels, changes auto button to reset button.)

To switch catalogs when opening, hold down Ctrl (Windows) / Opt (Mac).

Printed in the United States
125663LV00003B/10/P

9 780956 003027